American Masterpieces
from the National Gallery of Art

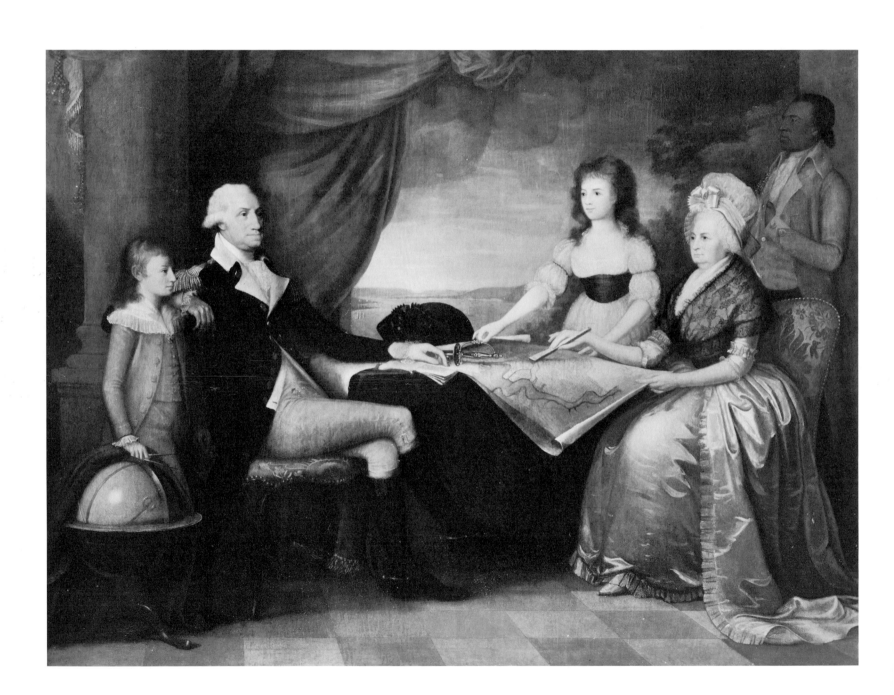

American Masterpieces
from the National Gallery of Art

Revised and Enlarged Edition

by John Wilmerding

Foreword by J. Carter Brown

Crescent Books
New York • Avenel, New Jersey

© 1980, 1988 by Hudson Hills Press, Inc.
All rights reserved under International
and Pan-American Copyright Conventions.
Published in the United States by
Hudson Hills Press, Inc., Suite 1308,
230 Fifth Avenue, New York, NY 10001-7704.
Distributed by Outlet Book Company, Inc.
a Random House Company, 40 Engelhard Avenue,
Avenel, New Jersey 07001
Random House
New York • Toronto • London • Sydney • Auckland

Editor: Paul Anbinder
Associate Editor: Margaret Aspinwall
Copy Editor, revised edition: Lydia Edwards
Indexer: Gisela S. Knight
Designer: James Wageman/Gilda Hannah
Composition: Kordon Typographers, Inc./J. M. Martin
Co., Inc.
Manufactured in Hong Kong

LIBRARY OF CONGRESS CATALOGUING-IN-PUBLICATION DATA

Wilmerding, John.
 American masterpieces from the National Gallery of Art / John
Wilmerding ; foreword by J. Carter Brown.—Rev. and enl. ed.
 p. cm.
 Bibliography: p.
 Includes index.
 ISBN 0-517-09310-3
 1. Art, American—Catalogues. 2. Art—Washington, D.C.— Catalogues.
3. National Gallery of Art (U.S.)—Catalogues. I. Title.
N6505.W56 1988
709'.73'0740153—dc19 88-13223

I should like to acknowledge with thanks the assistance of
Maria Mallus in preparing the manuscript, Ira Bartfield in
managing the photographs, and Linda Ayres in working on
the artists' biographies and the bibliography. J.W.

Frontispiece: Edward Savage, *The Washington Family,* 1796
Oil on canvas, 84⅜ × 111⅞ in. (213.6 × 284.2 cm.)
Andrew W. Mellon Collection, 1940

Contents

List of Colorplates

Foreword

One of the foremost missions of our nation's National Gallery has always been the collecting and exhibiting of the art of the United States in the larger context of western European civilization. This has implied a continuing obligation to acquire works of American art which could hold their own qualitatively in a constellation of galleries displaying the best examples of other national schools. Such an aspiration has also permitted us to examine American art both as an indigenous native expression and as a tradition woven into the complex fabric of European precedents.

Although the collections of American art at the National Gallery took basic shape under the guidance of my predecessors, we have seen continued steady growth over the last decades. Notable developments in recent years have especially invigorated our curatorial activities in the American area. Foremost was the dramatic physical expansion of the Gallery into its new East Building in 1978. Our new structure not least gave impetus to our collecting modern art, especially painting and sculpture in America since World War II.

Succeeding the late William Campbell, John Wilmerding joined the Gallery in 1977 as curator of American art and senior curator. Shortly thereafter he appointed Linda Ayres and Deborah Chotner as assistant curators in the department. They initiated the systematic rehanging of all the American galleries, and undertook the preparation and publication in 1980 of an updated handbook, *American Paintings: An Illustrated Catalogue*. At the same time the staff began work on a sequence of American exhibitions. Certainly, the major undertaking of these years was the landmark exhibition *American Light: The Luminist Movement, 1850–1875*, which proved to be a revealing and acclaimed reexamination of mid-nineteenth-century landscape painting in America. In collaboration with curators in our twentieth-century department, Mr. Wilmerding and Ms. Ayres joined in organizing a show on *Bellows: The Boxing Pictures*, centering around the Gallery's great Dale painting *Both Members of This Club*. During the early 1980s as well, the department initiated an important exhibition of a major private collection, *An American Perspective: Nineteenth-Century Art from the Collection of Jo Ann and Julian Ganz, Jr.* Subsequently, Mr. Wilmerding

organized another influential and groundbreaking show in his monographic study, *Important Information Inside: The Still-Life Paintings of John F. Peto*—as it turned out, his final one as department head.

In 1983 Mr. Wilmerding was appointed Deputy Director of the Gallery, and although he took on broader institutional responsibilities, his scholarly interest in the field remained undiminished. His successor as curator of American art was another accomplished scholar and teacher, Nicolai Cikovsky; and with Linda Ayres's departure for a senior position at the Amon Carter Museum, Franklin Kelly came to the Gallery as a new assistant curator. If anything, the pace of department activities quickened with the planning and mounting of an ambitious, ongoing series of key American exhibitions lasting throughout the decade. These included another large survey installation from a private collection, that of Richard A. Manoogian, as well as monographic presentations of William Merritt Chase, Fitz Hugh Lane, Raphaelle Peale, John Marin, Frederic Edwin Church, Childe Hassam, John Twachtman, Albert Bierstadt, and George Caleb Bingham. The resulting publications and installations arguably put the National Gallery at the forefront of American art-historical scholarship.

Besides devoting these energies to the exhibition program, the department continues to work in bringing new American acquisitions to the Gallery and in the corresponding process of researching and publishing the collection. The in-house staff, along with outside scholars, have made major strides in the writing of the several volumes planned for the Systematic Catalogue of the Gallery's American holdings. Working both with our department of Extension Programs in the Education division and, in two cases, with outside producers, Mr. Wilmerding and Mr. Cikovsky have made a sequence of half-hour films on American art, specifically on the subjects of luminism, Peto, Audubon, Homer, Chase, and folk art. These have become popular and widely shown adjuncts of our exhibitions and help to extend the knowledge about American art to a potentially vast audience around the world.

Mr. Wilmerding is the author of more than a dozen books on American art and artists, including monographs on Robert

Salmon, Fitz Hugh Lane, Winslow Homer, and the authoritative volume *American Art* in the Pelican History of Art series. We therefore welcome here his discussion of our own collection in this handsome publication *American Masterpieces from the National Gallery of Art*. Among the many outstanding American works he comments on in detail are several he has had a hand in bringing to the Gallery—Eastman Johnson's *The Brown Family*, Jasper F. Cropsey's *The Spirit of War*, Fitz Hugh Lane's *Lumber Schooners at Evening on Penobscot Bay*, Martin Johnson Heade's *Cattleya Orchid and Three Brazilian Hummingbirds*, and Rembrandt Peale's *Rubens Peale with a Geranium*. While this book concentrates foremost on the Gallery's American paintings, the reader is also treated to summary observations on our related holdings in graphic arts and sculpture.

In a learned yet lively manner Mr. Wilmerding examines afresh a broad range of our treasures. We hope that this finely illustrated volume will serve equally as a pleasure in itself and as an inducement to extend that pleasure by a visit to our galleries in person. As the National Gallery will mark its fiftieth anniversary in 1991, this invitation to enjoy our nation's treasures could not be more timely.

J. Carter Brown
Director, National Gallery of Art

American Masterpieces from the National Gallery of Art

As befits a democracy, America's great examples of its own native art are housed in many collections across the country. Important concentrations are to be found in several locations, and appropriately one of the premier places to find a broad and rich coverage of American art is in the nation's capital. The holdings of the National Gallery of Art are strongly complemented by the other major concentrations of American art in Washington, namely, the distinguished personal collections of the Corcoran, Freer, and Phillips galleries, and the broader surveys assembled at the Hirshhorn Museum, the National Museum of American Art, and the National Portrait Gallery. Along with the supporting resources in other sections of the Smithsonian Institution (for example, American Indian and Afro-American art), and in the Library of Congress and the National Archives, these together in Washington assume a pre-eminence of which the American citizen can be justifiably proud.

From the time of its opening in 1941 the National Gallery of Art has included among its public obligations the collection and display of many of the best examples of American painting as well as great works from other countries. Such efforts have been increasingly realized over the decades by the acquisition of outstanding American paintings through many generous gifts and occasional purchases. These represent the high points of the nation's cultural achievements from the colonial period to contemporary times. It has traditionally been the National Gallery's policy to collect where possible the supreme examples by the major artists in a national school rather than to assemble a survey of representative pieces.

A Brief History of the Collection

The growth in the National Gallery's American collections over the last decades has been notable in two significant areas: the addition of several nineteenth-century masterpieces and, concurrent with the completion of the Gallery's new East Building in 1978, the dynamic expansion in the area of twentieth-century modernism. When the Gallery opened in 1941, it owned only eleven American pictures given by Andrew W. Mellon. (Another thirteen were on view as loans.) By 1970 the summary catalogue could list 827 American paintings (and five pieces of American sculpture). The works documented for the 1980 handbook number over a thousand, and that total has grown extensively since.

The American collection has come to its present distinction in part through its shaping and nurturing by William P. Campbell, who was for many years the Gallery's Curator of American Painting and Assistant Chief Curator until his untimely death in 1976. The Gallery's holdings have also been defined and immeasurably enlarged by the many gifts to the nation from dozens of thoughtful, public-spirited donors.

A brief summary of some of the most notable donations will give a revealing indication both of the remarkable generosity of individual collectors and of particular areas of depth within the overall American collection. Among the first pictures to come to the Gallery in 1940 through gift or purchase funds of Andrew W. Mellon were such now-familiar images as Edward Savage's *Washington Family* of 1796, Gilbert Stuart's *Mrs. Richard Yates* of 1793/94, and Benjamin West's *Colonel Guy Johnson* of 1776. In one stroke superb examples by three of America's "old masters" assured the Gallery's commitment to high quality in the American school. They were quite different from one another—the Savage endures as a great national document, the Stuart as an unsurpassed individual study, and the West as an impressive academic accomplishment. Together they established a central concentration in portraiture, which would be reinforced over the following years by the addition of nearly a dozen works by John Singleton Copley; three times that number of other Stuart portraits; a later group by John Singer Sargent, Thomas Eakins, and James McNeill Whistler; and several strong portraits by three of the Ashcan painters: George Bellows, Robert Henri, and George Luks.

The early forties saw the further strengthening of the American collection with such additional major works as Copley's *Red Cross Knight*, 1793, the gift of Mrs. Gordon Dexter; Whistler's *White Girl*, 1862, which came from the Harris Whittemore collection; and Winslow Homer's *Breezing Up (A Fair Wind)*, 1876, a purchase in 1943 through the W. L. and May T. Mellon Foundation. The latter was the first of several great Homer oils

Gilbert Stuart, portraits of the first
five American presidents. All oil on wood

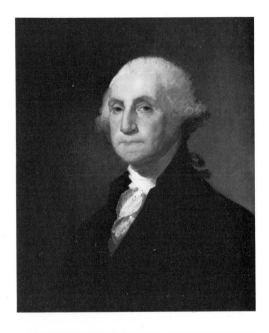

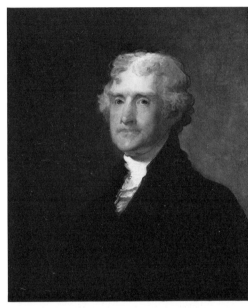

Top, left to right:

George Washington, c. 1810/15
26⅜ x 21½ in. (67 x 54.6 cm.)

Thomas Jefferson, c. 1810/15
26 x 21¼ in. (65.9 x 54 cm.)

Gift, 1979, and promised gift, respectively,
of Thomas Jefferson Coolidge IV
in memory of his great grandfather
Thomas Jefferson Coolidge, his grandfather
Thomas Jefferson Coolidge II, and his
father Thomas Jefferson Coolidge III

Bottom, left to right:

John Adams, c. 1825
26 x 21⅜ in. (66 x 54.2 cm.)

James Madison, c. 1810/15
25⅝ x 21¼ in. (65.2 x 53.9 cm.)

James Monroe, c. 1817
25½ x 21½ in. (64.7 x 54.6 cm.)

All Ailsa Mellon Bruce Fund, 1979

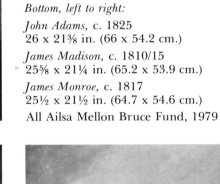

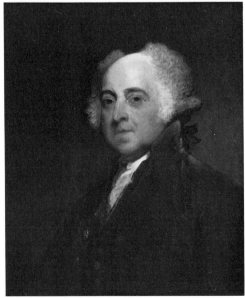

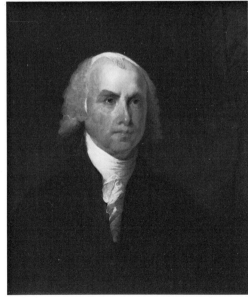

to come to the National Gallery over the years, a group significantly enhanced in the 1970s by the bequest of seventeen Homer watercolors from Mrs. Charles Henschel and the gift of a half-dozen Homer drawings from John Davis Hatch. The first years of the Gallery also benefited from the early and continuing generosity of Chester Dale, perhaps most familiarly in the French area, though notably in the American school as well. With a taste sensitive foremost to the Impressionist style, he gave William Merritt Chase's *A Friendly Call* in 1943, and two decades later he presented no fewer than seven works by Mary Cassatt, including the well-known *Boating Party* of 1893.

The decade of the fifties brought broad new support, especially from three collectors who were to enlarge the Gallery's American holdings markedly. Ailsa Mellon Bruce provided funds through the Avalon Foundation to make possible the acquisition in 1951 of *Right and Left*, the culminating achievement of Homer's career and certainly one of the most important American works in the National Gallery. In this period, too, Edgar William and Bernice Chrysler Garbisch initiated a gift of magnanimous and ongoing generosity with their donation of over three hundred American naive paintings. The group contained subjects of all types—portraits, landscapes, genre scenes, signboards. Most of these paintings were by anonymous, self-taught craftsmen. In addition to the marvelous variety of subjects by unknown artists, this group includes Joshua Johnson's *Westwood Children*, a pair of Winthrop Chandler portraits, eight landscapes by Thomas Chambers, fourteen works by Erastus Salisbury Field, and Edward Hicks's singular panorama of *The Cornell Farm* of 1848. At the same time the Andrew W. Mellon collection continued to provide important funds, and added to the growing Stuart holdings the artist's full-length tour de force, *The Skater*.

During the 1960s imposing new portrait and figure paintings came into the Gallery's collection from various donors: John Trumbull's *Patrick Tracy,* Charles Willson Peale's double portrait of *Benjamin and Eleanor Ridgely Laming,* Sargent's *Mrs. Adrian Iselin*, and Copley's first major subject of his English period, *Watson and the Shark*. But these gains were being matched with the acquisition in the mid-sixties of such key

Hudson River School landscapes as Thomas Cole's *Crawford Notch* and Frederic Edwin Church's *Morning in the Tropics*. Another sizable gift came in the collection of George Catlin cartoons given by Paul Mellon in 1965. Numbering more than three hundred and fifty, this remarkable group of finished oil sketches includes powerful Indian portraits as well as extensive renderings of Indian life—ceremonies, hunting, and other daily activities. With the incorporation of this group into the American collections, the National Gallery was the beneficiary of another broad collection within a collection. Indeed, more than two-thirds of the National Gallery's American paintings are associated with three donor names: Andrew W. Mellon, Colonel and Mrs. Garbisch, and Paul Mellon.

The Catlin collection and the Garbisch gifts assured that the American school at the National Gallery would have a rich and broad variety, spanning the full spectrum from self-trained to academic styles. Selections from the Garbisch and Catlin groups can be rotated periodically in the galleries, and dozens of works from these gifts go out on loan to other institutions across the country and abroad.

Thus we have seen in summary how, in the course of only three decades, the Gallery's American holdings emerged, both with great single works of art and with several broad areas of strength, to give the visitor an overview of America's evolving visual heritage. With this foundation of distinction to build on, the Gallery continued to receive or acquire during the 1970s additional American paintings of particular interest and quality.

At the beginning of the decade, and at the start of J. Carter Brown's directorship, Thomas Cole's major late series of *The Voyage of Life* came to light and was purchased through the Ailsa Mellon Bruce Fund. A large allegorical painting, *The Spirit of War* by Jasper Cropsey, was another rediscovery after many years of being unlocated, and in 1978 the Avalon Fund made it possible to acquire this work. That same year the bequest of Frederick Sturges, Jr., brought to the Gallery five beautiful Hudson River School paintings, among them an unsurpassed Massachusetts coast view by John F. Kensett, a work by Francis W. Edmonds and one by John W. Casilear, and two by Asher

Erastus Salisbury Field
"He Turned Their Waters into Blood," c. 1865/80
Oil on canvas, 30¼ x 40½ in. (76.9 x 102.9 cm.)
Gift of Edgar William and
Bernice Chrysler Garbisch, 1964

Opposite left:
George Catlin, *Catlin Painting the Portrait
of Mah-To-Toh-Pa—Mandan,* 1857/69
Oil on cardboard, 15⅜ x 21¹⁵/₁₆ in.
(39.1 x 55.6 cm.), oval
Paul Mellon Collection, 1965

Opposite right:
Asher B. Durand
Forest in the Morning Light, c. 1855
Oil on canvas, 24¼ x 18¼ in. (61.5 x 46.2 cm.)
Gift of Frederick Sturges, Jr., 1978

B. Durand, all artists up to this point unrepresented in the collection. Purchased shortly after, in memory of former National Gallery director David Finley and his wife, was *The Brown Family,* one of Eastman Johnson's finest group portraits.

The culminating acquisition of the 1970s was the group of five portraits by Gilbert Stuart of the first five American presidents, which came from the T. Jefferson Coolidge family of Boston. Known as the Gibbs-Coolidge portraits because they were originally painted between 1810 and 1825 for Colonel Gibbs of Rhode Island, they passed after his death into the Coolidge family, in which they descended until coming to the National Gallery. Although other versions by Stuart of these various eminent individuals exist, these have special importance as the only surviving group. (Stuart painted one other set, which was partially destroyed by fire in the Library of Congress in the middle of the nineteenth century.) Aside from their obvious historical and documentary significance, they also possess an impressive artistic power, deriving from their vitality as well as their sense of humane and accessible presence. By joining the already strong and varied number of Stuart paintings in the Gallery, this singular group of great American images now

establishes a preeminent concentration of this early American master's art in Washington.

With the accelerating pace of prices for American art and the sequence of changes in the tax laws during the 1980s, one might have thought that activities in this field would slacken. Moreover, the Gallery's staff settled into the new routines of the East Building and turned new energies to the exhibition program. Yet this period witnessed astonishing additions to the collections, as remarkable for their volume as for their quality. The new acquisitions came in four basic categories: single purchases, gifts in depth of large numbers of works by a single artist or closely related group, landmark gifts by previous Gallery donors, and the donation of key individual works, often by artists previously not owned by the Gallery. In many instances these additions built on existing strengths, bringing related examples of an artist; in other cases, unusual or important single pieces represented an American master in a new way.

In the middle of the decade the Gallery made its largest and most dramatic purchase to date of an American work of art when it bid successfully at auction for Rembrandt Peale's portrait of his brother, *Rubens Peale with a Geranium,* 1801. During

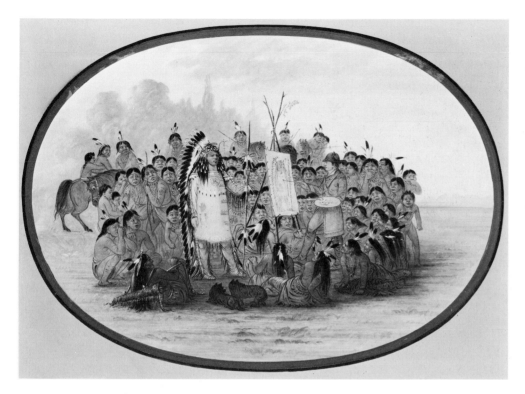

the early eighties the trustees had undertaken an ambitious and unprecedented campaign to raise at least fifty million dollars for the newly created Patrons Permanent Fund, of which only the income could be used for art acquisitions. More than completing its goal, the fund had also in its first years begun to accumulate substantial income, and the timing was such that the Peale appeared as a first critical target of opportunity. Because such a wide diversity of donors from all over the country had contributed to the fund, it seemed especially appropriate that the initial purchase (a record for the public sale of an American picture at the time) should have been a work of American art, acquired literally by and for the nation's citizens. The painting itself embodies the very essence of the national character in its beguiling informality of presence and combined stress on youth and nature.

Another purchase of surpassing beauty was that of Martin Johnson Heade's *Cattleya Orchid and Three Brazilian Hummingbirds*, 1871, one of his first paintings of this exotic subject repeated so often throughout his subsequent career. An original synthesis of still life and landscape, his art also embraced the rising passion for natural science in the second half of the

nineteenth century. Such singular acquisitions were complemented by large-scale donations in the graphics area of the comprehensive production of the Tamarind Lithography Workshop, Gemini G.E.L., and Graphicstudio Archive, and in paintings of the core group of works from the Rothko Foundation, as well as a final large bequest of American naive paintings from Colonel and Mrs. Garbisch. The Rothko gift was the result of a careful collaboration and selection made between National Gallery curators and trustees of the estate to ensure that a full cross-section of the artist's surviving oeuvre come to the nation. Along with a basic group of works from all periods and styles came important watercolor studies, sketches, and archival material, making the National Gallery the single most important repository of Rothko's achievement. Similarly, the Garbisch gift completed their long benefaction to the Gallery by adding another several dozen major naive oils and watercolors to the collection. Aside from including rare eighteenth-century portraits, this group also brought several new examples of works by Thomas Chambers, Edward Hicks, Erastus Salisbury Field, and Joshua Johnson. Because of the Garbisch's Maryland associations, Johnson was a particular favorite of theirs as an early

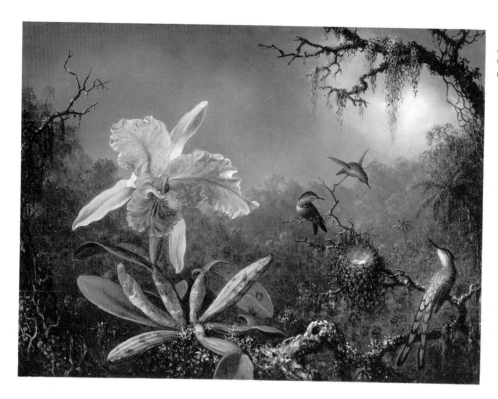

Martin Johnson Heade, *Cattleya Orchid and Three Brazilian Hummingbirds*, 1871
Oil on wood, 13¾ x 18 in. (34.8 x 45.6 cm.)
Gift of the Morris and Gwendolyn Cafritz Foundation, 1982

black painter in the state, and among the numerous paintings given by them is the only one with a definitive Johnson signature.

A related category of gifts in this decade was that of important miscellaneous works, often from previous donors. Foremost among these were those by former National Gallery trustees Paul Mellon and John Hay Whitney. The Mellon name, of course, has been associated with the institution since its founding, but Paul Mellon's sizable donations of art in 1983 and 1985 were among the most important in the long history of his generosity. Among the dozens of works he gave in the earlier group were five paintings by Bellows and two by Cassatt, complemented by numerous works on paper. The subsequent donation consisted of over one hundred and twenty pieces, again including works by such major figures as Homer, Eakins, and Prendergast. On yet other occasions Mr. Mellon offered the fine marine painting by Robert Salmon of *The Ship "Favorite" Maneuvring off Greenock*, 1819, and still another large urban view by Bellows, *New York, February, 1911*. Where the former canvas became the first by the artist to enter the collection, and provided a glowing counterpart to the Gallery's later Fitz Hugh Lane marine painting, the New York scene made a powerful

trilogy with the two well-known works given by Dale many years before.

The Whitney bequest was smaller in number but no less choice in quality or significant in impact. Along with four French paintings came four American ones: Edward Hopper's *Cape Cod Evening*, his first oil to enter the Gallery; Eakins's *Baby at Play*; Whistler's *Wapping on Thames*; and Bellows's *Club Night*, the latter three all rare additions to existing strengths. In fact, the boxing picture was an immediate pendant to the Dale variant. Equal enhancements of the collection in the twentieth-century field occurred with the gift from the estate of Georgia O'Keeffe of eight key paintings by her, and with the purchase of Barnett Newman's austere and elegant *Stations of the Cross*, fourteen related canvases at the heart of abstract expressionism, acquired with funds generously donated by Robert and Jane Meyerhoff. These two events made possible the inclusion of two modern artistic giants, at their best, in the Gallery's holdings.

The last category of acquisitions during the decade of the eighties was the more general one of individual objects from single donors, and this pattern saw the inclusion of fine representative paintings by artists from several different periods.

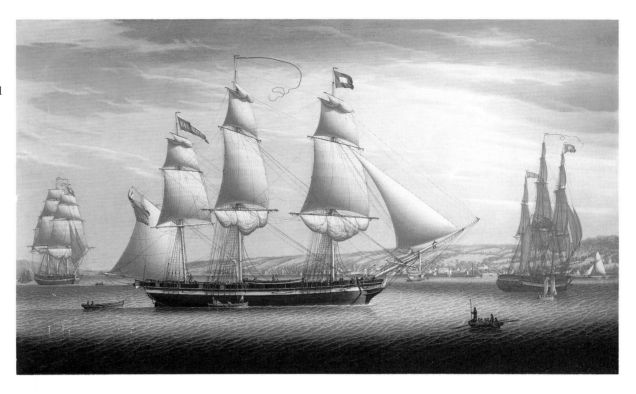

Robert Salmon, *The Ship "Favorite" Maneuvering off Greenock*, 1819
Oil on canvas, 30 x 50½ in. (76.2 x 128.3 cm.)
Paul Mellon Collection, 1981

For example, added in the colonial area were portraits by Copley and Charles Willson Peale; in the first half of the twentieth century types of realism by Robert Henri, Marin, and Grant Wood; in postwar art, aspects of abstract expressionism by Lee Krasner and Richard Diebenkorn, along with pop art variations by Warhol, Lichtenstein, Rauschenberg, and Richard Lindner. Finally, a mixed-media piece of 1982 by Frank Stella was acquired, joining several examples from key earlier phases of his career. In total, this period was one of exciting activity in the ongoing enrichment of the National Gallery's American collections. More than ever, they offer a full and distinguished panorama of the major developments in our nation's art.

The Collection and the History of American Art

If the major American works have come to the National Gallery through no particular order, but rather by the exemplary generosity of donors and the careful purchasing by several directors and curators, the cumulative result now offers an outstanding overview of our nation's achievements in the visual arts. For instance, there are several examples of the earliest colonial limners and a representative sampling of work by Jeremiah Theus, Robert Feke, John Wollaston, Joseph Badger, and John Greenwood. In these stern and sturdy visages, painted largely during the first half of the eighteenth century, we can see the first tentative but ambitious efforts of artists in the colonies to adapt basically English formats to the practical exigencies of the harsh New World environment. Undertaken to serve as realistic likenesses to pass on to posterity, these portraits testify to a world centered on the aspirations and achievements of individuals, presented often with the rough directness and manner of a people striving to establish culture in a new setting.

Only with the figures of Benjamin West and John Singleton Copley do we see the first great flourishing of accomplishment by American-born artists on a national and international stage. Exact contemporaries (both were born in 1738), they found it necessary to complete their artistic training and careers in England. After learning the rudiments of art and painting some charming portraits in the native limner tradition, West left as a youth to go abroad. Immersing himself in the artistic traditions and collections of Europe, he settled in London to an extraordinarily successful career, marked by the enthusiastic

patronage of the king, devoted assistance to other American colleagues passing through, and acceptance as one of Europe's foremost history painters.

In two of West's major accomplishments, *The Battle of La Hogue* and *Colonel Guy Johnson*, we can see his mastery of the late eighteenth-century high style of European academic art. In both he effectively blended contemporary portraiture and historical subject matter with allegorical allusion to create an imagery of moral force. These stylistic ingredients, along with his commanding technical abilities, were central in the establishment of his artistic leadership and influence. That influence is nowhere more vividly apparent than in the work of his colleague John Singleton Copley, whom West persuaded to leave the strife-ridden colonies in the midst of the Revolution for the promise of a grander career in England.

Before leaving, Copley had already enjoyed an unrivaled career based largely in Boston for some two decades. His style was well grounded in the American portrait tradition, which was indebted variously to practical necessities, celebration of the individual, and precedents in available English mezzotints. His earlier male portraits, such as those of *Epes Sargent* and *Eleazer Tyng*, give us the sturdy, solid presences of successful New England merchants with powerful realism comprised of palpable formal geometries and generally earthy colors. By contrast, many of the female portraits from these years—for example, *Mrs. Metcalf Bowler* and *Mrs. Adam Babcock*—display sequences of textures and surfaces in both flesh and costume that are of a ravishing virtuosity. All of them, however, share the common denominator of capturing on canvas a strong physical and personal presence.

Once settled in London, Copley undertook his first major group compositions, including the large and appealing portrait of *The Copley Family*, an image of new-found domestic serenity and self-confidence. But there is also a hint here of the brighter colors and richer brushwork which reflect his increasing consciousness of current English painting. At this time he also began in several versions his dramatic rendering of *Watson and the Shark*, which depicts an incident in the youth of the Lord Mayor of London, Brook Watson. While swimming in Havana harbor, Watson had been attacked by a shark and barely saved. Copley saw in the story the ingredients for drawing relatively contemporary events and ordinary individuals into the elevated context of heroic history painting. Aware of the precedents set by West in his recently completed popular paintings, Copley was also to enjoy a grand new reputation and favor with the king through such striking modernizations of traditional aca-

demic modes. Even more than West, however, Copley made paintings like *Watson and the Shark* life-size group portraits in action. In so doing, he carried over into his English career all the great strengths of individual observation and delineation that had characterized the realism of his earlier American portraits. At the same time much of his later work displays a heightened elegance and fluid handling of paint, inspired by his English colleagues.

The art of West and Copley provided a broad foundation for their younger American colleagues, most of whom made their own pilgrimages for study and work in England during the last decades of the eighteenth century and first of the nineteenth. Among the more prominent were Gilbert Stuart, Thomas Sully, and Charles Willson Peale, who differently adapted the stylistic formulas of West and Copley to the needs of a younger generation and the emerging nationalism of the newly independent country. Stuart's full-length portrait *The Skater*, for example, owes much of its softness of coloring and sinuosity of line to the type of painting then being practiced by Thomas Gainsborough, George Romney, and Joshua Reynolds. Stuart was to return to America to become the preeminent portraitist of his day of America's first presidents and early patriots. Among the Gallery's several dozen Stuart portraits are four of George Washington, including the first Vaughan likeness done from life in 1795. This sensitive but powerful interpretation shows the artist at his best in synthesizing the nobility and humanity in his sitter. Of his female likenesses none is more astute or memorable than the incisive image of *Mrs. Richard Yates*. Here we find that dexterity of brushwork in the crisp handling of details and subtle composition of grays which come from his English training, along with a directness of vision and uncompromising realism which are unmistakably American.

Thomas Sully, who was actually born in England and came to the United States as a youth, returned to London in 1809 for further artistic training in West's studio. Well aware of the elegant manner of Thomas Lawrence's painting style, Sully followed in the same tradition as Stuart, and brought to his subsequent American portraits some of the same formalities of English academic art. Typical of him are the smooth creamy textures for his figures and the imposing full-length compositions *Lady with a Harp: Eliza Ridgely* and *Captain Charles Stewart*.

For his part, Charles Willson Peale developed a somewhat rougher realism and more informal mode in his American work, even though he too had made the obligatory tour of study with West. In such a fine portrait as *Benjamin and Eleanor*

Ridgely Laming we find a particularly appealing openness and informality, characteristic of Peale's adaptation of English high styles to the more unpretentious and practical personalities of America's growing merchant class.

Indeed, the straightforward and inventive character of Peale's art was not only to influence an entire family of immediate relations and descendants (notably including his second son, Rembrandt), but also to set the stage for a younger generation of painters who rose to the challenge of portraying the faces of an ambitious and expanding middle-class America. Among the most competent of these portraitists at work during the first half of the nineteenth century were Jacob Eichholtz, Samuel F. B. Morse, John Neagle, and Charles Loring Elliott. Their work runs the gamut from the newly fashionable neo-classical taste seen in Eichholtz's smoothly modeled *Ragan Sisters*, to the photographic realism of Elliott's portrait style.

At the same time, by the second quarter of the nineteenth century other subject matter besides portraiture was beginning to engage the American artist's attention, notably genre and landscape. The topics of everyday life and the local environment appealed equally to the academic and the self-trained painter. These new interests are vividly apparent in the great rise of so-called naive art in these decades, and find full chronicling in the rich collection donated by the Garbisches. Also alluring were the challenges to document the native environment of America, familiar in John James Audubon's undertakings in the 1830s and 1840s to depict the birds and mammals of the continent. Concurrently, George Catlin set out to live with the various Indian tribes in the American West, in order to record all aspects he could of their habits, costumes, and physiognomic characteristics. The National Gallery's oil cartoons by Catlin offer a particular visual treasure, illuminating one of the period's most ambitious ethnological and artistic endeavors.

In fact, the themes and incidents of everyday life among ordinary citizens soon became popular as subjects for many artists. In the rambunctious and self-assertive world of Jacksonian democracy the common man was now the new hero of contemporary American history painting, and his doings were widely celebrated on canvas and replicated in prints. An index of this fundamentally self-confident and expansive world may be seen generally in the flourishing of genre painting during the first half of the nineteenth century, and specifically in such an engaging work as Francis William Edmonds's *The Bashful Cousin*. An interesting related development in American painting of these decades was the interplay between writers and artists, whose shared visions often fused poetic narrative with visual details of the native landscape. This synthesis extended into paintings of incidents from American romantic literature, like John Quidor's marvelous interpretation of *The Return of Rip Van Winkle*. Here a familiar native tale acquires a vitality and immediacy as real as contemporary life itself. Its interweaving of humor, nostalgia, and topicality complements contemporary sentiments about national youthfulness and regeneration.

Such notions of America's physical and moral vigor found their fullest manifestation in landscape painting. In part, this belonged to the larger rise of romanticism sweeping western Europe during the early nineteenth century. But more precisely Americans came to apprehend their vast and rugged landscape as the most appropriate metaphorical embodiment of their aspirations and special potential. Now the landscape painter could offer his paintings to the public at once to be read visually as literature and to be contemplated as history. For in America's wilderness geography and natural history citizens could find confirmed their belief in a national identity of uplifting promise and open-ended possibility.

Both native and visiting artists had begun to paint town, city, and estate views at the very beginning of the nineteenth century, and by the second quarter of the century an active generation of painters emerged under the rubric of the Hudson River School and led by the English-born artist Thomas Cole. Cole established the primary modes of emerging landscape styles in America, drawing in good measure on the precedents he knew of the sublime and the picturesque in English and continental art. He pursued two basic styles, allegorical-philosophical subjects on the one hand, and literal, identifiable views on the other. Both are represented in major examples at the National Gallery. In his second version of the well-known series *The Voyage of Life*, we have a major cycle unfolded from childhood to old age, with all the images unified by the river which meanders in and out of the sequential foregrounds. Here was the idea of landscape elevated to a higher moral plane—nature serving as a continuum for contemplating human experience.

Cole struck a different note in his view of *The Notch of the White Mountains*, where we have a recognizable recording of Crawford Notch, site of dramatic storms, rock slides, and other natural dramas. In this type of painting the artist sought to provide the American public with specific scenes capable of stimulating popular pride and wonder in the native landscape. Yet certain details, such as the blasted tree trunks in the foreground and the swirling mists in the distance, remain part of

that codified nature vocabulary which cumulatively described the full panoply of America's wilderness. These details reveal the higher forces of nature at work both in the past and present: they are evidence of former natural dramas as well as symbols of current purification and regeneration.

An older colleague of Cole's, Thomas Doughty, preferred to paint more fanciful landscapes, which often possess a pastoral charm thought appropriate to the American spirit of optimism. But it was increasingly the documentary side of Hudson River School painting that preoccupied Cole's younger followers, and by the 1850s many were giving intense attention to capturing particular nuances of light and atmosphere in their paintings. Even Jasper Cropsey's bold canvas *The Spirit of War*, so obviously indebted to Cole's allegorical precedents for its composition, brushwork, and Gothic subject matter, has in its vivid treatment of the sky a heightened sensitivity to specifically observed conditions of weather and time of day. More typical of developments in American painting at mid-century are the light-filled panoramas by Martin Johnson Heade, Fitz Hugh Lane, William Stanley Haseltine, John W. Casilear, and Cropsey's own later work. His monumental *Autumn—On the Hudson River* exemplifies this fulfillment of the style. Now our eyes are carried across a sweeping vista into the golden light suffusing this familiar scenery. Pure landscape has at last completely taken over the task of elucidating the moral lessons of history. No longer are human figures or literary narrative necessary on the pictorial stage to inspire. Rather, the pure shimmering ether of actual American space and light is sufficient to suggest the imperatives of the New World's ordained destiny.

Cropsey's contemporaries—notable among them Frederic Edwin Church, John F. Kensett, and George Inness—also arrived at variations of this style, now usually called luminism, at this same time. Though painted in different locations, Church's *Morning in the Tropics*, Kensett's New England coast views, and Inness's *Lackawanna Valley* all possess a glowing spaciousness of design and mood. Together, their work from those years offers an inspiriting index of American idealism not yet darkened by the torments of Civil War, regionalism, and technology. (Church's canvas, while dating from the 1870s, retains these radiant effects, but with a sense of some more escapist and hermetic vision.) The fact was that such pristine glories increasingly seemed inappropriate to the national upheavals of the Civil War years and their aftermath. The crises in national union as well as self-confidence called for a graver realism and more mortal subject matter.

The stylistic response was to be seen foremost in the work of Winslow Homer and Thomas Eakins, along with that of others painting during the latter half of the nineteenth century. An important precursor to Homer's work is to be found in the career of Eastman Johnson. His genre subjects form a transition from the more light-hearted and youthful subjects favored earlier in the nineteenth century to the darker palette and introspective air of later figure painting. In his scrupulously observed and finished *Brown Family* of 1869 we have a portrait at once of the founders of the prominent New York banking family and of a richly furnished Victorian parlor. The tight realism of this interior landscape derives in part from Johnson's earlier study in Europe, where he observed respectively the meticulous manner of the Düsseldorf school, small interiors by seventeenth-century Dutch painters, and carefully constructed compositions by Couture and his French contemporaries. *The Brown Family* came at the height of Johnson's maturity after his return to America. It combines all that he learned technically abroad with a sense of his own native genre tradition, and adds further a deeper consciousness of the inner psychological presences in his figures. On an immediate visual level we observe a finely delineated image of Victorian America with its indulgence in the material world of possessions. But we also become aware of an artist probing the complexities of human beings both isolated from and related to one another.

This sense of the human condition would especially concern Homer and Eakins. Like Johnson, Homer also grounded his early art on an older genre tradition, which took delight in recording youthful America at leisure. The summary image of this world of optimism and play may well be *Breezing Up (A Fair Wind)*, with its group of young boys and an older man out for a lively afternoon sail off Gloucester harbor. The colors are bright, the brushwork and composition animated, the entire scene full of vitality. At the same time this work also gradually makes us aware of a certain contemplativeness, as we come to realize that each of these figures is caught up in his own solitary stare at the horizon. This note of underlying seriousness emerged with increasing conviction during the subsequent decades of Homer's career, largely as he sensed the need of probing more deeply the interlocking forces of the human, animal, and natural worlds.

Thus, in *Hound and Hunter* we face more than a description of a familiar woodland adventure, but the precarious balances of life and death that exist between man and his environment. These larger themes of nature's power and of human mortality culminate in perhaps Homer's greatest work, one of the last before his death in 1910, the powerful *Right and Left*. The stilled forms of the two birds recall various possible sources—

Muybridge's contemporary animal photography, Audubon's bird watercolors, and imported Japanese prints—but Homer placed their strongly patterned forms in a nearly abstracted space. Compressed into the foreground, with the hunters behind appearing to fire at us as well, the large birds loom as uneasy metaphors for life and death suspended in a timeless moment of truth. Along with the watercolors in the Henschel and Engel bequests, these works represent one of America's preeminent artists at his best.

The country's other foremost painter, Thomas Eakins, can also be seen in important oils typifying key aspects of his career. *The Biglin Brothers Racing* belongs to the extensive series of rowing pictures Eakins painted during the 1870s, after his return from academic training in Paris. Images of self-discipline and order, they examine that continuing American pleasure in the out-of-doors, while also intimating a concern with time's passage in the conscious capturing of stilled action. Eakins was often attentive to the connections between action and thought, body and mind, as expressed through implicit coordination of head and hands, whether in his paintings of women at the piano, surgeons in the medical arena, or here of oarsmen in their scull. Partly because of the critical and popular distaste for the uncompromising realism of Eakins's mature work, most notably the great *Gross Clinic* now in the Jefferson Medical College in Philadelphia, the artist increasingly turned his later attention to portraiture. In the human face and figure he could scrutinize—frequently to the displeasure of his sitters—the human condition. The burdens of age, the consciousness of failure, fragility, and loss come across in a strained neck tendon, furrowed brow, and saddened eyes. A profoundly contemplative air marks the best of Eakins's late portraits, both the smaller torso-format pictures, like those of the Husson family, and the brooding spiritual presence of the full-scale *Archbishop Diomede Falconio*.

This introspective quality in American art at the end of the nineteenth century reflected in Eakins's personal case his own sense of difficulty and rejection, but in a larger sense was a mirror of the uneasiness in American life as a new age seemed to be unfolding. Henry Adams articulated some of these brooding speculations in his *Education*. Here he cited with a combination of exhilaration and anxiety the coming of the dynamo as a symbol of the mechanized energies and philosophical ambivalences of the new century. We can find further possible parallels in the hermetic still life compositions of ordinary objects painted in this period by John F. Peto, William M. Harnett, and Emil Carlsen. These are in part carefully crafted formal arrangements and in part serious meditations on the humble things of this world. The same dark palette and ruminating imagination also inform the landscapes of Ralph A. Blakelock and Albert P. Ryder.

Yet if this graver current in the American imagination seemed to be a central theme in later nineteenth-century painting, it was paradoxically part of a pluralism of styles running through these decades. Where a bright and harmonious vision of a regenerative national landscape gave pre-Civil War art an overriding unity of feeling, no single manner of painting or type of subject dominated the last half of the century. Rather, something of the period's self doubts and confusions found appropriate voice in multiple styles concurrently appearing. These ran from the objective realism of Homer and psychological realism of Eakins, through the trompe l'oeil illusionism of Harnett, to the formalist abstractions of Whistler and the variations on impressionism practiced by another sizable group of Americans.

Frank Duveneck's broadly painted portrait of *William Gedney Bunce* is typical of the Munich school, which captivated Duveneck and William Merritt Chase during the early 1870s. By contrast, Whistler developed his own highly personal investigations of nearly monochromatic arrangements of form, whether figural or landscape, partially based on his study of contemporary French and English painting. The National Gallery is fortunate to own several impressive full-length portraits by him, including the early landmark work, *The White Girl*. Likewise, the collection holds two powerful portraits of incisive realism by John Singer Sargent: *Mrs. William Crowninshield Endicott* and *Mrs. Adrian Iselin*. Although many of his later portraits moved into purely fashionable displays of virtuoso brushwork, gauzy colors and textures, and superficial notations of personality, he was also capable of such compelling distillations of mood as *Repose* and *Street in Venice*.

Chase, Edmund Tarbell, Childe Hassam, and Mary Cassatt all attempted individual adaptations of impressionism, the first with his wonderfully delicate interior scene, *A Friendly Call*. We recognize the bright colors, evanescent strokes of paint, and informal moment so characteristic of the style pursued earlier in the French school. Chase also shows an awareness of the flat patterns and spatial manipulations of Japanese prints in his repeated rectangular patterns throughout the design and the subtle use of the mirror view to the right of the figures. Tarbell undertook similar interior scenes of young ladies relaxing or conversing, while Hassam more often sought the sparkling colors of flower-filled parks and animated street vistas. His *Allies Day, May 1917* is a celebration of shared optimism—indeed,

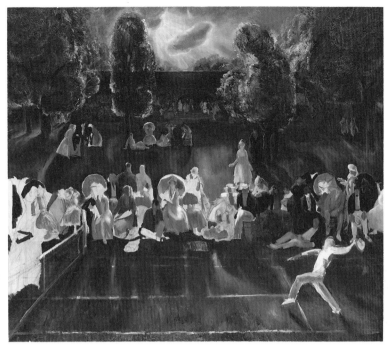

George Bellows, *Tennis Tournament*, 1920
Oil on canvas, 59 x 66 in. (149.8 x 167.6 cm.)
Collection of Mr. and Mrs. Paul Mellon, 1983

one of the best in this series he did—yet it also seems to be a final nostalgic testimony to a happier and more colorful way of life. In fact, the elegant and charming indulgences of the late nineteenth century faced rude disruptions politically and socially with World War I, and artistically with the Armory Show of 1913. In the work of Thomas Dewing, *Lady with a Lute*, we find a theme which preoccupied this artist throughout these decades, and which touches so many of the notes mentioned here: the formal arrangements of Whistler, the jewel-like touch of Harnett, the elegant fashionableness of Sargent, and the elegiac thoughtfulness of Eakins. These artists belonged to a world all regretted was passing but few acknowledged was over.

Mary Cassatt became perhaps the most determined expatriate of this generation. She was so accomplished as an impressionist that she was accepted fully by her French colleagues, and her work was included in their Independent exhibitions. The Gallery possesses several of her oils depicting her familiar themes of women and children in various interior and exterior settings. A couple display rather inventive treatments of com-

pressed spaces made interesting by mirrors placed behind seated figures. Certainly one of her most original achievements is *The Boating Party*, indebted partially to earlier paintings of such subjects by Manet and Monet, but highly personal in its bold patterning of the closely seen and strongly colored figures. Henry O. Tanner, one of Eakins's most talented students and colleagues, also made his way to Paris at the end of the century. His little oil of *The Seine* provides yet another example of how well American painters observed and modified elements of impressionist brushwork, color, and design.

While the incipient qualities of abstraction and subjectivity which we note occasionally in Cassatt and Tanner look forward to developments in twentieth-century art, basically the colorful and often pastoral world of the Impressionists was considered inappropriate to the tempo of the new century. A younger generation of artists at work in New York were dubbed the Ashcan school for their conscious rejection of the bright impressionist palette and gauzy, delicate brushwork. Instead, this group, mostly trained as newspaper illustrators, embraced what they viewed as more modern subjects—current city life— and a suitably new manner of painting with vigorous strokes of paint and strong tonal contrasts. This approach is evident in the active street scenes painted by Robert Henri and the elevated railway at night captured by John Sloan in *The City from Greenwich Village*. The same style suited well the directly painted faces of working-class children and laborers so favored by Henri, George Luks, and George Bellows. Bellows was the outstanding artist in the group, and happily the National Gallery owns nearly a dozen major works by him, including two large portraits, two striking boxing pictures, and three great urban views, as well as tennis and family subjects.

The Ashcan style dominated much of American painting during the first two decades of the twentieth century, but for all its assumed modernism, a critical challenge came in the 1913 Armory Show, where the most avant-garde painting by contemporary Europeans was shown in New York for the first time. Early Cubism and Fauvism especially shocked the American public and challenged native artistic conventions. Some painters reacted by insistently continuing their earlier modes of realism, others by attempting to adapt the new ideas of abstraction and expressionism with varying degrees of understanding. The rhetorical dialogue between abstract art and realism, initiated with fervor at this moment, was to claim artistic attention in America through subsequent decades of the twentieth century.

A number of artists from Alfred Stieglitz's circle are represented in the collections, most notably works in various media

by John Marin, and oils by Georgia O'Keeffe, Max Weber, Arthur G. Dove, and Marsden Hartley. The last was typical in his fascination with different aspects of contemporary European modernism, apparent in his 1914 painting of *The Aero* with its allusions to synthetic cubism and Kandinsky's abstractions. Hartley continued to search for a sense of permanence, both in his own peripatetic life and in his artistic style. He came as close as he ever would in such later works as his *Mount Katahdin*, with its massive forms, solid brushwork, and brooding colors. Numerous other artists of his generation were equally preoccupied with pursuing the implications of Cubist fragmentation and expressionist coloring, among them the German-born Lyonel Feininger, whose two works in the Gallery reveal the stylistic continuities from his early to later career.

America recovered from World War I during the 1920s, but became increasingly fearful of threatening new entanglements abroad in the thirties, and many championed a strongly isolationist posture. One major artistic response was the emergence of regionalism, practiced foremost by John Steuart Curry, Thomas Hart Benton, and Grant Wood. Typical works by all three now belong to the Gallery. Coming from the Midwest, these artists sought to celebrate solidly American virtues and values, and argued for adherence to realist styles independent of what they considered to be the decadent and confusing abstractions of modern European art. Forms of realism have indeed retained a strong hold in the American artistic tradition. Among other twentieth-century realists in the American collection are Ivan Albright, whose carefully encrusted detailing of the human figure carries his art close to the edge of a mysterious surrealism; Walt Kuhn, five of whose paintings have come to the Gallery from the W. Averell Harriman Foundation; Jacob Lawrence, who has in his own distinctive way blended subjects from black social history with colorful, nearly abstract designs; and Andrew Wyeth, whose haunting monochromatic tempera *Snow Flurries* came as a bequest of Dr. Margaret I. Handy in 1977. Because the National Gallery has long held a policy of not purchasing the works of living artists, it has been especially fortunate to receive fine examples by such artists as Albright, Lawrence, and Wyeth as gifts.

Stimulated partly by the present century's concern with mechanization and technology, and partly by the purely formal issues developed internationally during the last fifty years, various Americans engaged themselves in compositions of geometric imagery. Where Ralston Crawford's work retains obvious references to a modern industrial landscape, the canvases of I. Rice Pereira and Julian Stanczak delight exclusively in elaborate constructed geometries of pure line and color. We may enjoy these just for their formal aesthetics, at the same time realizing that they also belong to a civilization of modern architecture, scientific optics, and computer technology sharing many similar values.

The full ascendance of abstract art in America to a position of international dominance came with the emergence of the New York School after World War II. Although many of its members and adherents were born elsewhere, either in the western part of the country or in Europe, most eventually migrated to this city of preeminent vitality. There were dozens of Europe's finest creative minds, who had fled during the war and now invigorated firsthand the American artistic scene with their recent developments in abstraction and Surrealism.

Abstract Expressionism flourished in the years following 1945 in reponse to a number of stimuli—the automatism and subjectivity of surrealist art, the vast and powerful scale of the country so influential for preceding generations, and the heightened tempo of contemporary life. In a time of increasing mechanization and conformity, the impulses to self-liberation and individual expression acquired special urgency. For artists like Jackson Pollock, Mark Rothko, and Franz Kline earlier modes of narrative realism and the representation of literal objects no longer seemed adequate, superseded now by the pure and full expression of personal feelings on canvas. Through gestures of touch these artists activated brushwork and color to convey sensations independent of described form or subject.

Concurrent with the National Gallery's planning and completion of its new East Building in 1978, a Collector's Committee was established. Consisting of prominent citizens and collectors across the country, this group assisted in the purchase and commissioning of major works of modern art, largely to be housed in the new structure. Gifts and acquisitions from other sources were also made in this period—for example, an important group of works by Arshile Gorky, acquired in 1979— with the result that a strong core collection of classic modern art began to take shape for the Gallery. Several fine works came as well from the artists themselves, their widows, or estates, in particular donations from Thomas Hart Benton, Lorser Feitelson, Marcella Louis Brenner, Julia Feininger, and the Rothko Foundation.

By far the largest portion of the postwar American collection entered the Gallery during the decades of the seventies and eighties, thanks to the collective efforts of these individuals. A full cross section of the Abstract Expressionist movement is

now present, highlighted by the centerpiece painting, *No. 1, 1950 (Lavender Mist)* by Jackson Pollock, bought through the Ailsa Mellon Bruce Fund. In this great work by the leader of the school we have the exuberant energies of his classic maturity. The spacious canvas seems to have no boundaries, only an implied space expanding laterally as well as in depth, filled with densities of pure color direct from the imagination and pure lines direct from the body in action. Mark Tobey's *New York* makes an appealing comparison to the Pollock as a similar work in a more muted key, one reflecting rather the quieter Northwest Coast seclusion of Tobey and his orientation to the meditation, mysticism, and delicate patterns of Far Eastern art.

An even bolder and broader presence of artistic gesture is apparent in the mature art of Franz Kline, whose abstractions titled, respectively, *Four Square* and *C & O* refer loosely to his youthful memories of western Pennsylvania coal country, but also to the urban world of massive skyscraper construction he knew later in New York. The painter's hand is also evident in Mark Rothko's canvases, although these have come to exemplify another side of the Abstract Expressionist movement, characterized as color-field painting. Thanks to the Rothko Foundation, virtually all phases of his work are represented in the Gallery at their best. Mostly through his large hovering fields of limited colors, as in *Orange and Tan*, Rothko was able to convey a wide variety of moods often approaching the spiritual in their transcendence and intensity. These were occasions inviting contemplation, not just formally of richly sensuous surfaces, but also imaginatively of complex philosophical allusions. Together, Pollock, Kline, Rothko, and their contemporaries achieved a new creative response both to their time and place and to the imperatives of modern painting.

Other artists pursued the implications of the Abstract Expressionists' artistic innovations, as may be seen in the Gallery's examples of work by Ad Reinhardt or Milton Resnick, who pursued different ways of dividing and filling pictorial space with a field of color. Larry Poons, Gene Davis, and Alexander Liberman have moved more toward issues of scale and optical relations of colors, working for awhile at least with strictly precise geometries of design. Yet another development out of the first phase of Abstract Expressionism occurred with the poured and stained canvases of Jules Olitski, Kenneth Noland, and Morris Louis—all represented at the Gallery by exemplary works. Now color no longer appears to reside within the shapes of objects, let alone on the surface of the canvas, but rather actually at one and within the very weave of the material itself. In formal terms these inventions create fresh

Mark Tobey, *New York*, 1944
Tempera on paperboard
33 x 21 in. (83.7 x 53.2 cm.)
Gift of the Avalon
Foundation, 1976

Opposite left:
Kenneth Noland
Another Time, 1973
Acrylic on canvas, 72 x 72 in.
(182.9 x 182.9 cm.)
Gift of the Collectors
Committee, 1979

Opposite right:
Morris Louis, *Beta Kappa*, 1961
Acrylic resin on canvas
103¼ x 173 in.
(262.3 x 439.4 cm.)
Gift of Marcella Louis
Brenner, 1970

implications about the nature of pictorial space and about the functions of color and line. But they also suggest inner visions of exquisite beauty, perhaps not surprisingly conjured up in an age of America's outer agonies in Vietnam and the drug culture.

Particularly with the addition of *No. 1, 1950 (Lavender Mist)* to its collection, the National Gallery decisively put a major contemporary American work into the larger context of its national school. It inspires us to consider anew the character and continuities of our artistic achievement, as we realize, for example, that Pollock's sense of scale and ruggedness sympathetically recalls similar qualities in Cropsey's *Spirit of War*. We can likewise recognize links of a spacious and spiritual world in turning our attention from Church's *Morning in the Tropics* to Morris Louis's *Beta Kappa*. Furthermore, the American taste for realism is constantly evident across many periods and subjects, whether we cite Harnett's still lifes, Kensett's landscapes, or Eastman Johnson's portraiture. Democracy's deep beliefs in the integrity and possibilities of human individuality strike us forcefully in the painting of faces from Copley in the eighteenth century to Eakins in the nineteenth and Henri in the twentieth. The national love of sports and the out-of-doors is evident repeatedly in the passions of Homer, Eakins, and Bellows. Above all, the landscape—whether once a corner of Eden or now a question of ecology—has seemed a favored domain for this country's original experiment in the New World. From

Cole's *Crawford Notch* to Wyeth's *Snow Flurries* on the hills of the Brandywine, Americans have engaged themselves in their geography of promise. These surely are some of the themes running through the American tradition, and while the National Gallery's collection does not aim to offer an absolute survey, the native spirit is visible here in some of its finest manifestations.

Drawings and Watercolors

Like the American paintings collection, the holdings of graphic arts (including drawings, watercolors, prints, and photographs) at the National Gallery have also taken shape in unpredictable and idiosyncratic ways. Indeed, before gifts of American prints and drawings were systematically sought or purchases considered, the Gallery already had an unusual foundation of American graphics in the Index of American Design. This remarkable gathering of more than seventeen thousand works on paper began as a project of the Federal Art Project under the Works Progress Administration during the Depression. Partly to provide work for talented craftsmen nationwide and partly to record in image form the vast cross section of surviving early American decorative arts and design, more than one thousand artists from thirty-four states were hired to make precise watercolor renderings of a broad spectrum of objects and artifacts, including

furniture, glass, textiles, toys, dolls, weathervanes, interior design, and architectural elements. In a day when color photography was not yet predictably stable or indefinitely accurate, the concept was to executive these images in meticulous watercolor, or occasionally pencil drawings and ink sketches, and then produce lithographic portfolios to make the material widely and inexpensively available to the public. The portfolio production never took place, though today the goals are being met by the dissemination of imagery through books, microfiche, and slide sets. In additon, the Gallery regularly installs focused selections from the Index, and makes groups of subjects available for exhibition elsewhere through programs circulated by the National Lending Service. An invaluable resource for research and documentary purposes, now consulted by historians, artists, designers, collectors, and writers, these delicate yet precise renderings have also been recognized as beautiful watercolors in their own right. The Federal Art Project which supervised this work operated between 1935 and 1942. Work was terminated the following year with the Index incomplete, though substantial nonetheless. After negotiations with the Library of Congress and the Metropolitan Museum of Art, the National Gallery became the final repository for the material. As part of the institution's larger gatherings of art held in trust for the nation, the Index appropriately offers material with a combination of practical, historical, and aesthetic interests.

23

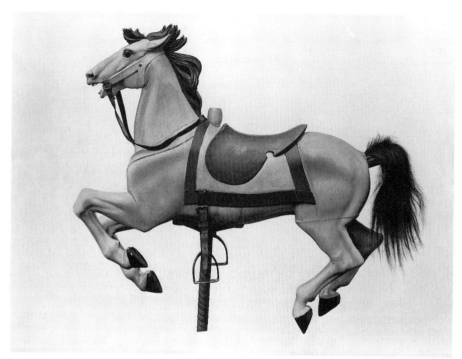

Carousel Horse
Watercolor rendering by John Kelleher, c. 1939
13⅛ x 17½ in. (33.3 x 44.4 cm.)
Index of American Design

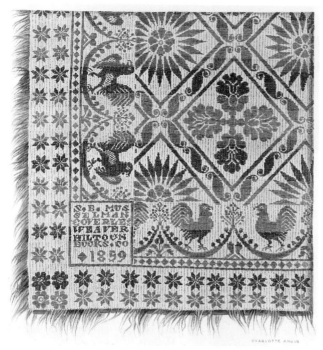

"Peace and Plenty" Coverlet
Watercolor rendering by Charlotte Angus, c. 1940
19⁷⁄₁₆ x 16⅜ in. (49.3 x 41.6 cm.)
Index of American Design

Since then, by means of periodic purchases made through the Ailsa Mellon Bruce and other funds, the collection of works on paper in the American area has steadily grown. Also owing to the generosity of other noteworthy donors, including Ruth K. Henschel, John Davis Hatch, Julia Engel, and Paul Mellon, significant concentrations of major artists have been built up. The Hatch collection was a combined purchase and gift acquired over a five-year period beginning in 1978, and brought to the Gallery more than one hundred and fifty American drawings dating from the colonial period to World War I. This is a particularly important contribution to the Gallery for several reasons: it greatly strengthens an area largely neglected heretofore; it brings several very rare works of exceedingly high quality, almost unobtainable on the market, along with a large survey group most useful for study purposes; it covers a wide variety of subjects, including genre, portraiture, and landscape; it offers fine examples of differing techniques of pen, pencil, wash, chalk, and gouache; it covers most stylistic periods in American art from the late eighteenth century to early twentieth-century modernism; above all, it brings subconcentrations of several drawings by a number of major artists, among them John Singleton Copley, John Vanderlyn, Thomas Cole, William Sidney Mount, Eastman Johnson, and Winslow Homer.

For example, among the earlier drawings in the collection one may make an instructive comparison between the two treatments of historical subjects, by Benjamin West and Copley respectively. The former's *George III Resuming Royal Power* of c. 1789 is a free yet strong ink sketch in contrast to the more tightly drawn and delicately highlighted drawing by Copley of the *Death of the Earl of Chatham* from ten years earlier. In addition, there is an elegant pencil drawing of *A Gentleman* by Copley which affords revealing comparison with two similar clothing and figure studies by Vanderlyn. Needless to say, such works by Copley and others in the Hatch group greatly enhance and complement oil paintings by the same artists already in the National Gallery.

24

Benjamin West, *George III*
Resuming Royal Power in 1789, c. 1789
Brush and sepia ink and wash
on cream laid paper, 6¼ x 8⅝ in.
(15.8 x 21.9 cm.)
Andrew W. Mellon Purchase Fund
and Avalon Fund, 1978

John Singleton Copley, *Study for*
"The Death of the Earl of Chatham," 1779
Pencil and white chalk
12¹/₁₆ x 19⁷/₁₆ in. (30.7 x 49.4 cm.)
Andrew W. Mellon Purchase Fund
and Avalon Fund, 1978

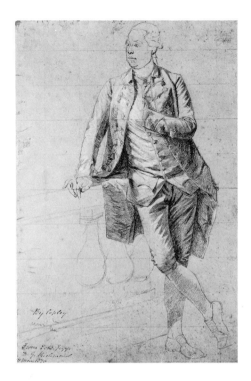

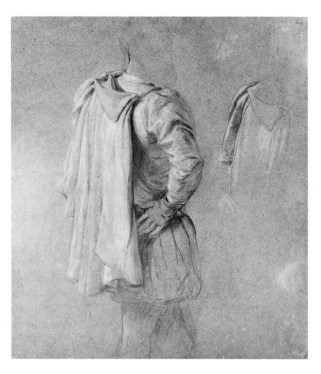

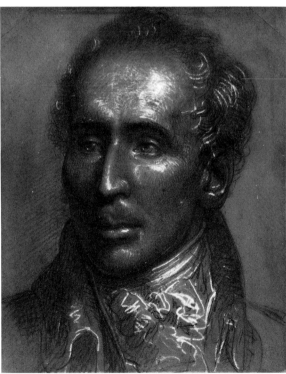

Top left:
John Singleton Copley
A Gentleman, 1776–80
Pencil and white chalk, squared
16⅝ x 10¾ in. (42.2 x 27.3 cm.)
Andrew W. Mellon Purchase Fund
and Avalon Fund, 1978

Top right:
John Vanderlyn, *Study of a Cape,* c. 1838
Brown and black chalk, heightened with
white chalk and pastel, on blue board
15¹⁵/₁₆ x 14 in. (40.5 x 35.5 cm.)
Andrew W. Mellon Purchase Fund
and Avalon Fund, 1978

Bottom left:
Rembrandt Peale, *Dr. John Warren,* c. 1806
Black, white, and light brown chalks,
and stump and graphite on dark brown
prepared paper, 14 x 11¹⁵/₁₆ in.
(35.6 x 28.9 cm.)
Andrew W. Mellon Purchase Fund
and Avalon Fund, 1978

Bottom right:
Charles Wesley Jarvis, *Henry Clay,* c. 1840
Pencil, brush and gray wash on ivory
wove paper, 8³/₁₆ x 5¼ in. (20.9 x 13.3 cm.)
John Davis Hatch Collection

Opposite

Top left:
William Sidney Mount, *Shepard
Alonzo Mount, Age Twenty-Three,* 1827
Pencil on ivory laid paper, 5⁹/₁₆ x 5⅛ in.
(14.2 x 13 cm.), irregular

Top right:
Thomas Cole, *Temple of Juno,
Agrigentum,* 1842
Pencil and white chalk on gray laid
paper 10⁷/₁₆ x 14¾ in. (26.5 x 37.4 cm.)

Bottom left:
Emanuel Leutze, *Studies for "Washington
Crossing the Delaware,"* 1849
Pen and sepia ink and pencil on buff wove
paper, 11⁹/₁₆ x 12⅜ in. (29.4 x 31.3 cm.)

Bottom right:
Jasper F. Cropsey
Villa d'Este, Tivoli, 1848
Pencil touched with white, and
brown wash on buff wove paper
11¹¹/₁₆ x 16⅝ in. (29.7 x 42.2 cm.)

All John Davis Hatch Collection

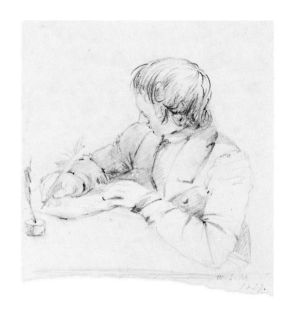

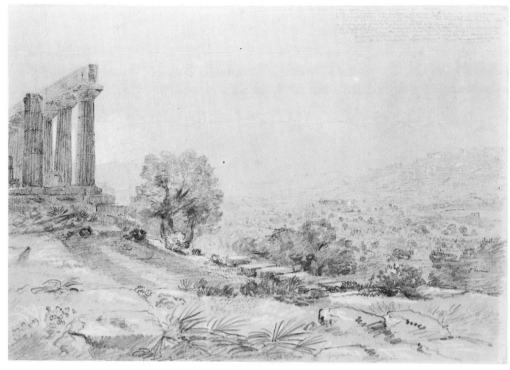

John W. Casilear, *Hudson Highlands,* 1860s
Pencil touched with white on buff wove paper
9³/₁₆ x 13⅞ in. (23.2 x 35.2 cm.)
John Davis Hatch Collection

John F. Kensett, *North from Storm King,* 1860s
Pencil touched with white on cream wove paper
9¹⁵/₁₆ x 14¹⁵/₁₆ in. (22.6 x 35.3 cm.)
John Davis Hatch Collection

William Trost Richards, *Paradise, Newport,* 1877
Watercolor and gouache on gray paper, 23 x 37 in. (58.4 x 94 cm.)
Adolph Caspar Miller Fund and Pepita Milmore Memorial Fund, 1979

Opposite left

Top:
Eastman Johnson
Head of a Young Woman
late 1870s
Charcoal, 10⅝ x 7⁷/₁₆ in.
(27 x 18.9 cm.)
John Davis Hatch Collection

Bottom:
Winslow Homer, *Zouave
(Study for "Pitching
Horseshoes"),* 1864
Black and white chalk on
olive-green wove paper
15⁹/₁₆ x 7¹³/₁₆ in.
(40.3 x 19.2 cm.)
John Davis Hatch Collection

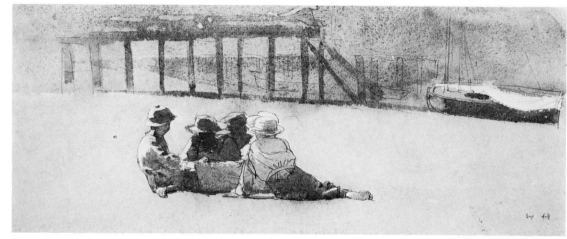

Winslow Homer, *Four Boys on a Beach,* c. 1873
Pencil, brush and watercolor on cream wove paper, 5⁹/₁₆ x 13⁷/₁₆ in. (14.1 x 34 cm.)
Andrew W. Mellon Purchase Fund, 1979

Winslow Homer, *Girl Carrying a Basket,* 1882
Watercolor, 14⅝ x 21¾ in. (37.1 x 55.3 cm.)
Gift of Ruth K. Henschel in memory of her husband, Charles R. Henschel, 1975

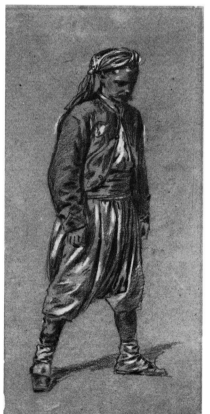

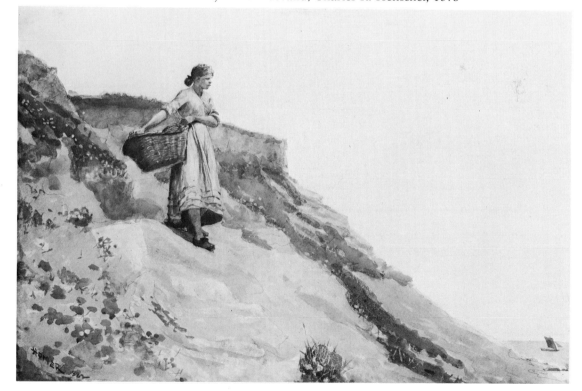

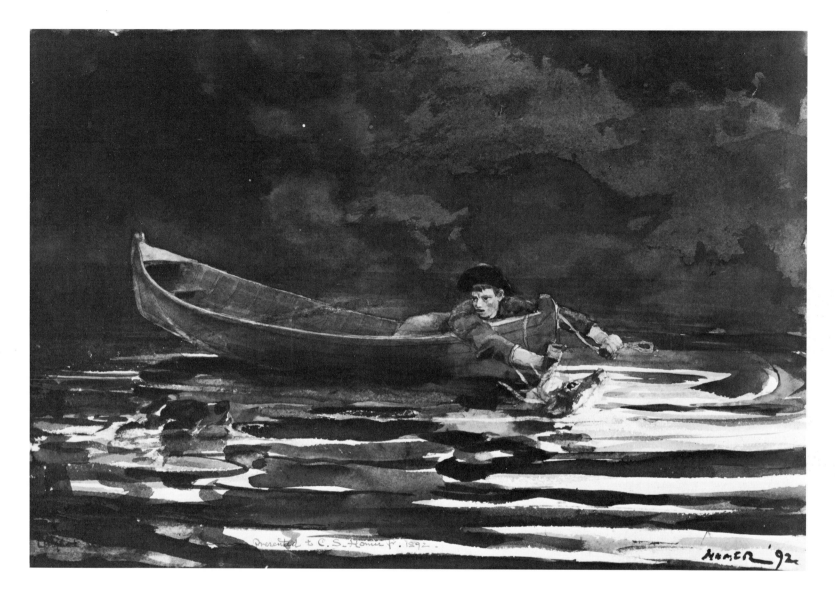

Among the stronger sequences of Hatch drawings are those devoted to portrait faces and figure studies. In such examples as Rembrandt Peale's *Dr. John Warren* and Charles Wesley Jarvis's *Henry Clay* we have images expressing a powerful American character in their striking directness of realism, and drawn with remarkable self-assurance and conviction. Other pieces suggest a charming intimacy, as in Mount's touching record of his younger brother at work, or carry unusual historical importance, as in Emanuel Leutze's pen sketch for his famous canvas of *Washington Crossing the Delaware*.

The Hudson River School is well represented now with allegorical and Italian landscape subjects by Cole, a shimmering wash drawing of *Villa d'Este, Tivoli* by Jasper F. Cropsey, and similar Hudson River views by John W. Casilear and John F. Kensett. Since paintings by all of these artists were already in the Gallery's American collection, these smaller studies help much to enlarge our sense of their personal artistic styles. In the context of this group a large and beautifully finished gouache of *Paradise, Newport* by William Trost Richards was purchased by the Gallery in 1979. One of a series of studies

30

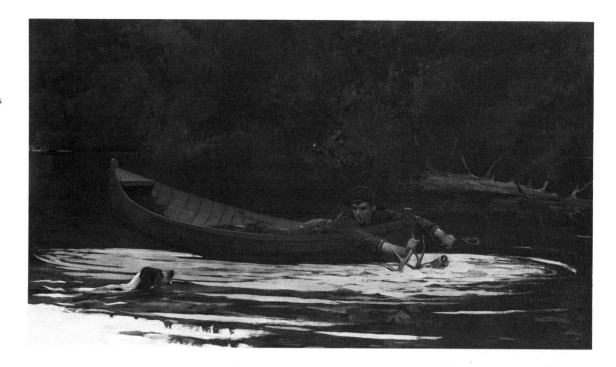

the artist made on carpet paper at Newport and Narragansett, Rhode Island, during the 1870s, this is especially effective in the way untouched sections of the gray paper show through to suggest the textures of rock and fog.

Highlighting the works of the later nineteenth century in the Hatch collection are a number of characteristic figure drawings by both Eastman Johnson and Winslow Homer. With the latter group was an especially happy item, Homer's drawing after the Gallery's major oil by him of *Breezing Up (A Fair Wind),* but of equal interest and quality were two Civil War charcoals and a small fresh watercolor of *Four Boys on a Beach* done in preparation for a *Harper's* magazine engraving of 1873. Lively and appealing in its own right, this watercolor joined other gifts to the Gallery of larger Homer watercolors from various phases of his career.

One such gift of Homer works came in 1975 from Ruth K. Henschel in memory of her husband Charles R. Henschel, and at one stroke gave the Gallery more than a dozen of Homer's finest achievements in the watercolor medium, all generally in superb condition. Homer began working in watercolor during the 1870s, when he produced sheets that were close to colored drawings, drawn as tightly and carefully as his previous graphic illustrations. His subjects then were still the youthful boys of Gloucester and young farm girls of Houghton Farm, treated in the anecdotal tradition of earlier American genre painting. The Henschel group includes a couple of such images, but also ranges through the innovations and transformations of Homer's subsequent watercolor style, as he took up his subjects in Tynemouth, England, in 1880–82, and then the great scenes of hunting and fishing occupying him through the 1890s and 1900s. In these later works his figures tended to become more anonymous, isolated, and often heroic: Frequently men or animals were depicted in contest with nature, usually in a more intimately scaled setting or corner of nature than those painted at the same time in his larger oils on canvas. Within the Henschel group we can see Homer moving toward the stark and profound themes of his later career, as well as toward a greater freedom of execution, abstract power, and subjective intensity. One of these later watercolors, *Hound and Hunter* of 1892, is of special interest for its relation to the larger oil version already in the Gallery's collection. In these two paintings we can appreciate not just Homer's use of the watercolor as a preliminary sketch, but how he was able to exploit the nature of each medium to its fullest expressive possibilities.

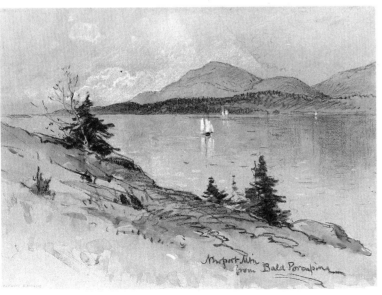

Above:
Winslow Homer, *Santiago de Cuba*, 1885
Watercolor and pen and black ink over graphite, 11½ x 19¹⁵⁄₁₆ in.
(29.2 x 50.7 cm.)
Bequest of Julia B. Engel, 1984

Left:
George Henry Smille, *Newport Mountain from Bald Porcupine*, no date
Black and white chalk and watercolor, 14⅛ x 19¼ in. (35.8 x 49 cm.)
John Davis Hatch Collection, 1984

Opposite:
Thomas Eakins, *The Poleman in the Ma'sh*, c. 1881
Brown wash heightened with white, graphite, and black chalk,
11 x 5¹⁵⁄₁₆ in. (28 x 15.1 cm.)
Julius S. Held Collection; Avalon Fund, 1984

A second important Homer gift came in 1984 with the bequest of five beautiful watercolors from Julia Engel. Aside from their fine condition, they made strong complements to the Henschel group in adding a powerful English subject as well as one of Homer's rare Cuban views. The Engel gift also brought to the Gallery its first graphics by the Ashcan artist Everett Shinn, with four pristine pastels of New York scenes. Still other donations at this time greatly enlarged the collection in nineteenth- and early twentieth-century material, for example, Thomas Eakins's *Poleman in the Ma'sh*, one of his last pen drawings still in private hands, a gift from the great scholar and collector Julius Held; and from Paul Mellon a panoply of superb drawings and watercolors by Audubon, Harnett, Cassatt, Prendergast, and Bellows. The Bellows group alone numbered eleven pieces, enhanced further by single sheets of charcoal studies given respectively by Rita and Daniel Fraad and Ray and Margaret Horowitz. Three other exemplary watercolors from very different moments and styles in the twentieth century—by Prendergast, Wyeth, and Pollock—highlighted this category of graphics acquisitions.

A sense of the later development of the American watercolor tradition is provided by characteristic and fresh examples by John Singer Sargent and John Marin. Marin's *Storm over Taos* of 1930 is one of his best-known images in this medium, perfectly balancing his feeling for recording the personal experience of place with a dramatic pictorial structure and bold washes of color.

Largely thanks to the kind offices of Lawrence Fleischman, Mr. and Mrs. John Marin, Jr., offered to the Gallery an extraordinary trove of Marin works in 1987. The centerpiece was a powerful late oil painting, *Grey Sea*, matched in quality by a sparkling early New York watercolor, and amplified by more than a dozen oil studies and sketchbooks by the artist from all periods of his career. Many include highly finished watercolors along with more cursory images, all on an intimate scale and fresh in feeling. Like other concentrations of American works at the National Gallery, notably the Catlin, Garbisch, and Rothko groups, the Marin assemblage brings into the public domain material with great potential for research, exhibition, and loan purposes.

Later American drawings in the collection include a sharply observed Ashcan scene by John Sloan and portrait drawings by George Bellows and Marsden Hartley. Sloan's combines his familiar tenderness of spirit with confident solid modeling, while Hartley's image of himself powerfully reveals the currents of anxiety both he and his age so turbulently felt.

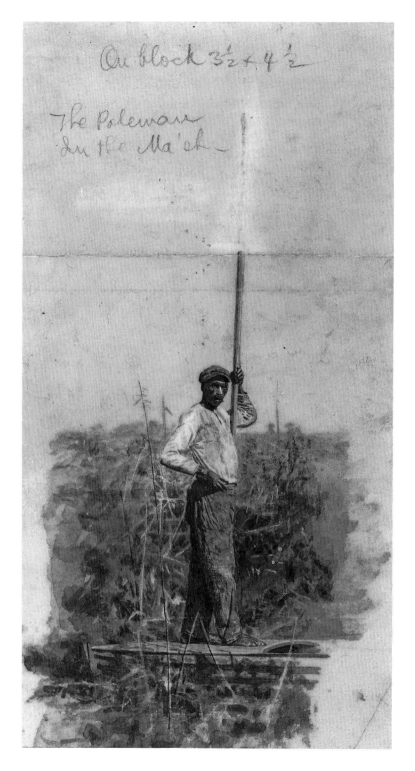

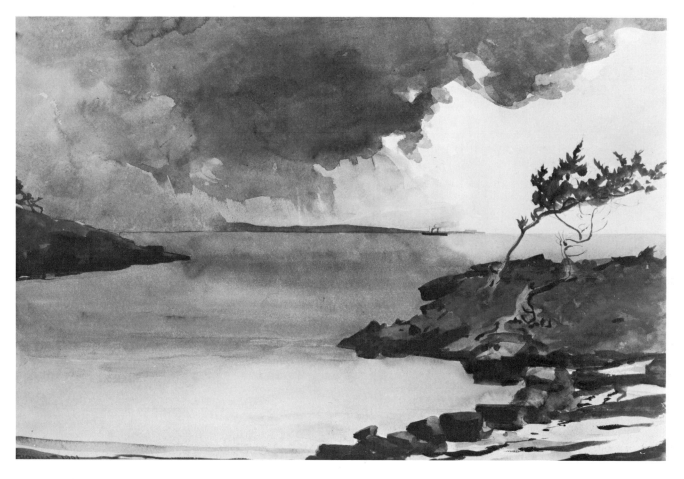

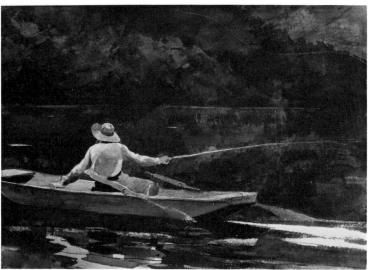

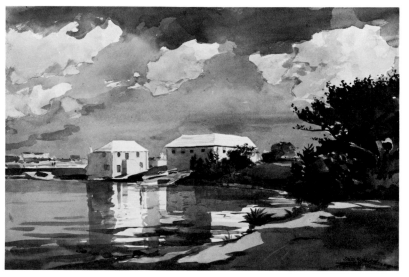

Opposite

Top:
Winslow Homer, *The Coming Storm,* 1901
Watercolor, 14½ x 21⅛ in. (36.9 x 53.6 cm.)
Gift of Ruth K. Henschel in memory of her husband,
Charles R. Henschel, 1975

Bottom left:
Winslow Homer, *Casting, Number Two,* 1894
Watercolor, 15⅛ x 21⁷/₁₆ in. (38.4 x 54.4 cm.)
Gift of Ruth K. Henschel in memory of her husband,
Charles R. Henschel, 1975

Bottom right:
Winslow Homer, *Salt Kettle: Bermuda,* 1899
Watercolor, 14 x 21¹/₁₆ in. (35.5 x 53.5 cm.)
Gift of Ruth K. Henschel in memory of her husband,
Charles R. Henschel, 1975

This page

Top:
John Singer Sargent, *Grand Canal, Venice,* c. 1907/11
Watercolor over pencil sketch
15¾ x 17⅝ in. (39.9 x 44.9 cm.)
Ailsa Mellon Bruce Collection, 1969

Bottom:
John Marin, *Storm over Taos,* 1930
Watercolor on composition board
15 x 20¹⁵/₁₆ in. (38.1 x 53.2 cm.)
Alfred Stieglitz Collection
(Gift of Miss Georgia O'Keeffe), 1949

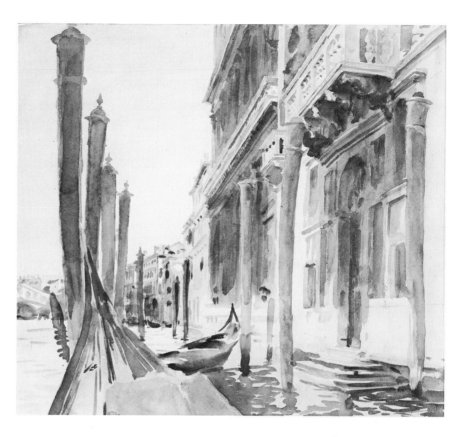

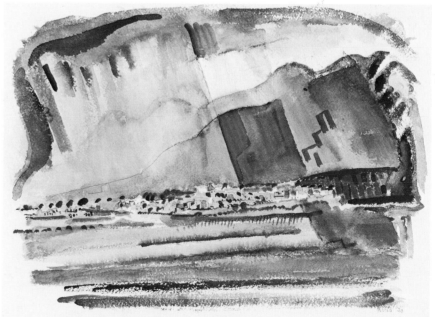

35

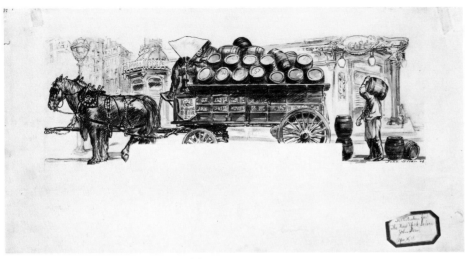

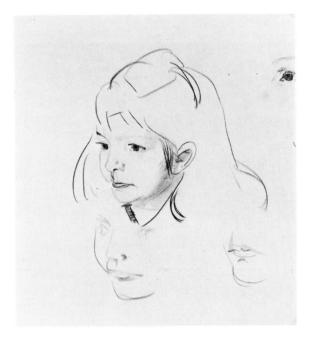

John Sloan, *Medusa Beer Truck*, 1908
Pencil, black crayon, brush and black and gray ink with gray wash on board
11⁹/₁₆ x 21¾ in. (29.4 x 55.3 cm.)
John Davis Hatch Collection

Top right:
George Bellows, *Studies of Jean*, c. 1920
Black crayon on cream wove paper, 10⁵/₁₆ x 9⅜ in. (26.1 x 23.9 cm.), irregular
John Davis Hatch Collection

Bottom right:
Marsden Hartley, *Self-Portrait*, c. 1918
Black crayon on ivory wove paper, 11¹⁵/₁₆ x 8⅞ in. (30.3 x 22.6 cm.)
John Davis Hatch Collection

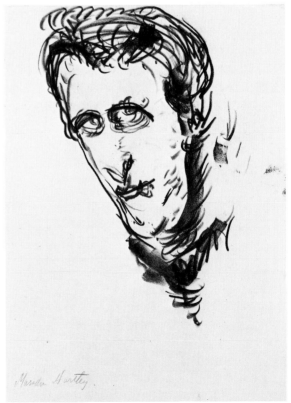

Prints and Photographs

As with other areas of the American collection, there are unusual single pieces and groups of works in strength by American graphic artists and photographers. These too run in date from the period of the Revolutionary War to the present. Numerous different donors have been generous, though none more so in the field of prints than Lessing Rosenwald, a former trustee of the National Gallery, and in photographs Georgia O'Keeffe, who donated an important set of prints by her husband, Alfred Stieglitz, a gesture repeated by Virginia Adams who gave a so-called museum set of the photographs of her husband, Ansel Adams, in 1986.

A fine rare impression of Paul Revere's engraving of *The Boston Massacre*, an early historical image, takes its appropriate place within the Gallery's large collection of history paintings and portraits from the colonial and Federal periods. Benjamin West's lithograph of 1801, *"He Is Not Here, He is Risen,"* is not only one of the earliest works in that medium by an English or American artist (lithography having been invented in Germany during the mid-1790s), but it also provides a good example of West's command of the sublime style in his interpretation of historical and religious subjects. Its strong contrasts of tone and lively compositional tensions find provocative echoes in works by him in other mediums in the Gallery, whether pen sketches from the Hatch collection or large oils on canvas hanging in the American galleries.

The most important graphic work from the first half of the nineteenth century is a set of folio engravings of *The Birds of America* by John James Audubon. From the second half of the century there are small groups of etchings by James McNeill Whistler, covering various phases and subjects in his career, and colored aquatints by Mary Cassatt, including rare intermediate proofs from her unsurpassed 1891 series of prints. In addition, the Gallery was fortunate to purchase a complete set of Winslow Homer's wood engravings. Paralleling the Gallery's recent growth in its twentieth-century collections of paintings and sculpture are the gifts to the Print Department of lithographs by Jasper Johns and Robert Rauschenberg, two of America's foremost living artists and printmakers.

But representation of these two masters was just a first step in what followed during the 1980s with the large-scale donations of modern American graphics. In fact, three comprehensive collections—the Graphicstudio Archives, Tamarind Lithography Workshop, and Gemini G.E.L. (Graphics Editions Limited)—gave to the Gallery an in-depth survey of virtually

Benjamin West
"He Is Not Here, He Is Risen," 1801
Lithograph
12⅞ x 8⅞ in.
(32.7 x 22.5 cm.)
Rosenwald Collection, 1946

John James Audubon
White Pelican (Pelicanus Americanus)
1836
Engraving, mezzotint, and hand coloring
38¹/₁₆ x 25⅝ in.
(96.7 x 65.1 cm.)
Gift of Mrs. Walter B. James, 1945

The BLOODY MASSACRE perpetrated in King---Street BOSTON on March 5th 1770 by a party of the 29th REGT.

BUTCHER'S HALL

Engrav'd Printed & Sold by PAUL REVERE BOSTON

Unhappy BOSTON! see thy Sons deplore,
Thy hallow'd Walks besmear'd with guiltless Gore:
While faithless P—n and his savage Bands,
With murd'rous Rancour stretch their bloody Hands;
Like fierce Barbarians grinning o'er their Prey,
Approve the Carnage, and enjoy the Day.

If scalding drops from Rage from Anguish Wrung,
If speechless Sorrows lab'ring for a Tongue,
Or if a weeping World can ought appease
The plaintive Ghosts of Victims such as these;
The Patriot's copious Tears for each are shed,
A glorious Tribute which embalms the Dead.

But know, Fate summons to that awful Goal,
Where JUSTICE strips the Murd'rer of his Soul:
Should venal C—ts the scandal of the Land,
Snatch the relentless Villain from her Hand,
Keen Execrations on this Plate inscrib'd,
Shall reach a JUDGE who never can be brib'd.

The unhappy Sufferers were Messrs. SAML. GRAY, SAML. MAVERICK, JAMS. CALDWELL, CRISPUS ATTUCKS & PATK. CARR
Killed. Six wounded, two of them (CHRIST. MONK & JOHN CLARK) Mortally

Paul Revere, *The Boston Massacre*, 1770
Engraving, 9⅝ x 8⅝ in. (24.4 x 21.9 cm.)
Rosenwald Collection, 1941

Top left:
James McNeill Whistler
Black Lion Wharf, 1859
Etching, $5^{15}/_{16}$ x $8^{13}/_{16}$ in.
(15.1 x 22.4 cm.)
Rosenwald Collection, 1943

Top right:
Mary Cassatt, *The Letter,* 1891
Colored etching, $13⅝$ x $8^{15}/_{16}$ in.
(34.6 x 22.7 cm.)
Rosenwald Collection, 1943

Bottom left:
James McNeill Whistler
Venice, 1880s
Etching, $11^{9}/_{16}$ x $7⅞$ in.
(29.4 x 20 cm.)
Rosenwald Collection, 1943

Bottom center:
James McNeill Whistler
Weary, 1863
Drypoint on thin Japanese paper
$7¾$ x $5⅛$ in. (19.7 x 13 cm.)
Gift of Myron A. Hofer
in memory of his mother,
Jane Arms Hofer, 1947

Bottom right:
Mary Cassatt, *La Toilette
(Woman Bathing)*, 1891
Drypoint and aquatint printed
in colors, $14^{5}/_{16}$ x $10^{9}/_{16}$ in.
(36.4 x 26.8 cm.)
Rosenwald Collection, 1946

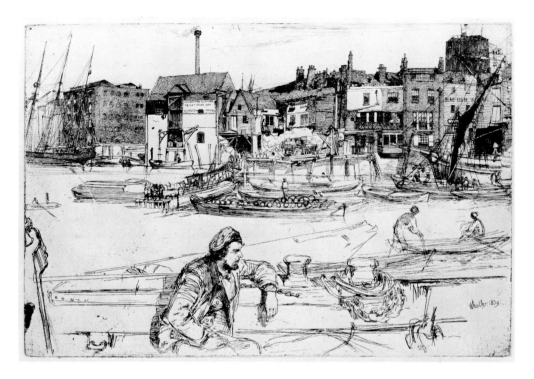

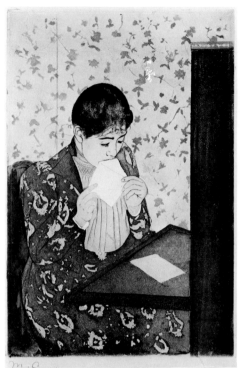

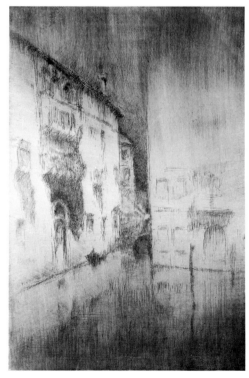

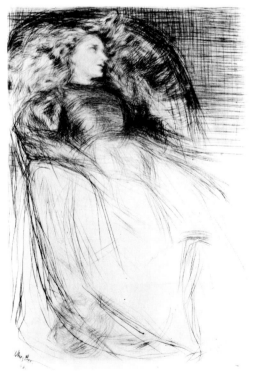

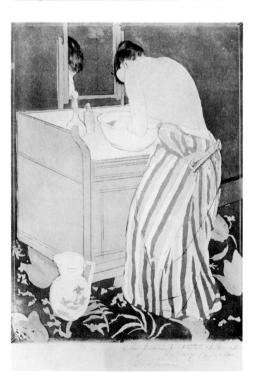

39

Jasper Johns, *Numerals*, 1970
Lead, polystyrene backing, wood, aluminum frame,
30⅛ x 23⅝ x 1½ in. (76.5 x 60 x 4 cm.)
Gift of Gemini G.E.L., 1981

Robert Rauschenberg, *Front-Roll*, 1964
Lithograph, 41¼ x 29½ in. (104.8 x 74.9 cm.)
Gift of the Woodward Foundation, Washington, D.C., 1976

all the major styles and most influential figures in postwar American art. Resulting from the kindness and interest of several individuals, these gifts came in sequential phases a few years apart, but cumulatively represented some of the finest experiments by more than a hundred different artists and totaled nearly two thousand works on paper. These respective publishers, over a couple of decades, helped to sponsor and produce limited-edition original prints, initially by older established names and soon by the adventurous and most talented figures of the younger generations. Having such richness in numbers, as well as in quality and variety, now allows the Gallery to make increasingly available for loan and exhibition focused concentrations covering the full range of contemporary artistic currents. These resources also make possible regular rotating installations of graphics in spaces in the ground-floor galleries of the West Building recently dedicated to ongoing surveys of prints, drawings, and watercolors.

As with most institutional art collections, this is an admittedly idiosyncratic group of American graphic arts, but it does as a whole vividly illustrate the progress of a native tradition, firmly

Top:
Alfred Stieglitz, *The Hand of Man*, 1902
Silver print, 3⁹/₁₆ x 4¹¹/₁₆ in. (9 x 11.9 cm.)
From the Alfred Stieglitz Collection, National Gallery of Art, 1949

Bottom left:
Alfred Stieglitz, *Marsden Hartley*, 1915
Platinum print, 9¹¹/₁₆ x 7¹¹/₁₆ in. (24.6 x 19.5 cm.)
From the Alfred Stieglitz Collection, National Gallery of Art, 1949

Bottom right:
Alfred Stieglitz, *Winter—Fifth Avenue*, 1893
Carbon print, 9¹/₁₆ x 7¼ in. (23 x 18.4 cm.)
From the Alfred Stieglitz Collection, National Gallery of Art, 1949

41

Ansel Adams, *Moonrise, Hernandez, New Mexico*, 1941
Gelatin silver photograph, 15¹⁄₁₆ x 19⁷⁄₁₆ in. (38.2 x 49.4 cm.)
Gift of Virginia B. Adama, 1986

scrutiny of New York's moods and facets reminds us of the similar themes pursued by Bellows and Henri. But supremely, his photographs bring to an institution concerned with artistic excellence the achievement of a master photographer who personally raised the level of his medium to a fine art.

Another much-acclaimed American photographer who cared deeply about purity of image and perfection of technique was Ansel Adams. A year after his death in 1985, the National Gallery had the opportunity of mounting an exhibition of some eighty of his best photographs in conjunction with the United States government's official naming of a western mountain peak after Adams. The core of the exhibition was what he called his "museum set," a gathering of his eighty finest images, specially printed in fewer than a dozen sets which he hoped would end up in the public domain. At year's end in 1986 the artist's widow, Virginia Adams, to the surprise and delight of the Gallery, offered her own set to the collection. Needless to say, the addition of this group gives new meaning to the foundation established with the Stieglitz set, and eloquently captures the strong realist currents in the American vision. Aside from showing the range of Adams's interest in broad landscapes, selected natural details, memorable light effects and textures, his subjects of wilderness scenery are alternatively meditations of devotion and songs of praise. As such, they speak the nation's language from Thoreau to Whitman, and echo in silvery stillness the images seen elsewhere on canvases by Hudson River and luminist painters in the Gallery's American collections.

grounded in historical and scientific documentation, and also evolving into concerns with plein-air observation and genre material, decorative pattern, and technical experimentation.

Primarily because of the comprehensive collections of American photographs in the Library of Congress and the National Archives, the National Gallery has not actively purchased in this area. At the same time, it has gratefully accepted donations, especially when they reinforce existing strengths. Such has been the case with the gifts of Stieglitz photographs from Georgia O'Keeffe and those of Ansel Adams presented by his widow. The former group numbers more than two thousand, and constitutes the so-called master set of prints made by Stieglitz over his prolific and influential career. Almost every image he produced is here, including a complete set of *Camera Work* with its original photogravures. Aside from the importance of this gift as a resource and complete body of work, many of the images Stieglitz captured relate directly to issues of content and form taken up by other American artists of the twentieth century. His conscious observation of fact and distillation of abstract design have their pictorial counterparts in the paintings of his friends and students like Hartley, Dove, and Marin. His loving

Sculpture

Since the National Gallery essentially took as its model the great picture galleries of European capitals, which were devoted foremost to displaying paintings of the major national schools in the modern western tradition, sculpture and decorative arts have tended to come as secondary acquisitions. Largely because certain early bequests and donations to the Gallery brought sizable groups of objects along with collections of paintings, there is now a separate department of sculpture. An occasional piece of earlier American sculpture has been purchased, such as a bronze casting of William Rimmer's tortured image of the *Dying Centaur* of 1869, and a fine small figure piece by Daniel Chester French. Other unusual modern pieces have been given, such as the Art Deco figures from the early twentieth century by Elie Nadelman and Paul Manship.

In anticipation of the opening of the Gallery's new East Building in 1978 and its central commitment to active collecting in

modern art, a full curatorial department of twentieth-century art was formed in 1974. Since then the Gallery has supported a program of exhibitions, acquisitions, and publications in this field, making purchases as well as encouraging gifts. The Ailsa Mellon Bruce Fund has made possible the purchase of a characteristic plaster figure by Pop sculptor George Segal, while the Gallery's core of Abstract Expressionist paintings has been complemented by the acquisition of six steel constructions by David Smith, acknowledged to be one of America's greatest twentieth-century sculptors. *Sentinel, Three Circles,* a Voltri, and a Cubi represent the major serial achievements of Smith's career, and follow the Gallery's conscious policy of buying the art of a major figure in strength when possible.

For the opening of the East Building itself the Collectors Committee commissioned several distinguished living artists in America and Europe to make works for permanent installation. Among those designed by American sculptors was a painted aluminum construction of angular volumes by James Rosati, the clean, sharp geometries of which enhance I. M. Pei's architectural setting, and Alexander Calder's huge mobile, which dominates the central public space of the new building's interior. This, Calder's final work (its design completed but a week before his death), is of unprecedented size for him. Only a technology of lightweight honeycomb aluminum made possible hanging and moving this great playful ensemble. Like all of his best sculptures, it is perfectly suited for a place of public circulation, augmenting the actuality of human motion nearby and embodying the ideas of process and change in contemporary life. It reminds us, without diminishing its own complete presence as a work of art, that Pei's surrounding structure of marble, glass, and concrete may also be appreciated as a vast sculptural expression, stimulating in its own tensions between classical order and modern dynamism, and possessing a protean vitality in the changing conditions of day and season.

With the opening and full functioning of the East Building, statistically the Gallery's physical spaces literally doubled in square footage, and there were comparable increases in staffing, budgets, exhibition programs, and public attendance. Two of the principal purposes of the new structure were the mounting of major loan exhibitions and display of the growing twentieth-century collection. In both categories sculpture, particularly modern and American sculpture, was strikingly well served. A special installation in one major space was devoted to the works of David Smith, acknowledged as America's greatest modern sculptor. Periodically changing loans from his estate have augmented the Gallery's own strong selection of his art.

William Rimmer, *Dying Centaur*
c. 1869 (cast 1967)
Bronze, 25¾ x 25⅝ x 21½ in.
(65.4 x 65.1 x 54.6 cm.)
Gift of the Avalon Foundation, 1968

Elie Nadelman, *Two Nudes,* c. 1911
Plaster relief, 47⅞ x 58¾ x 3¾ in. (121.5 x 149.2 x 9.6 cm.)
Gift of Robert P. and Arlene R. Kogod, 1975

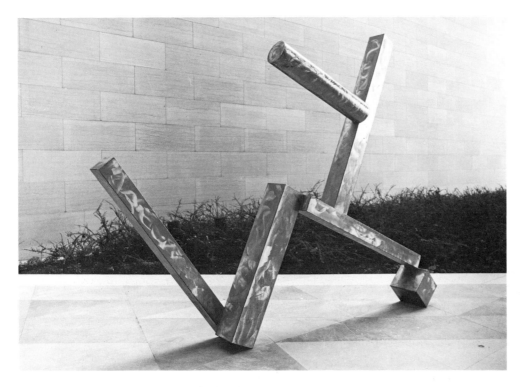

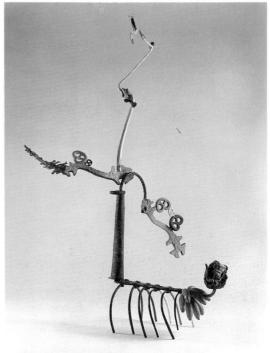

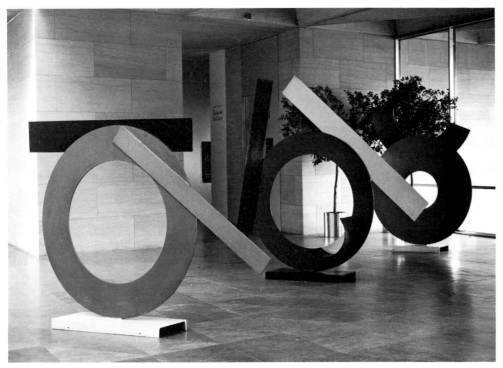

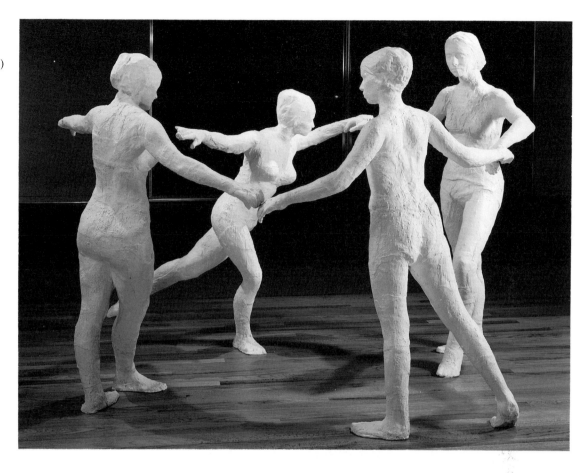

George Segal, *The Dancers*,
1971/1982
Bronze with white patina, 70½ x
106 x 71 in. (179 x 269.2 x 180.3 cm.)
Gift of the Collectors Committee,
1983

These took on even greater significance when they became part of a full-scale Smith retrospective in 1982, filling all levels of the East Building with sculpture from half a dozen key phases of his career. (A comparable sweeping survey of Rodin's sculpture was also an early exhibition in the new building, and demonstrated its own muscular power within the Pei architecture.) Yet another massive introduction of modern sculpture took place in 1987–88 with the showing of twentieth-century pieces from the collection of Raymond and Patsy Nasher. This assemblage ranged over all the century in date, style, and medium, and demonstrated how well both European and American sculpture could work throughout the Gallery's spaces.

This exhibition activity served as a backdrop to the energetic pace of acquisitions of American sculpture that joined the collection after the initial commissions. Rather than disbanding, as had originally been envisioned, upon conclusion of making the first gifts of sculpture for the new building, the Collectors Committee so enjoyed its work that it remained active and played an increasingly productive role in continuing to purchase modern works for the Gallery. During its first ten years of association the Committee acquired great examples of European painting, but its growing list of gifts in this period included a handful of works by notable American sculptors as diverse as Joseph Cornell, Tony Smith, and George Segal. The Cornell piece is one of his classic poetic meditations in a mixed-media box construction. Smith's multiple geometries give strong presence to the purest statements of conceptual and environmental art that emerged in the 1960s. The Segal *Dancers* brought a second typical figure piece by him into the collection; this one contained its own play on art's form and content, first in treating the medium of bronze to look like white plaster and then to pun in three dimensions on Matisse's memorably painted figures on canvas. Finally, being life-size, Segal's forms always tease the viewer in his own space, and when installed in one of

45

James Rosati, *Untitled*, 1977
Painted aluminum, 113½ x 249½ x 106¾ in.
(288.2 x 633.5 x 271.1 cm.)
Gift of the Collectors Committee, 1978, based on
model given by the artist in memory of William C. Seitz

Alexander Calder, *Untitled*, 1976
Aluminum and steel, 29 ft. 10½ in. x 76 ft.
(910.3 x 2315.5 cm.)
Gift of the Collectors Committee, 1977

the Gallery's open floors, this work appears to be a constant provocation and delight to the Gallery's visitors.

During the 1980s other pieces came by gift as well. Not surprisingly, Paul Mellon's name appears as a donor in this category, with the gift of a second large work by Alexander Calder, this one a colorful red and blue stabile, *Obus*. When periodically installed on one of the main levels of the East Building, it gestures in sympathetic visual dialogue with its majestic sibling turning above in the mainframe. New to the collection was the work of John Flannagan, represented by the charming and witty stone carving of a *Gorilla*. From more recent currents in figural abstraction were works by Seymour Lipton and Nancy Graves. Paralleling the development of the American collections in other media, the sculpture holdings have evolved in similar selective and uneven ways, but always with an eye on the key moment, the leading name, and the exemplary piece.

The American Collections in Sum

All museum collections reflect the special tastes of their founders and shapers, and the National Gallery is no exception. In the pantheon of America's major cultural institutions it is a remarkably young creation, and therefore perhaps surprising in the range and quality of its collections formed in less than

half a century. That until recent years American art was largely unprobed by scholars and collectors has made possible the gathering of so many outstanding works in a relatively short time. By not seeking necessarily to form comprehensive or encyclopedic collections in any of the national schools, the Gallery's successive directors and curators have been able to concentrate on the aspiration to acquire singular works of the highest quality by each country's outstanding artists. The result of these efforts in the American area has been the shaping for the nation of a collection with some memorable and truly distinctive works of art.

These goals have not been inconsistent with a historical survey, and indeed the totality of the collection does fairly present the high points of America's artistic achievements over the more than two hundred years of the nation's history. But an even more significant achievement has been the selection and display of American art that stands up with comparable attainments by English, French, Dutch, Italian, and Spanish artists. At its best, American painting may be appreciated both for its own native qualities and for its complex relationships to the rich traditions of European culture. Thus it is hoped that the cumulative experience for the visitor to the American rooms at the National Gallery of Art will be one in which the celebration of individuals and their favored landscape is clearly mirrored.

Colorplates

1 Benjamin West
Colonel Guy Johnson

Generally considered one of the founding masters of the American school, West was largely responsible for transforming the relatively primitive tradition of earlier limner portraiture into a sophisticated academic achievement. Before leaving for Europe in 1760 as a young man, he had already painted a number of full-length portraits of children in the rather stiff but charming manner of William Williams and other colonial practitioners.

Colonel Guy Johnson is an impressively scaled canvas typical of West's mature work, in which he carefully balanced the solidly modeled figures, the warm tonalities of color, and finely highlighted details on the clothing. We also become aware of his intentional synthesis of the real and the ideal. Johnson poses in the immediate foreground, in his capacity as Superintendent of Indian Affairs for North America, a post to which he had been appointed in 1774. Standing just behind him in shadow is the Mohawk chief believed to be Joseph Brant, and in the background to the left we can make out a small Indian encampment with a glimpse of Niagara Falls in the far distance. At the same time the classical pose and rather generalized features of these two figures suggest a heroic cast, appropriate to their joint leadership of the Iroquois against the American Revolutionary forces on the frontier. Symbolic of their involvement in the day's great issues of peace and war, Brant and Johnson respectively hold a peacepipe and a rifle.

1776. Oil on canvas, 79¾ x 54½ in. (203 x 138 cm.)
Andrew W. Mellon Collection, 1940

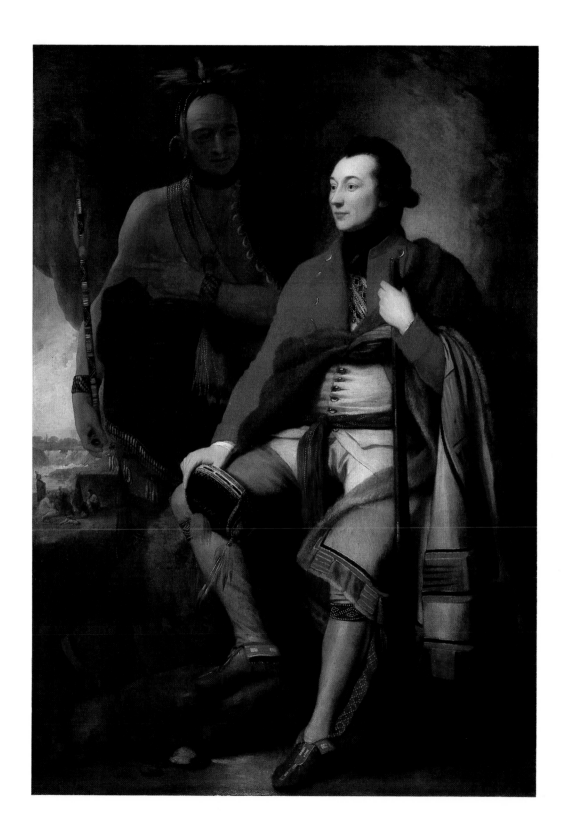

2 Benjamin West
The Battle of La Hogue

This colorful and dynamic history painting is typical of West's ambitious compositions done over many years in England under the patronage of King George III. In the late 1760s West began large-scale historical subjects drawn from religious and ancient history, usually reinterpreted in a heroic cast to provide strong moral exempla for a modern audience. Such works usually included sculpturally modeled figures based on poses and designs taken from classical or Renaissance art. But the stately and stoic manner of such previous undertakings as *Agrippina Landing at Brundisium with the Ashes of Germanicus,* 1766–68 (Yale Art Gallery), and *The Death of General Wolfe,* 1770 (National Gallery of Canada), has now shifted to more dramatic coloring and an animated organization of powerful diagonal forms. As such, this battle scene stands on the threshold of West's more painterly and turbulent style and sublime subject matter, which preoccupied him from the 1780s onward in vast canvases like *Death on a Pale Horse,* 1787 (Pennsylvania Academy of the Fine Arts).

At La Hogue in 1692 the British successfully battled the naval fleet of Louis XIV. In the middle foreground is Rear Admiral George Rooke with raised sword, while the shirtless sailor at the center was modeled after West's first teacher, William Williams.

1778. Oil on canvas, 60⅛ x 84⅜ in. (152.7 x 214.3 cm.)
Andrew W. Mellon Fund, 1959

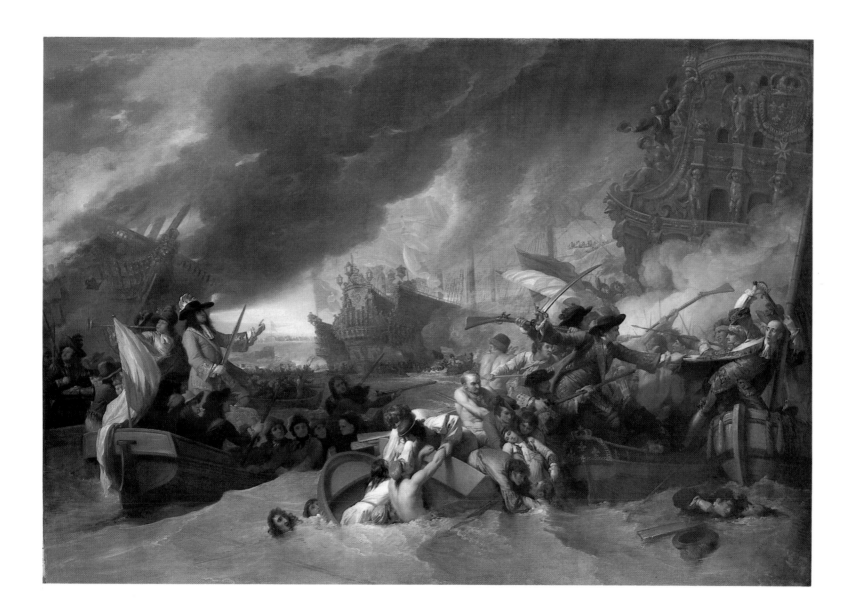

3 John Singleton Copley
Mrs. Metcalf Bowler

Born the same year as Benjamin West, Copley grew up and began his artistic career in Boston, emerging as America's most talented portraitist before the Revolution. His early work reflected the styles of such predecessors as John Greenwood, Joseph Badger, John Smibert, and Robert Feke, as well as the compositional formulas of imported mezzotints based on English portraits. Developing his own style of crisply outlined forms, clear areas of color, and brightly shining textures, Copley evolved a manner of portraiture which exactingly recorded the features of both an individual and his or her immediate environment.

This portrait marks the full technical self-assurance of Copley's early maturity, and is one of several strong American portraits by the artist, along with the formidable *Epes Sargent* of 1759–61, in the National Gallery's collection. A pencil study of drapery from the Hatch collection for an earlier portrait also complements this work nicely, for it draws our attention to Copley's unsurpassed abilities to render the sheen of materials with an almost abstract sense of surface and shape. Mrs. Bowler's portrait is one of the most attractive in a series of three-quarter-length female portraits Copley painted in these years. It is a graceful image of self-possession and well-being, highlighted by such sparkling details as the jewel necklace and bouquet of flowers.

c. 1763. Oil on canvas, 50 x 40¼ in. (127.2 x 102.2 cm.)
Gift of Louise Alida Livingston, 1968

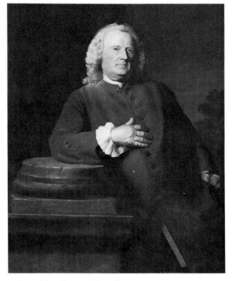

John Singleton Copley
Epes Sargent, 1759–61
Oil on canvas, 49⅞ x 40 in.
(127.1 x 101.8 cm.)
Gift of the Avalon Foundation, 1959

John Singleton Copley, *Drapery Study for*
"The Portrait of Mary and Elizabeth Royall," c. 1758
Pencil and white chalk on gray-brown laid paper
8¹³/₁₆ x 15¹/₁₆ in. (24.9 x 38.2 cm.)
Andrew W. Mellon Purchase Fund
and Avalon Fund, 1978

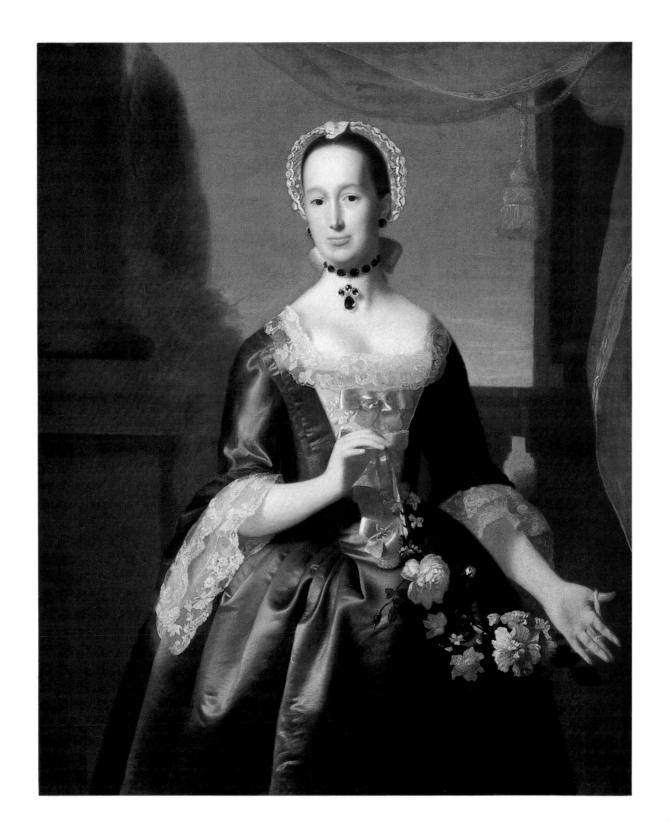

4 John Singleton Copley
The Copley Family

Increasingly caught up in the fervent allegiances and turmoil in the opening months of the American Revolutionary War, and with patrons as well as relatives divided on both sides, Copley decided to leave America (as it turned out, for good) by sailing for London in 1774. He was equally lured by the appeals of Benjamin West, who was now well established as a prominent history painter in the king's service, and by the promise of more international success as a painter of grander subjects than individual likenesses.

After arriving in London, Copley had to wait an anxious year before his wife and family could follow him, and this full-size family portrait commemorates their reunion. In fact, it is an important landmark in the artist's career both personally and stylistically. Not merely an affectionate record of recently recovered domestic happiness, it also states newly heightened artistic ambitions. Copley's wife holds two of the children at the right, while the artist's father is seated opposite; behind him the painter himself turns calmly to face us, as if just looking away from the radiant landscape vista beyond, with plans for the future metaphorically in hand. This was his first large group portrait or complex figural composition since his early years as a painter. The softer coloring, more fluid brushwork, and elaborate setting all reflect a fresh career boldly launched in the European tradition.

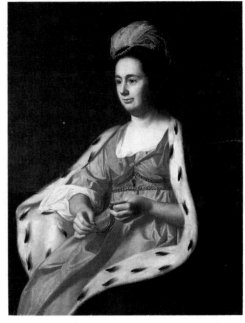

John Singleton Copley, *Mrs. Adam Babcock*, c. 1774
Oil on canvas, 46⅛ x 36⅛ in.
(117.3 x 91.5 cm.)
Gift of Mrs. Robert Low Bacon, 1985

1776–77. Oil on canvas, 72½ x 90⅜ in. (184.4 x 229.7 cm.)
Andrew W. Mellon Fund, 1961

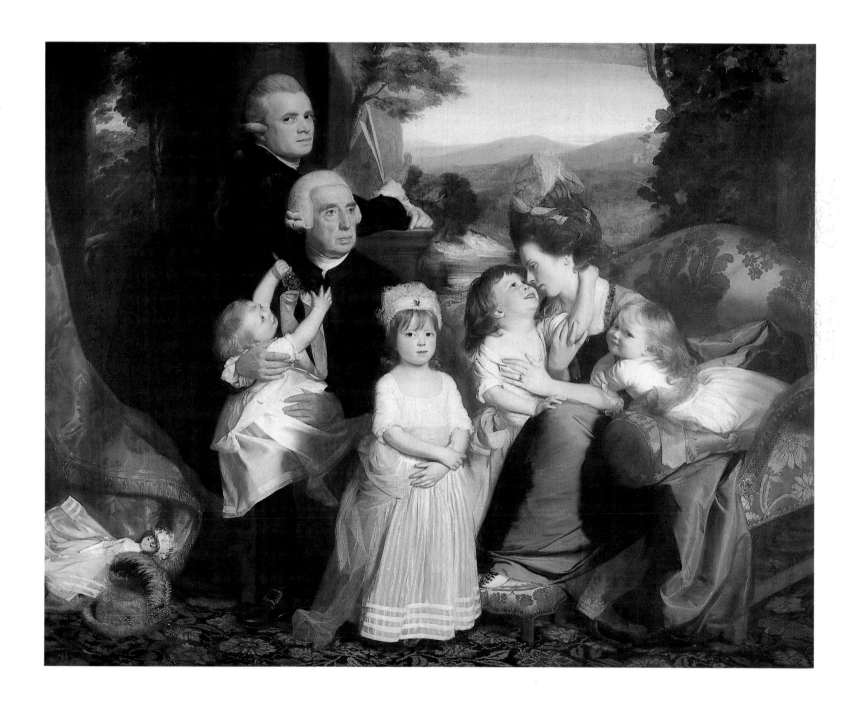

5 John Singleton Copley
Watson and the Shark

Once settled in London under the helpful guidance and stimulating influence of West, Copley soon turned to essaying history paintings on very large canvases. His expatriate American friend had already established a provocative new direction in academic neoclassicism with his *Death of General Wolfe* of 1770 (National Gallery of Canada). In that painting West deliberately chose a modern history subject for treatment in contemporary, rather than ancient, garb, while basing his design on a Renaissance Pietà. Copley also drew on classical sculpture and prints for his work, but went a step further in illustrating a more personal, if equally heroic, event. Meeting the Lord Mayor of London, Brook Watson, Copley heard about the dramatic moment in Watson's youth when he was attacked by a shark while swimming in Havana harbor. Of obvious interest to the American painter was the New World setting, which he precisely delineated, as well as the sublime activity of a man caught between life and death, not on a battlefield but in nature's wilderness waters. Although the pyramidal arrangement derives partially from Renaissance geometries, the whole gains a modern romantic tension from the differently spotlighted figures, the animated silhouette of the group, and the various diagonal accents crossing the picture space. Still foremost a painter of likenesses, Copley has above all rendered a complicated and ambitious group portrait in action.

1778. Oil on canvas, 71¾ x 90½ in. (182.1 x 229.7 cm.)
Ferdinand Lammot Belin Fund, 1963

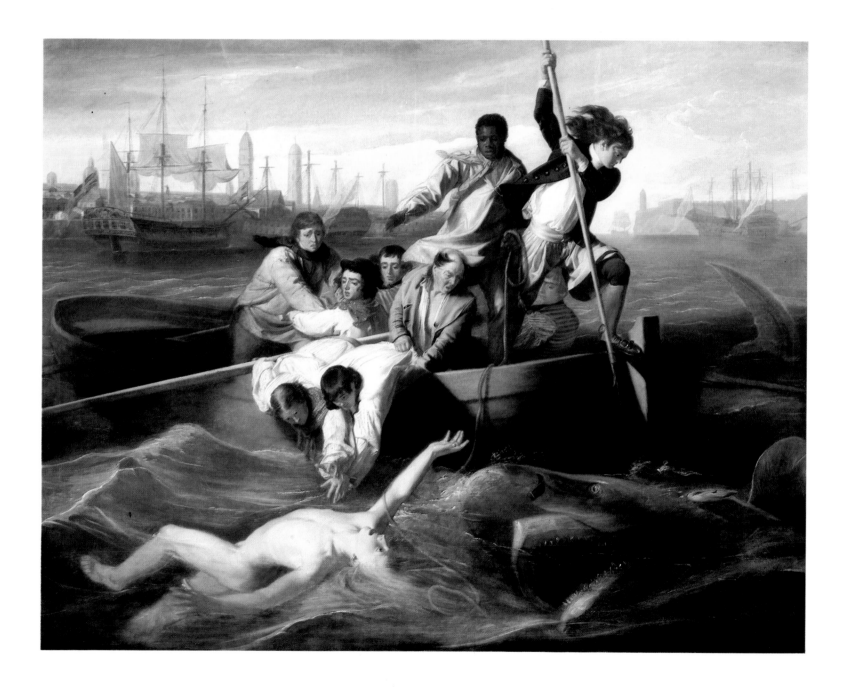

6 Gilbert Stuart
The Skater (Portrait of William Grant)

Within the generally strong area of colonial portraiture in the National Gallery's American collection stands the special strength of works by one of the nation's so-called old masters, Gilbert Stuart. The forty-three paintings are one of the largest Stuart groups anywhere; among them are some of his most famous images and finest achievements. There are four portraits of George Washington, including the original Vaughan version, the first done from life in 1795, and an Atheneum replica (see page 10), acquired in 1979 as part of the only surviving set of portraits by Stuart of the first five presidents. These faces naturally have an interest for us as much for their powerfully evocative historical importance as for their sensitive interpretation of early national heroes.

Stuart's artistic training came to maturity under the tutelage of West in London, where he quickly rose to prominence executing commissioned portraits of well-known personalities. One of his most masterful accomplishments there was the full-length portrait of William Grant, which at once culminated the artist's apprenticeship under West and established his independent success with the London critics. On the appointed day for the sitting Grant noted the weather was more conducive to skating than painting, and Stuart seized the opportunity to suggest an outing on the Serpentine in Hyde Park. The result finished in the studio was this wonderfully fresh portrait in pale greens and grays of the figure gracefully poised between motion and stopping. Appropriately, the turn of his torso and sinuous outline of his clothing find gentler formal echoes in the figures and trees behind.

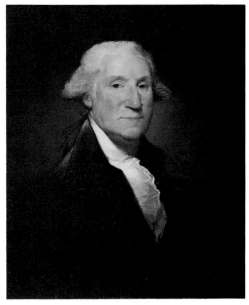

Gilbert Stuart, *George Washington*
(Vaughan portrait), 1795
Oil on canvas, 29 x 23¾ in.
(73.5 x 60.5 cm.)
Andrew W. Mellon Collection, 1942

1782. Oil on canvas, 96⅝ x 58⅛ in. (245.5 x 147.6 cm.)
Andrew W. Mellon Collection, 1950

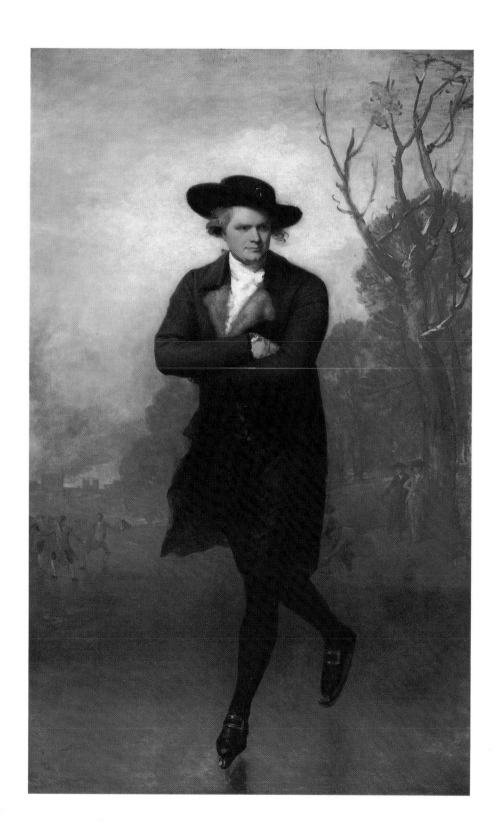

7 Gilbert Stuart
Mrs. Richard Yates

Stuart had so mastered English style during his stay in London and subsequent period in Ireland that his work was often confused with that of Gainsborough, Romney, and Raeburn. For his British patrons he had achieved a relatively painterly dash and the generally paler colors of the European rococo. After he returned to America in 1792, he undertook to secure the patronage of an equally prominent and powerful clientele, highlighted by his various life and replica portraits of Washington. Stuart now painted with a tougher, more direct realism, suitable to the practical and straightforward tastes of the stalwart young nation. Two of his strongest portraits of women are in the National Gallery, *Mrs. John Adams,* c. 1800–15, and the remarkable *Mrs. Richard Yates,* as incisive an image as any he ever completed. The companion portrait of her lawyer husband, also in the Gallery's collection, shows a stolid personage seated in a solid dark blue jacket. For Mrs. Yates, however, the muted silvery grays and whites are a tour de force of near-monochromatic coloring, fitting for the steely expression of her gaze, and not matched again until Whistler's *White Girl* (Plate 48) in the next century. Like the capturing of William Grant while skating, this portrait is unusual for Stuart in showing a sitter in action. Here Mrs. Yates looks up from her sewing as if momentarily diverted. Known to be slightly cross-eyed, she views us out of the corner of her eyes, a clever posing device to diminish this awkward fact. The fine detailing throughout, from the cap to her hands, combines precision with delicacy and perfectly matches this intelligent, wellborn, and able individual.

1793/94. Oil on canvas, 30¼ x 25 in. (77 x 63 cm.)
Andrew W. Mellon Collection, 1940

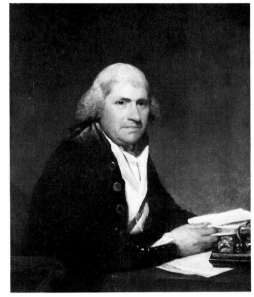

Gilbert Stuart, *Richard Yates,* 1793/94
Oil on canvas, 32¼ x 27⅜ in.
(82 x 68.5 cm.)
Andrew W. Mellon Collection, 1942

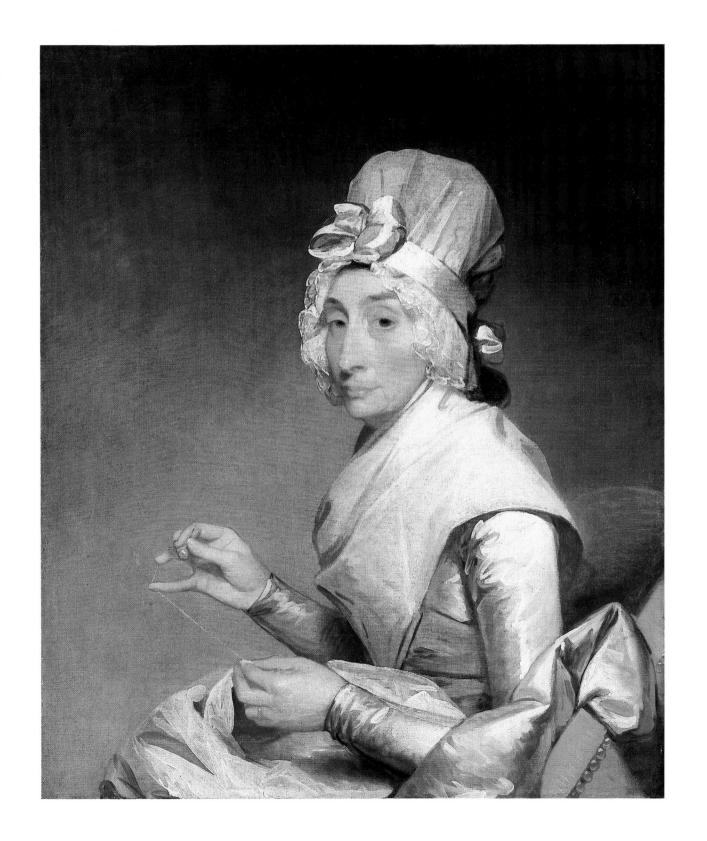

8 Thomas Sully

Lady with a Harp: Eliza Ridgely

In the Gallery are a handsome group of early full-length American portraits, which include, besides Stuart's *Skater* (Plate 6), *Patrick Tracy* by John Trumbull, and two by Sully: *Captain Charles Stewart* and *Eliza Ridgely.* The latter is surely one of the finest in the artist's prolific output of more than two thousand portraits and among the most elegant in the English academic manner. Sully had come from England as a youth, and he inherited the mantle of fashionable portraiture from Gilbert Stuart, whom he visited in Boston in 1807. Shortly after, Sully went to London, where his style was shaped foremost by Thomas Lawrence. Later settled in Philadelphia, Sully brought the English manner of fluid brushwork and sleek coloring to bear on his American subjects, with much-appreciated flattering results.

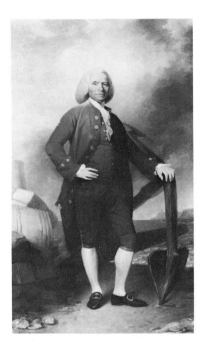

Sully painted Eliza Ridgely in 1818 when she was only fifteen, but by attenuating her figure under the shimmering organdy gown and partially generalizing her features, he gave her presence a poised elegance. Ten years later she married the son of Maryland's governor, and on her father's death in 1829 the painting went to Hampton, the grand Ridgely mansion in Baltimore County, where it hung until acquired by the National Gallery. The delicate English harp serves as a clever formal foil for the figure. In one hand she holds a tuning key, while the other tries the strings, as her right foot presses down on the floor pedal. Glowing colors—the azure scarf, warm white gown, and red velvet stool—reinforce the sense of grand refinement.

1818. Oil on canvas, 84⅜ x 56⅛ in. (214.5 x 142.5 cm.)
Gift of Maude Monell Vetlesen, 1945

Top: John Trumbull, *Patrick Tracy,* 1784–86
Oil on canvas, 91½ x 52⅝ in. (232.5 x 133.7 cm.)
Gift of Patrick T. Jackson, 1964

Bottom: Thomas Sully, *Captain Charles Stewart,* 1811–12
Oil on canvas, 93¼ x 58¾ in. (237 x 149.2 cm.)
Gift of Maude Monell Vetlesen, 1947

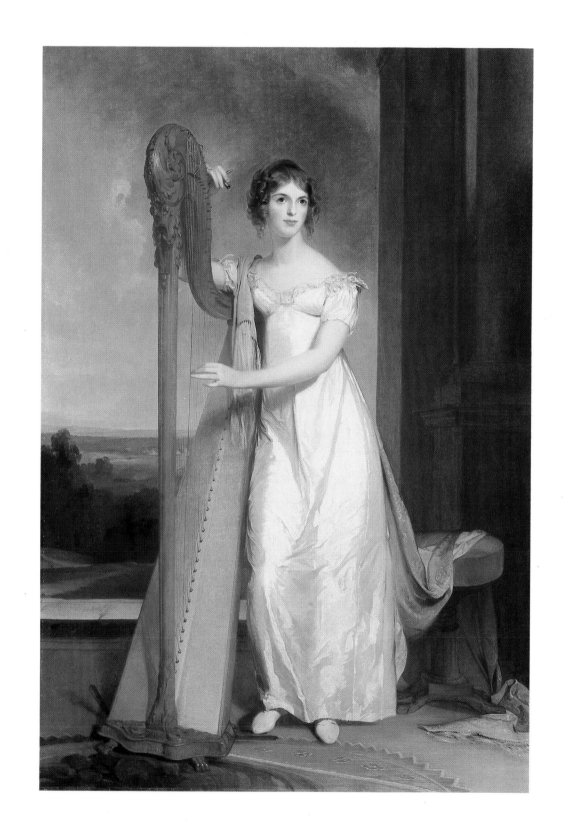

9 Charles Willson Peale

Benjamin and Eleanor Ridgely Laming

Peale's graceful and informal double portrait makes an interesting contrast to Sully's interpretation of Eliza Ridgely (Plate 8). Though the women share the name of a prominent Baltimore family, Sully's work derives from the high manner of English portraiture, while Peale's represents a more down-to-earth approach oriented to his American audience. Peale had joined many of his generation in visiting London and studying under the helpful tutelage of Benjamin West, but he was singularly eager to return home to pursue his career in America. An extraordinarily creative and inventive individual, he carried on several careers as museum founder, scientist, and painter. To his prolific number of portraits he brought an equal variety, rendering faces with a straightforward realism, posing figures in relaxed postures, and placing them in familiar surroundings. Indeed, the portraits of himself and of his family (e.g., *The Staircase Group, The Exhumation of the Mastodon, The Artist in His Museum*) are more than just records of likenesses; they give us images incorporating personal history and interests. As such, they are fresh syntheses of figure, landscape, history, and genre painting.

The Laming double portrait presents an accomplished Baltimore merchant and his wife seated with a distant view of the city at the left. His leaning pose was a happy solution to pairing a very tall man with a petite woman. Details like the strutting bird, telescope, fruits, and flowers all suggest a union of warm and gentle felicity.

1788. Oil on canvas, 42 x 60¼ in. (106.6 x 152.9 cm.)
Gift of Morris Schapiro, 1966

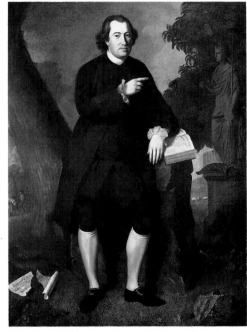

Charles Willson Peale, *John Beale Bordley*, 1770
Oil on canvas, 79⅛ x 58³⁄₁₆ in. (201 x 147.6 cm.)
Gift of the Barra Foundation, Inc., 1984

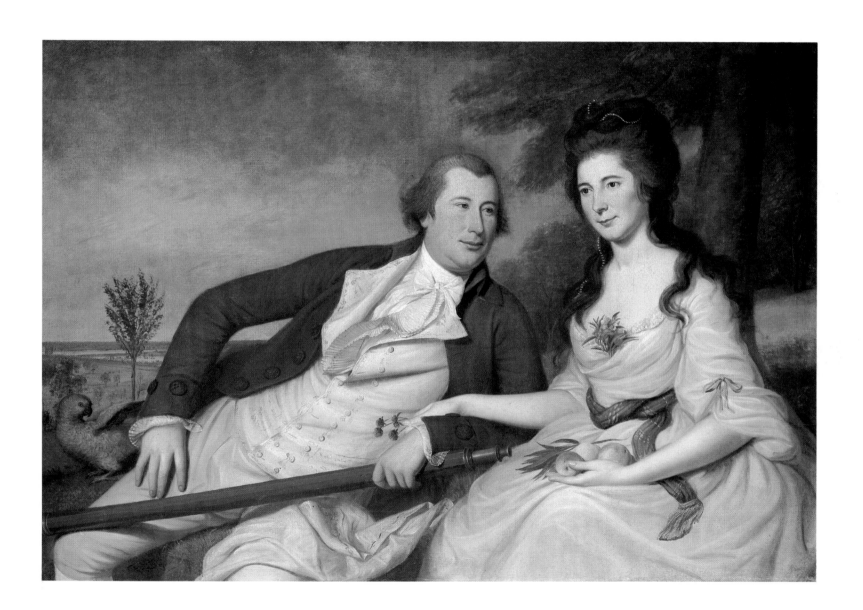

10 Rembrandt Peale
Rubens Peale with a Geranium

This is one of the most remarkable, attractive, and revealing works in the history of American art. In its artist, subject, and date the image speaks to a number of important concepts: art, originality, nature, nation, and family. Painted in 1801, when its maker was just twenty-three and the sitter only seventeen, the image on several levels embodies the promise and aspiration of beginnings, those of a new century and republic, and those of the versatile and ingenious progeny of the Peale family. Like the other children of Charles Willson Peale by his first and second wives, all bore the names of famous artists or scientists, by implication laying claim to the broadest prospects for American achievements.

We recognize the directness of the glance and the casual informality of the pose as especially native in feeling, a mode first introduced into American portraiture by Copley and Stuart. The sense of familial devotion is also obvious in the utter sympathy of treatment, seen only in the best works by the Peales when painting other close members of the family. But this is not just a tribute to art or a fellow artist; the equal presence of the geranium plant—itself thought to be one of the first brought to America—indicates that this is as much a celebration of natural science. In the one gesture of Rubens's hand resting on the flower pot, we understand both an image of possession as well as the practical act of feeling moisture in the dirt. Most of the full blooms have fallen off, some stems are bare, one leaf is turning brown, another has dropped to the table, while small new red buds appear above—all suggesting the cycle of natural growth and regeneration. The metaphor and reality of science are also present in Peale's two pairs of spectacles. The lower set has a wider bridge to be placed farther down the nose in order to gain extra magnification. Besides hinting at the need for careful looking both up close and at a distance, they ultimately celebrate the deepest rigors of seeing, perception, and self-awareness.

1801. Oil on canvas, 28¼ x 24 in. (71.8 x 61 cm.)
Patrons' Permanent Fund, 1985

66

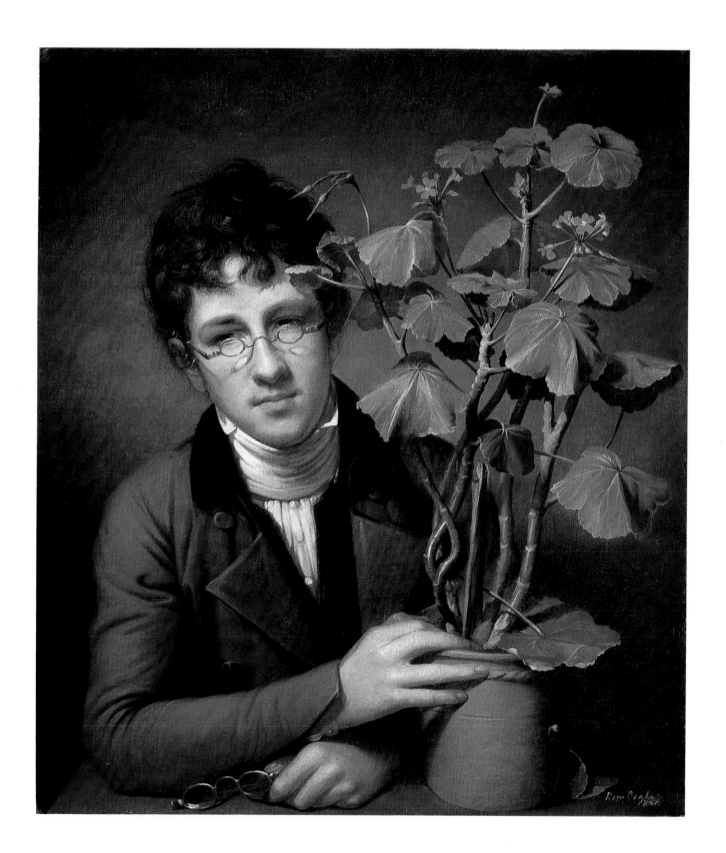

11 Joshua Johnson
The Westwood Children

Johnson, a mulatto of West Indian background, was America's first professional black painter. Turning up in Baltimore in the last years of the eighteenth century, he most likely studied with one or more members of the Peale family, possibly Charles Willson Peale or more likely Charles Peale Polk. His manner of rather stiffly posed figures and smooth, simplified faces recalls the Peale tradition, though with a more primitive character of linear patterns and flat areas of color. Often he seated individuals alone or in family groups around a country empire sofa, highlighting his design with the decorative rhythms made by such details as brass buttons or lace collars. Johnson's arrangement of the Westwood children is one of his more appealing in its asymmetric posing of the three figures, all dressed in similar dark green uniforms, but subtly differentiated by their hair styles, feet placement, and the objects each holds. Balancing the three youths on the right are the dog in profile, holding for contrast a retrieved bird in his jaw, and the tree glimpsed out the window behind. The slightly oversized oval faces emphasize Johnson's portrait aspirations, while to modern eyes the special charm of this painting seems to reside in the artist's unpretentious abstract sense of figural silhouettes and planar surfaces. As such, Johnson's work stands at an interesting juncture between the academic and folk traditions in early American art.

c. 1807. Oil on canvas, 41⅛ x 46 in. (104.4 x 116.8 cm.)
Gift of Edgar William and Bernice Chrysler Garbisch, 1959

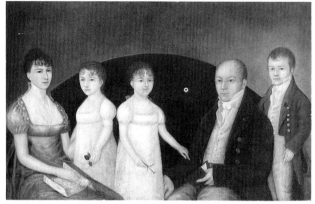

Joshua Johnson, *Family Group*, c. 1800
Oil on canvas, 34¾ x 53½ in. (88.3 x 136 cm.)
Gift of Edgar William and Bernice Chrysler Garbisch, 1980

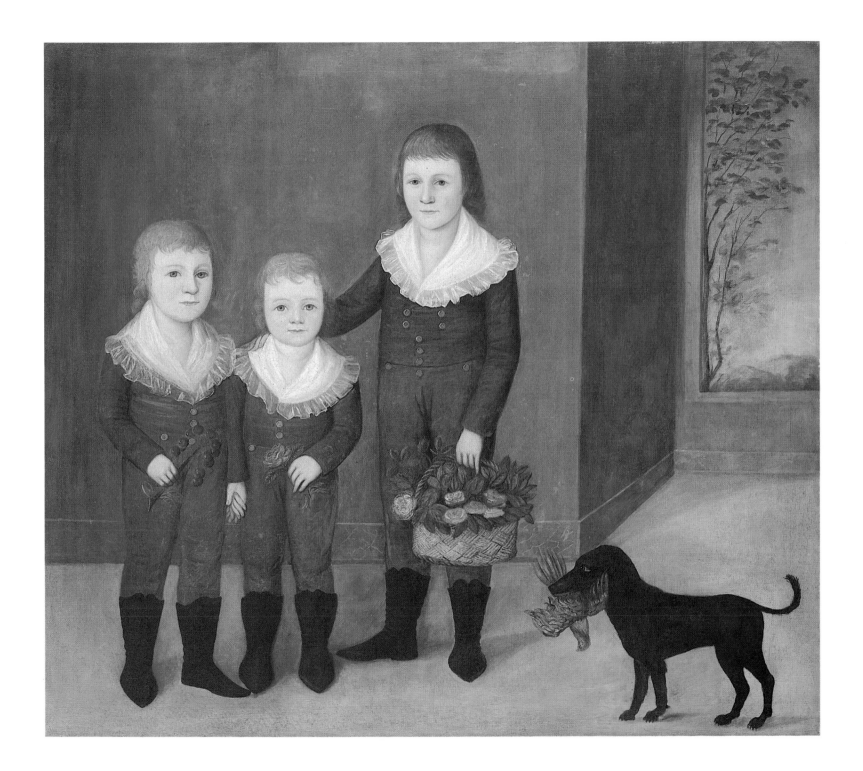

12 Ralph Earl
Daniel Boardman

The formulas of full-length portraiture were grounded in the English academic tradition and were most often employed for royalty and titled or wealthy individuals. The pose usually meant a canvas of ambitious size and the challenge of convincingly rendering the weight and volume of the complete figure. In the eighteenth century we find it most comfortably employed by those Americans who had spent time studying or working in England, for example, West, Copley, Trumbull, and Sully. Earl grew up in central Massachusetts, and during the American Revolution he left for England, where he received the hospitality of West and painted several attractive portraits of children. Returning to America in 1785, he embarked on a productive career painting individuals eminent in Federalist American society and politics up and down the Connecticut River valley. Among the most accomplished politicians and businessmen were the Boardman brothers of New Milford, Connecticut, whom Earl painted in 1789. He depicted Elijah standing in the family dry-goods store, while Daniel poses gracefully before the gentle rolling landscape along the Housatonic River. Earl's smooth rendering of the fashionable costume and relaxed full-length stance derive from English precedents; at the same time the new informality of posing and the fresh combination of the figure with the broad landscape background suggest a practicality and immediacy which seem especially American. The prosperous and self-confident Major Boardman stands at ease in a sunlit world, prophetic of the promise nature would hold for the nation's imagination in the coming generation.

1789. Oil on canvas, 81⅝ x 55⁵/₁₆ in. (207.5 x 140.5 cm.)
Gift of Mrs. W. Murray Crane, 1948

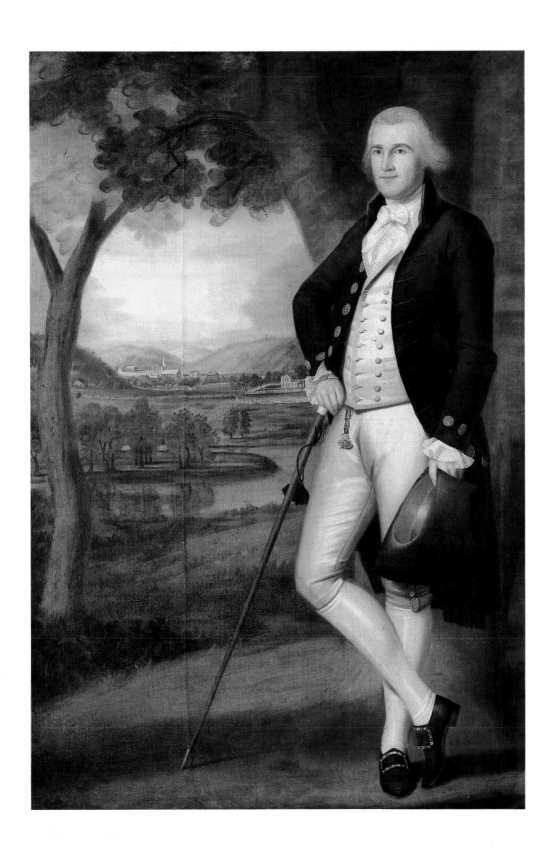

13 Winthrop Chandler

Mrs. Samuel Chandler and
Captain Samuel Chandler

Among the highlights of the munificent gift to the National Gallery of more than three hundred and fifty American naive paintings from Colonel Edgar William and Bernice Chrysler Garbisch is this pair of portraits by Chandler. He was born and spent much of his career in Woodstock, Connecticut, though he probably received some training as a house and sign painter in Boston. This seems confirmed by his sense of composing large clear forms, for his figures sit strongly silhouetted in their shallow spaces, with certain details of clothing creating bold patterns across the surface. These simple yet self-confident images belong in the larger context of a Connecticut school of painters, including Ralph Earl, Reuben Moultrop, John Brewster, Jr., Joseph Steward, and William Jennys, all working in this manner during the later eighteenth and early nineteenth centuries. Painted foremost for posterity as records of individual likenesses, they answer those continuing demands of practicality and necessity. But they also tell us of an aspiring and ambitious citizenry establishing and shaping the young American republic. The artist here shows his older brother in his blue captain's uniform with gold epaulettes, while Mrs. Chandler sits beside a family tripod table and rows of books. Above her hang invented swags of drapery; behind the captain is an appropriate view of a Revolutionary War engagement. Later he went on to serve in the Connecticut legislature.

c. 1780. Oil on canvas, 54¾ x 47⅞ in. (139.1 x 121.7 cm.)
Gift of Edgar William and Bernice Chrysler Garbisch, 1964

c. 1780. Oil on canvas, 54⅞ x 47⅞ in. (139.4 x 121.7 cm.)
Gift of Edgar William and Bernice Chrysler Garbisch, 1964

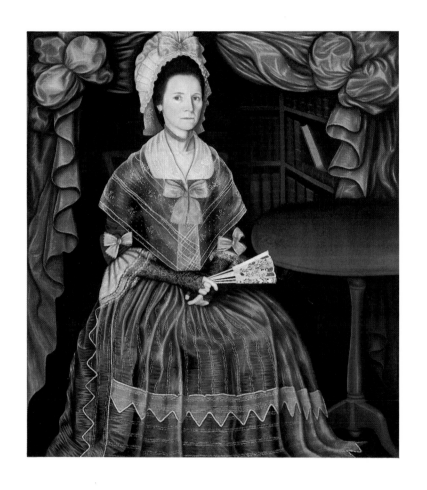 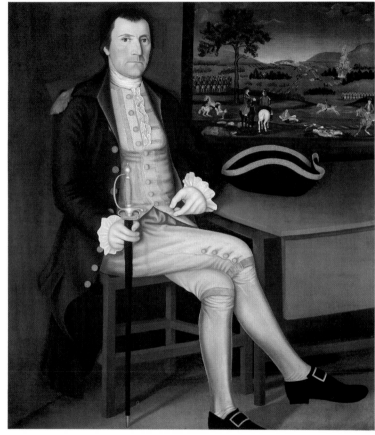

14 Jacob Eichholtz
The Ragan Sisters

Like two Greek columns in white marble—in fact framed by neo-classical architectural details—these two sisters stand gracefully and securely poised before us. Eichholtz came from Lancaster, Pennsylvania, and received artistic encouragement from the leading portrait painters of the Philadelphia tradition, Thomas Sully and Gilbert Stuart. Their influence is apparent here in the creamy smooth surfaces of flesh and clothing and the sense of bright, refined elegance. But just as the attenuated delicacies of the Federal style in architecture at the beginning of the nineteenth century yielded to the more solid geometric classicism of pure Greek revival forms a generation later, so do Eichholtz's fully modeled masses succeed the polished beauty of his predecessors' work, such as *The Skater* by Stuart (Plate 6) and *Lady with a Harp* by Sully (Plate 8). To the left holding a book in her hand is the younger of the two sisters, Elizabeth Barbara Ragan, born in 1809, while the older girl, Mary, born in 1807, stands at the right with her bonnet on her arm. Eichholtz filled his entire composition, simplified as it is, with gentle balances and contrasts: one girl's hat is on, the other off, while ribbons and a bouquet of flowers adorn each. Parallel architectural forms behind echo their paired vertical figures. In this straightforward yet subtle way the artist differentiates for us two separate personalities at the same time that he conveys their familial closeness as sisters.

c. 1820. Oil on canvas, 59 x 43 in. (150 x 109.5 cm.)
Gift of Mrs. Cooper R. Drewry, 1959

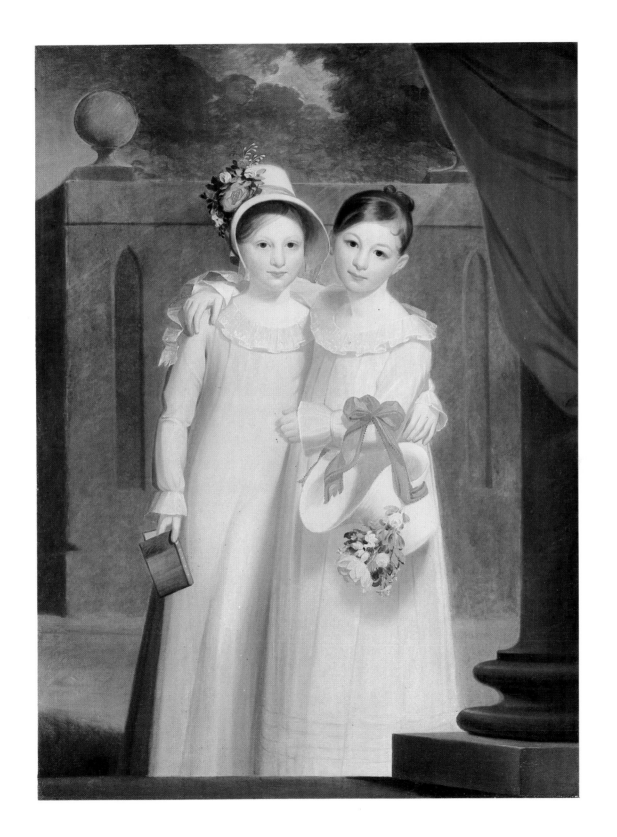

15 Chester Harding

Amos Lawrence

This impressive yet informal full-size portrait is one of two versions. Scholars feel that this is probably the first, painted at the behest of the sitter himself. About it the artist was to write: "The most liberal patronage I have enjoyed has been, perhaps, from the Lawrences. I have painted all of them, and many of their children. My full-length portrait of Amos Lawrence I consider the best thing I have ever done in my whole artistic career." It is thought that Lawrence asked Harding to make another version, since the trustees of Williams College requested a portrait of Lawrence in recognition of his munificent gifts to the institution in 1844–45. In any case, the resulting image is a combination of dignity and intimacy.

Although Harding was born and brought up in the rural wilderness of New Hampshire and western New York, he successfully established himself in England during the early 1820s and adopted in particular some of the stylistic conventions of Sir Thomas Lawrence's portraiture. In this work we find such formal elements from the grand manner as the stagelike column and drapery along with colorful idiosyncratic details like the brightly patterned rug and dressing gown, the invalid's chair on casters, and the self-confident immediacy of Lawrence's pose.

c. 1845. Oil on canvas, 84⅝ x 54 in. (215 x 137.2 cm.)
Given in memory of the Right Reverend William Lawrence by his children, 1944

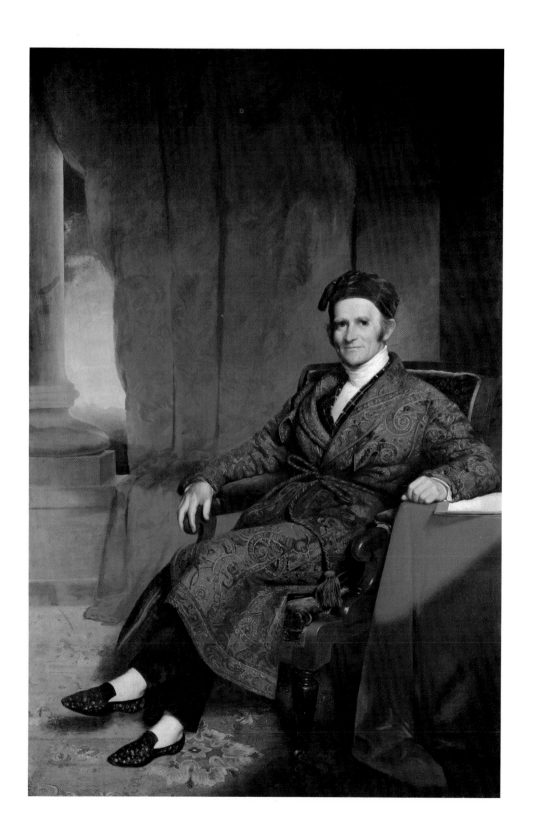

16 John Quidor
The Return of Rip Van Winkle

Full of humor often tinged with mystery, Quidor's paintings frequently took as their subject the legendary heroes and incidents of Washington Irving's and James Fenimore Cooper's stories. This painting comes from a scene in Irving's *Sketch Book:*

> In the midst of his bewilderment, the man in the cocked hat demanded who he was, and what was his name? "God knows," exclaimed he, at his wit's end; "I'm not myself—I'm somebody else—that's me yonder—no—that's somebody else got into my shoes—I was myself last night, but I fell asleep on the mountain, and they've changed my gun, and everything's changed, and I'm changed, and I can't tell what's my name, or who I am!"

Slouching by the tree is the figure of Rip's son, whose familiarity perplexes him, but whose isolation also recalls similar figures in other Quidor works and may well allude to the artist's own idiosyncratic place in the mainstream of American realistic painting at this time. It is unknown whether the Michelangelesque aspects of the central characters are intentional, but Quidor almost certainly knew through prints or copies the seventeenth-century genre compositions of Adrian van Ostade and his contemporaries. Originally this painting was thought to have been dated 1829, but the 2 has clearly been scratched, and a more probable dating, consistent both with Quidor's mature style and with mid-century exhibition records, suggests 1849 instead.

18(4?)9. Oil on canvas, 39¾ x 49¾ in. (101 x 126.5 cm.)
Andrew W. Mellon Collection, 1942

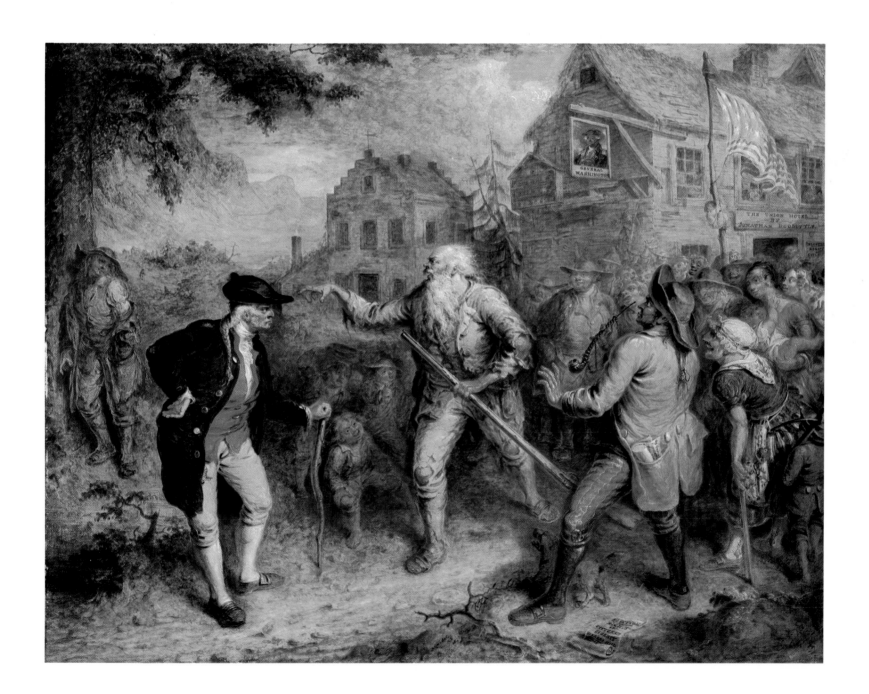

17 Francis William Edmonds
The Bashful Cousin

Interest in seventeenth-century Dutch life and painting flourished especially during the first third of the nineteenth century, specifically in New York with its Dutch inheritance, but more generally in America so conscious of similar values of mercantilism, Protestantism, and industriousness. Dutch scenes by Adrian van Ostade, Jan Steen, and their contemporaries were well known through engraved or painted copies, and these genre traditions were further popularized by prints after later eighteenth-century English artists like William Hogarth and Thomas Rowlandson. Several American genre painters, including Edmonds, Richard Caton Woodville, and Eastman Johnson had actually seen firsthand in Europe examples of the Dutch old masters. As a consequence, their compositions with American subject matter often emulated the Dutch interiors and moral anecdotal narratives. In fact, this painting may well have been inspired by a popular story called *The Dutchman's Fireside* by James Kirke Paulding, published in 1831. Passages in it describe Dutch interiors, a bashful young gentleman, the ambitious mother, and a black cook—elements prominent in Edmonds's work. When the artist first saw the old masters in London and Paris, he wrote in his autobiography, "they seemed to me too dark and too low in tone to please the eye, but when I came to repeat my visits . . . I became their warm admirer."

c. 1842. Oil on canvas, 25 x 30 in. (63.6 x 76.1 cm.)
Gift of Frederick Sturges, Jr., 1978

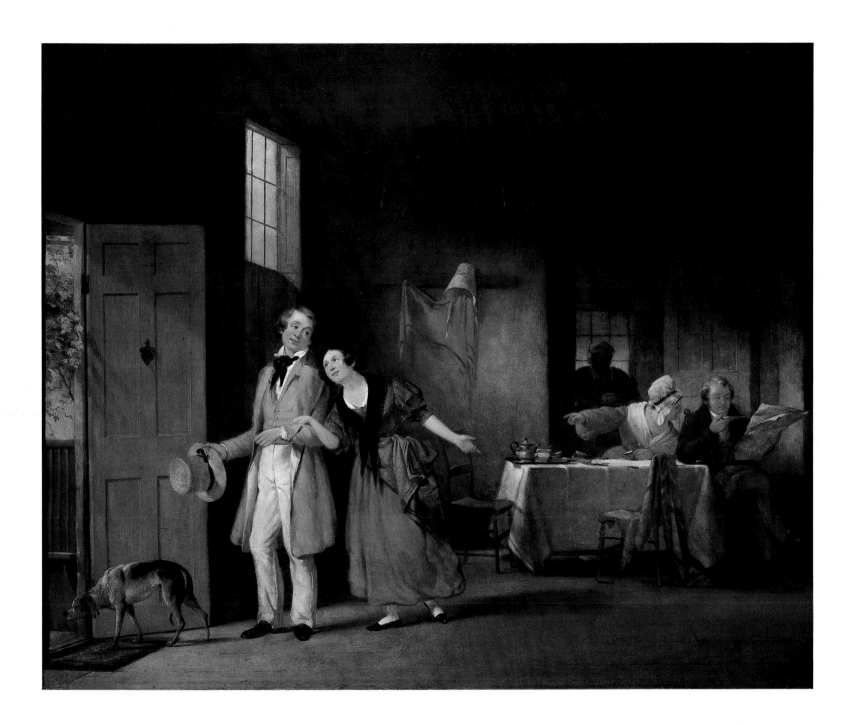

18 Eastman Johnson
The Brown Family

This is a second, smaller version of the subject painted for the family of James Brown on the occasion of their move from a handsome Victorian house on University Place in New York to a new one on Park Avenue. The larger canvas in the Rockefeller collection given to the Fine Arts Museums of San Francisco is vertical in format and shows a good deal more of the parlor interior. This version in turn concentrates more on the psychological relationships among the three family members, James Brown, his wife, and their grandson William Adams Brown. A prominent banker and investor, Brown headed the venerable firm still in business today as Brown Brothers Harriman. The elaborate furniture, carving, and moldings reflect a prosperous world of wealth and well-being. Johnson's sturdy realism and incisive delineation of details are indebted to a combination of stylistic influences. Two decades earlier the artist had traveled to Düsseldorf where he learned the tight drawing and sharp coloring favored by that school. Then in Holland he came to admire the rich chiaroscuro of seventeenth-century Dutch painting, and finally he spent some time in Paris with Thomas Couture, who would have strengthened Johnson's sense for carefully constructed spatial interiors. Above all, however, we can recognize his native sense of the American genre tradition running from William Sidney Mount to Winslow Homer. Painted as a memento of the Brown's old French Renaissance-style dwelling, this picture descended in a collateral branch of the family in England until its acquisition by the National Gallery in 1978.

Eastman Johnson, *The Early Scholar*, c. 1865
Oil on academy board mounted on canvas
17 x 21⅛ in. (43.2 x 53.7 cm.)
Gift of Chester Dale, 1962

1869. Oil on paper mounted on canvas, 23⅝ x 28½ in. (59.3 x 72.4 cm.)
Gift of David Edward Finley and Margaret Eustis Finley, 1978

19 George Catlin
The White Cloud, Head Chief of the Iowas

This is one of an extraordinary group of paintings given to the National Gallery by Paul Mellon in 1965. During the 1830s Catlin had conscientiously sought to record all of the Indian tribes of North America (much as John James Audubon essayed his comprehensive visual catalogue of the continent's birds and mammals). An even larger and more finished group of Indian paintings by Catlin are housed in the National Museum of American Art, thus giving Washington a unique concentration of Catlin's work. The later collection, at the National Gallery, is sketchier and in some ways, therefore, more immediate and fresher. Catlin called these oil drawings on cardboard "cartoons" to indicate their character as finished study sketches. Four portraits on canvas, slightly larger than the rest of the group, cannot be identified with certainty as being a part of the original cartoon collection. This one, like its three companions, depicts close up the head and torso of a prominent chief or medicine man. Particularly striking in each is the elaborate headdress, decorative necklace, and painted facial stripes. Sympathetically, Catlin wanted to paint all aspects of Indian life: the costumes, ceremonies, ways of hunting, and special regional customs. In part these were intended as images for posterity, as many tribes increasingly faced uprooting, even extinction, at the hands of the white man and the accompanying encroachments of technology, population expansion, and modern industry. As paintings they survive equally as powerful artistic and ethnographic documents.

Probably 1845. Oil on canvas, 27¾ x 22¾ in. (70.5 x 57.8 cm.)
Paul Mellon Collection, 1965

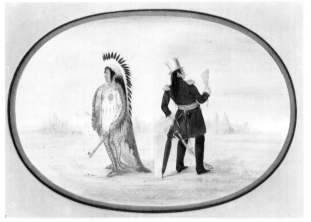

George Catlin, *Assiniboin Chief Before and After Civilization*, 1857/69
Oil on cardboard, 15⅜ x 21¾ in.
(39 x 55.3 cm.), oval
Paul Mellon Collection, 1965

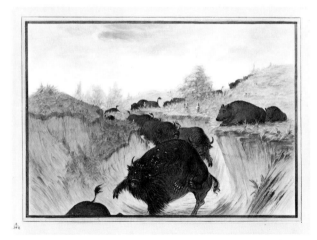

George Catlin, *Grizzly Bears Attacking Buffalo*, 1857/69
Oil on cardboard, 15¼ x 21½ in. (38.7 x 54.6 cm.)
Paul Mellon Collection, 1965

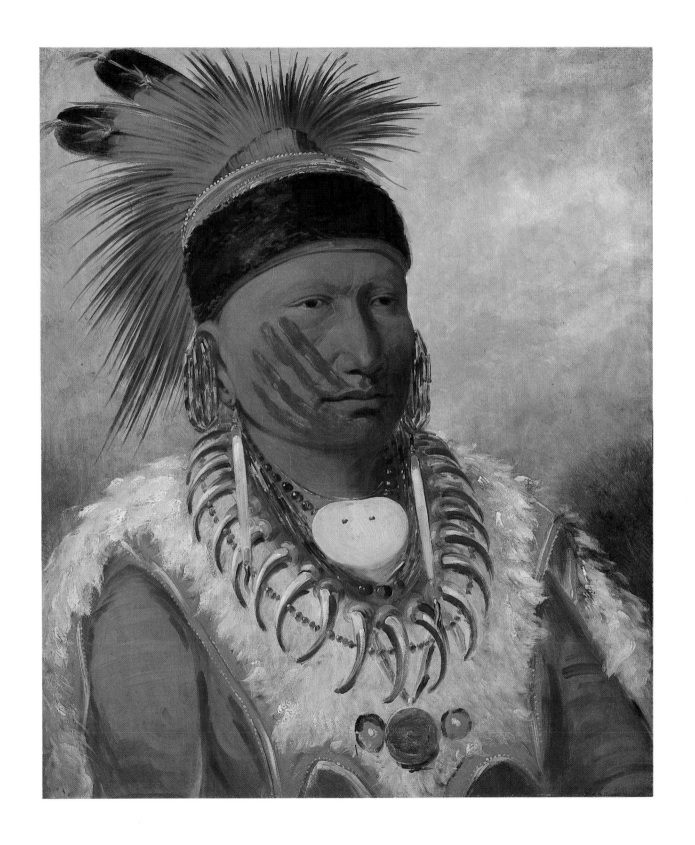

With the deaths of Colonel and Mrs. Garbisch in the late 1970s the Gallery had the wonderful opportunity of selecting which pictures it wished to have from those remaining in the Garbisches' personal collection. Already strong in this field, thanks to the Garbisches' sustained generosity since their founding gifts in the 1950s, the Gallery now saw an unprecedented richness and depth come to the American collections with several dozen more paintings acknowledged to be among the finest of their type. Theirs was a private collection, which in turn gave its character to the Gallery's holdings, with a very personal stamp and interests. On the one hand, the Garbisches acquired rare eighteenth-century portraits; on the other, they sought works of distinctive whimsy, humor, and domestic charm, as exemplified in such recurrent subjects as children with toys, fanciful figures, and colorful still lifes, and above all playful animals.

The Cat is perhaps the most imaginative and delightful picture in this category, and has long been one of the most popular and reproduced of the Garbisch collection. Its great wit derives of course from the absurd disjunctions in scale between cat and landscape and the looming detached head occupying center stage. Not a real world of violence or tragedy, this fantasy of cunning cat and observant birds makes the hunter seem benevolent and comical, an elevation of ordinary fact into the artifice of theater or dream. As such, its touch of surrealism greatly appeals to modern eyes, as its playful design, distortions of size, and romp of imagination all find sympathetic parallels in the abstract currents and primitive tastes of twentieth-century art. Because the usually self-trained folk artist had little concern with the academic recording of reality, an image such as this could be simultaneously a portrait, still life, landscape, and genre picture. As a work of the mid-nineteenth century, it also expresses that period's exuberant optimism and self-confidence.

c. 1840. Oil on canvas, 16 x 20 in. (40.7 x 50.8 cm.)
Gift of Edgar William and Bernice Chrysler Garbisch, 1980

Charles V. Bond, *Still Life: Fruit, Bird and Dwarf Pear Tree*, 1856
Oil on canvas, 25 x 30⅛ in. (63.5 x 76.5 cm.)
Gift of Edgar William and Bernice Chrysler Garbisch, 1980

Gansevoort Limner, *Susanna Truax*, 1730
Oil on bed ticking, 37¾ x 32⅞ in. (95.8 x 83.6 cm.)
Gift of Edgar William and Bernice Chrysler Garbisch, 1980

21 Edward Hicks
Peaceable Kingdom

One of the noteworthy characteristics of the Garbisch collection is their accumulation of groups of works by major artists. Their bequest in 1980 gave to the Gallery even more concentrations in depth, with the addition of another half-dozen works by Edward Hicks, and multiple examples as well of Thomas Chambers, Joshua Johnson, and Erastus Salisbury Field. In the case of Hicks, where the Gallery had long owned only his late masterpiece, the golden so-called Indian summer view of the *Cornell Farm* painted at the end of his life, now the artist was represented by a sequence of pictures of different subjects from various phases of his entire career. These include an attributed portrait of a child, along with examples of his best-known historical subjects.

Peaceable Kingdom is probably Hicks's most famous theme, one he painted in more than sixty variants over his lifetime, and carrying significance on several levels: personal, regional, and national. All were inspired by the lines from Isaiah (XI: 6–9) which begin: "The wolf also shall dwell with the lamb, and the leopard shall lie down with the kid; and the calf and the young lion and the fatling together; and a little child shall lead them." Hicks was a Quaker, and these biblical lines articulated his preacher's convictions, but the Quaker community became split in the second quarter of the nineteenth century, so that this subject also spoke to the hope and prophecy for reconciliation within the house. On yet a broader level the imagery of peace and plenty was a logical expression of American destiny and aspiration in these decades, of nature's bounty, and the national sense of promise and well-being. In the Gallery's painting we enter into an imaginary composite of Isaiah's kingdom in the foreground with William Penn's peace gathering with the Indians just beyond and a golden wilderness panorama in the background. Ultimately fused together were personal and national beliefs in an America that was both a productive farmyard and a new Eden.

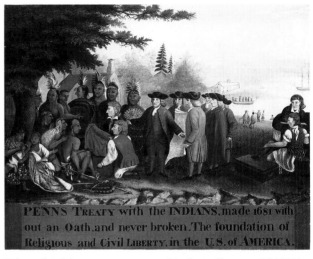

Edward Hicks, *Penn's Treaty with the Indians*, c. 1840/44
Oil on canvas, 24¼ x 30⅛ in. (61.7 x 76.5 cm.)
Gift of Edgar William and Bernice Chrysler Garbisch, 1980

c. 1834. Oil canvas, 30 x 35½ in. (76.2 x 90.2 cm.)
Gift of Edgar William and Bernice Chrysler Garbisch, 1980

22 Edward Hicks
The Cornell Farm

Perhaps best known for his series of paintings devoted to the theme of "the Peaceable Kingdom," based on the words of Isaiah, Hicks also undertook several canvases of tranquil farm scenes in his native Bucks County, Pennsylvania. One of his largest and finest views is this one, bearing the revealing descriptive caption: "An Indian Summer view of the Farm w. Stock of James C. Cornell of Northampton Bucks county Pennsylvania. That took the Premium in the Agricultural Society, October the 12, 1848. Painted by E. Hicks in the 69th year of his age." Indeed, a gold haze suffuses this early autumn landscape with its line-up of fully grown cattle (Cornell raised Guernsey, Ayrshire, Holstein, and Angus), along with sheep and solid farm workhorses. A large proud bull serenely dominates the center of this progression, with cows ready for milking to the left, while behind stand various members of the Cornell family. In the distance one field is still being plowed while another ready for harvesting extends out of our range of sight. The whole image has overtones of both a secular Noah's Ark and Peaceable Kingdom, with the animal and natural world seen at a moment of promise and harmony. The lush green foreground and red roofs of the Quaker barns accent an otherwise muted and orderly world, arranged in the flattened patterns of the folk artist's eye. Above all we sense here a celebration of productivity and well-being in an America just then reaching a high moment of expansive optimism.

1848. Oil on canvas, 36¾ x 49 in. (93.3 x 124.4 cm.)
Gift of Edgar William and Bernice Chrysler Garbisch, 1964

An Indian summer view of the Farm & Stock of JAMES C. CORNELL of Northampton Bucks county Pennsylvania. That took the Premium in the Agricultural society, october the 12, 1848.
Painted by E. Hicks in the 69th year of his age.

23 Linton Park
Flax Scutching Bee

Linton Park grew up in western Pennsylvania, where his father was a surveyor. He was apprenticed in a cabinet shop, and knew well a number of practical trades. This familiarity with the activities of communal life is evident in his attentive yet humorous treatment of a group preparing flax for weaving into linen. The wilderness setting is evident in the log house in the left background, while the barn to the right is constructed of unhewn tree trunks interlocked in such a way as to allow air for ventilation and drying of the hay within. Two girls are playing in the window opening onto the central breeze-way, which was where a wagon would enter to unload its hay into the loft. In the center background stand crossed staves under a lean-to for holding fodder and hay for the farm animals. Across the foreground is a lively visual parade of family and friends joining in the work and play. At the left a man operates the flax brake, or grinding machine, while beside him an amused woman smokes her pipe and watches others in the group waving their paddles (known as swingling knives), used to beat the fibers over boards until sep-arated. Like the barn scenes of William Sidney Mount, George Caleb Bingham, and John Quidor, this image recalls similar precedents by seventeenth-century Dutch painters known to Americans through prints and copies. But above all this is an affectionate testimony to the pleasures of ordinary American life during that long period when the country's new territories were expanding and being settled.

1885. Oil on bed ticking, 31¼ x 50¼ in. (79.4 x 127.6 cm.)
Gift of Edgar William and Bernice Chrysler Garbisch, 1953

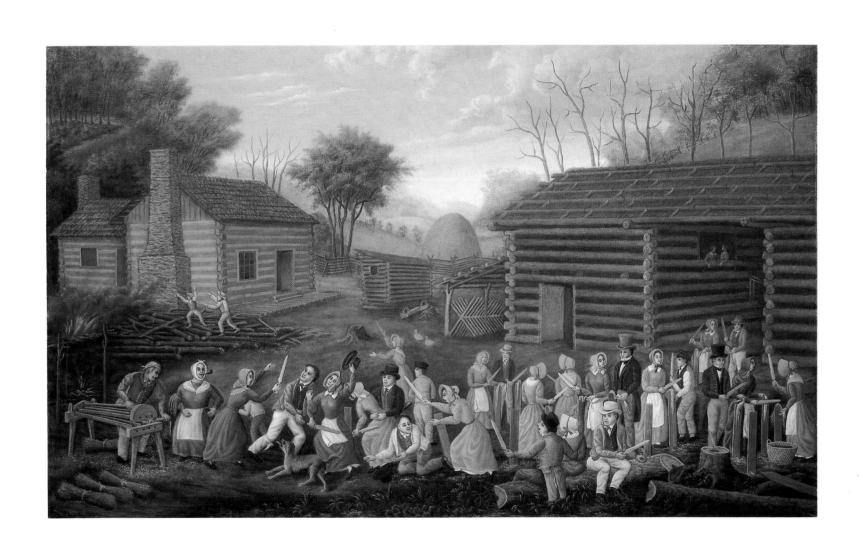

24 Thomas Chambers
The Hudson Valley, Sunset

Thanks to the Garbisch gifts over several decades of American naive paintings, the National Gallery now has some two dozen works by Erastus Salisbury Field and a half-dozen by Chambers, of which this is one of the most colorful. In the background the Hudson River highlands drop down to the tranquil valley at sunset, with a village nestled alongside, its various chimneys puffing smoke in a suggestion of industry and communality. Born in England, Chambers was actively at work in the New York, Boston, and Hudson valley areas from the mid-1830s through the fifties, producing pictures with broad and bold patterns of color, animated further by lively rhythms of brushwork and repeated shapes of trees, waves, or buildings. He completed a number of strongly designed canvases on major naval battles in the War of 1812. These, as well as many of his landscapes, were probably inspired by popular contemporary prints, though he obviously also took delight in selecting his own views based on his own firsthand travels through the countryside. There is a close variant of this particular scene in the Smith College Museum of Art which has been titled *Looking North to Kingston.* In both instances Chambers made obvious distortions in the scale and proportion of certain details (such as the village buildings and headland itself) primarily for the sake of enlivening his overall design. The result is an engaging synthesis of personal observation and imaginative artifice.

Mid-19th century. Oil on canvas, 22 x 30 in. (56 x 76.2 cm.)
Gift of Edgar William and Bernice Chrysler Garbisch, 1967

25 American Nineteenth Century
Mahantago Valley

Like the professionally trained academic artist, his self-trained folk counterpart chose as one of his major interests the local countryside. Along with portraiture, native scenery and everyday surroundings held special appeal for American painters through much of the nineteenth century. Such views as this were records of daily activity and familiar places at the same time that they embodied a sense of celebration—of the productivity of the land, of its boundless expanse and beauty, and of the larger national well-being. Although this painter employed a diminishing scale for his forms and a narrowing road into the distance, there is no systematic vanishing point or consistency of viewpoint characteristic of the academic artist. Rather, this artist delighted in the overall aerial vantage to capture the receding rows of cultivated fields, while showing the barns at a three-quarter angle to illustrate as many of their sides as possible, and gave us side views of most of the foreground animals to indicate their most recognizable shapes. The colors are bright, simple, unmodulated, and self-contained within repeated rhythmic patterns. The dominant contrasts are those between the red geometric rectangles of the barn roofs and the green undulating stretches of fields beyond. The Mahantago River flows into the Susquehanna on the east side, about midway between Sunbury and Harrisburg, Pennsylvania, where this painting (executed on a window shade) was found.

Late 19th century. Oil on window shade, 28 x 35⅜ in. (71.1 x 89.9 cm.)
Gift of Edgar William and Bernice Chrysler Garbisch, 1953

26 Thomas Doughty
Fanciful Landscape

Born in 1793, Doughty was the oldest of the founding members of the Hudson River School, America's first coherent movement of landscape painting, which emerged during the second quarter of the nineteenth century. Brought up and trained in Philadelphia, he exhibited regularly at the Pennsylvania Academy from the 1820s on, and knew well a number of colleagues (like Thomas Sully, Chester Harding, and Joshua Shaw) also working there. Late in 1828 Doughty left for Boston, where he stayed briefly, then returned to Philadelphia, but was back in Boston from 1832 to 1837. During this particularly productive and lucrative period for him he painted this canvas, typical of his lyrical and imaginative mode at its best. When exhibiting, he usually submitted his works under one of three categories: "from nature," "from recollection," or "composition." This painting is obviously an example of the last type, and contains much of the artist's characteristic vocabulary — the looming feathery tree to one side, a bold promontory at the other, eroding Gothic ruins, and a central passage of quiet water carrying the eye from the darkened foreground to silvery mountains in the distance. The whole is bathed in cool glowing light and invites the spectator to contemplate the poetry of nature's benevolence. This generalized and distilled evocation of nature remained popular for awhile with Doughty and his colleagues, but was soon to be replaced by more precisely identifiable American scenes (such as Thomas Cole's *Notch of the White Mountains,* Plate 27) with their more insistent celebrations of the national identity.

1834. Oil on canvas, 30⅛ x 39⅞ in. (76.5 x 101.5 cm.)
Gift of the Avalon Foundation, 1963

27 Thomas Cole

The Notch of the White Mountains (Crawford Notch)

Cole developed two parallel modes of landscape painting—one literal and the other philosophical—both in response to the rising tide of romanticism in America which, among other things, came to associate the virgin wilderness of the New World with the mission and promise of the young republic. By recording literally the specific sites and scenes of the national landscape, artists hoped to educate the public in the sublime and superior virtues of American nature, in contrast to the tired civilization and eroded terrains of Europe. Man's experience in the American wilderness was both challenging and exhilarating, as the small figure on horseback before the towering slopes of Crawford Notch suggests. While we are presented with one of the dramatic locales of the nation's countryside, enhanced by the intensely colored foliage and strong lighting, we can make out such clues to man's adaptability to nature as the houses built in this wilderness and the stumps of cut-down trees. Still other details carry a language of time's larger passage: the dying branches and rotting tree trunk surrounded by lush younger growth evoke the natural world's ancient cycles of regeneration. Likewise, the clearing storm over the mountain is at once a record of an observed phenomenon and a symbol of American nature cleansed and purified before us, as Eden at Genesis.

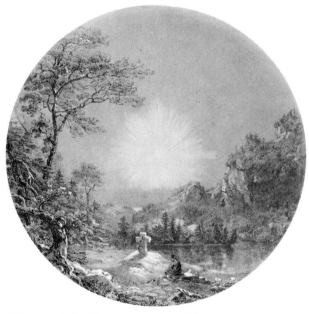

Thomas Cole, *The Cross in the Wilderness,* c. 1844
Pencil and white, gray-green and green-brown chalks on gray board, 7⁵/₁₆ in. (18.6 cm.) diameter
John Davis Hatch Collection

1839. Oil on canvas, 40 x 61½ in. (101.6 x 156 cm.)
Andrew W. Mellon Fund, 1967

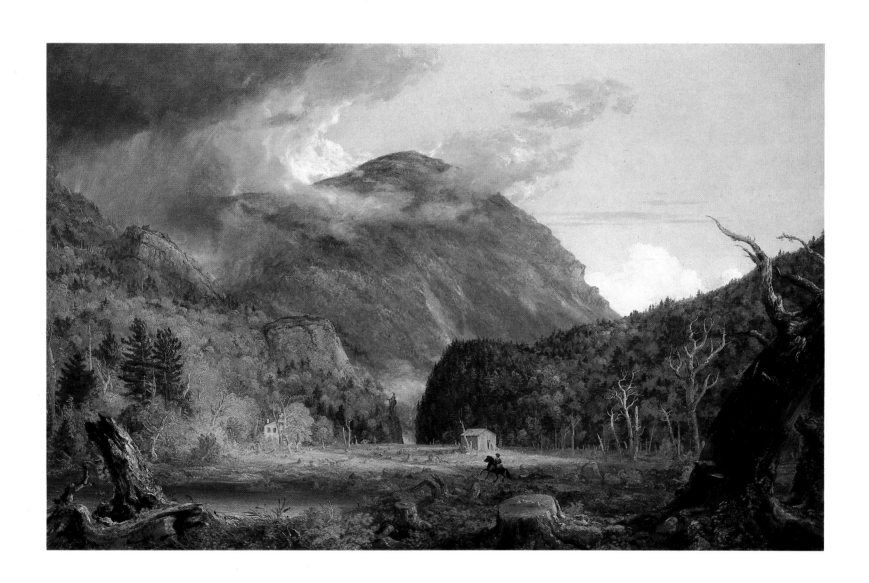

28 Thomas Cole
The Voyage of Life: Youth

In 1840 Cole, the founding father of the Hudson River School, America's first movement of landscape painting, painted his first version of *The Voyage of Life* series (Munson-Williams-Proctor Institute, Utica, New York). In the second set, completed in Rome two years later, he repeated with minor variations a group of pictures which had found wide popularity and influence. Although the allegory embodied here was more explicitly religious than the broadly philosophical *Course of Empire* of 1836 (New-York Historical Society), both were ambitious serial cycles addressing the evolution of nature and nations. Appropriately, the scene moves from one of early morning light and newly blooming flowers, with man as a babe emerging from the earth's womb, to the turbulence of manhood, and finally the serenity of old age, as he returns to the eternity of the open sea and heavens beyond. Cole wrote in a letter that the "second picture represents youth on the verge of manhood. In that season of life all is hope and expectation. The world spreads out before us a wide paradise. Visions of happiness and glory rise in warm imagination." The guardian angel here waves off the youth towards his lofty daydreams and "aspirations after glory and fame." Compositionally, Cole tied the whole series together by such devices as the repeated figures and foliage and the serpentine river moving in and out of the foregrounds sequentially. This set combines with Cole's canvas of *Crawford Notch* and several drawings given in the Hatch collection to provide the National Gallery with a particularly strong concentration in the work of America's first landscape master.

1842. Oil on canvas, 52⅞ x 76¾ in. (134.3 x 194.9 cm.)
Ailsa Mellon Bruce Fund, 1971

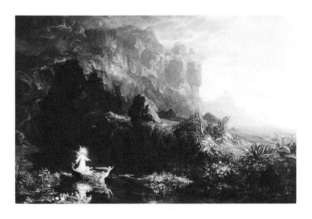

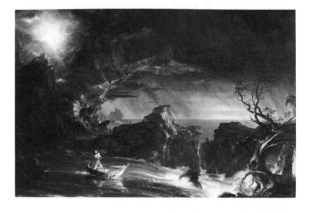

Thomas Cole, *The Voyage of Life*, 1842
All oil on canvas. Ailsa Mellon Bruce Fund, 1971
Top: Childhood. 52⅞ x 77⅞ in. (134.3 x 197.7 cm.)
Center: Manhood. 52⅞ x 79¾ in. (134.3 x 202.6 cm.)
Bottom: Old Age. 52½ x 77¼ in. (133.3 x 196.2 cm.)

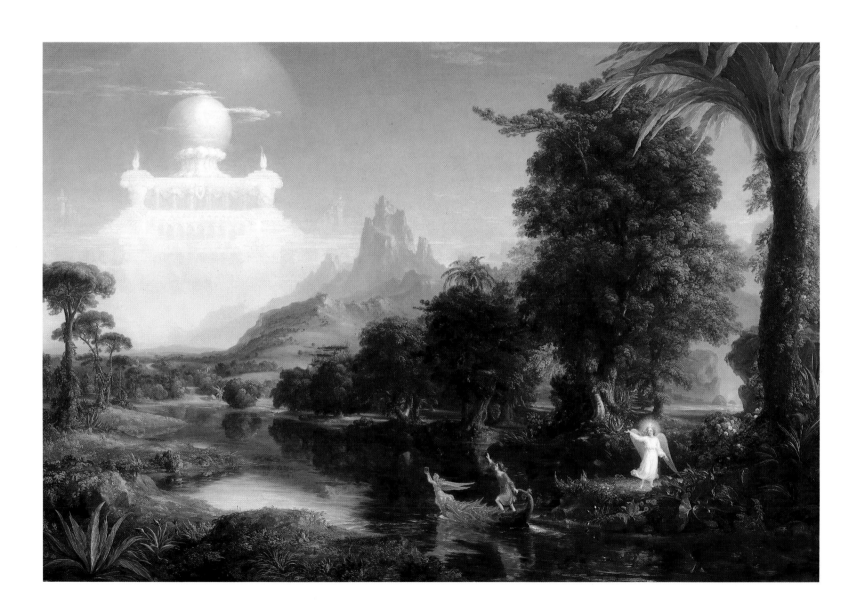

29 Fitz Hugh Lane
Lumber Schooners at Evening on Penobscot Bay

The National Gallery has only a few, but very choice, examples of luminism, that style of landscape painting at mid-nineteenth century which exploited open panoramic compositions and evocative effects of light and atmosphere. Exemplary works representing aspects of this style include William Stanley Haseltine's *Marina Piccola, Capri*, as well as John F. Kensett's two coastal views (see Plate 30), Martin Johnson Heade's *Rio de Janeiro Bay* (Plate 31), and Frederic Edwin Church's *Morning in the Tropics* (Plate 34). One of the most serene and exquisite luminist images is this late canvas by Lane. With its gently rippling foreground of water and unrestricted openness to either side, the painting leads the eye across the clarified realm of spacious calm to the distant horizon, where the subtle radiance of the sun's evening light is most intense. This is a moment of nature's perfection, and day's end stands as a time of distilled harmony, order, and resolution. Paralleling Emerson's transcendentalist vision, the painting presents us with a devoted scrutiny of the world, but so balanced and poised in its design, so delicate in its controlled nuances of tinted light, that we are emotionally and intellectually led into a timeless spiritual world beyond. Although nominally a documentation of the lumber schooner business seen on a late summer's day along the Maine coast, this work more significantly reveals the luminist painter's aspirations to contemplate and interpret the ordained glories of American nature. The painting is a culminating achievement both of Lane's last years and of mature luminism.

1860. Oil on canvas, 28 x 40 in. (71.1 x 101.6 cm.)
Andrew W. Mellon Fund and Gift of Mr. and Mrs. Francis W. Hatch, Sr., 1980

William Stanley Haseltine
Marina Piccola, Capri, 1856
Oil on paper mounted on canvas
12 x 18½ in. (30.5 x 47 cm.)
Gift of Mrs. Roger H. Plowden, 1953

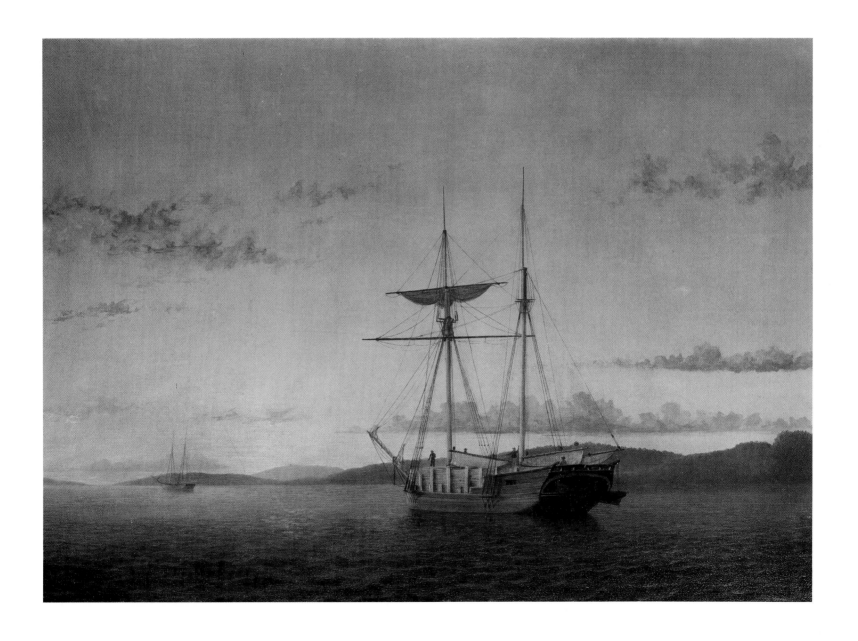

30 John F. Kensett
Beach at Beverly

In 1978 Frederick Sturges, Jr., gave to the National Gallery this painting along with four other works by Hudson River School artists previously unrepresented in the Gallery's collection—two by Asher B. Durand, and one each by John W. Casilear and Francis Edmonds. Aside from this interest and their noteworthy quality, they had also remained in the same family since the time of their purchase directly from the respective artists a century before. This Kensett joins two others already belonging to the Gallery: one a Newport harbor scene, and the other a view at Lake George. Previously thought to be a view at Newport, this scene has been shown by recent investigations to be one of a rocky promontory between Curtis Point and Mingo Beach on the Beverly, Massachusetts, shore.

In *Beach at Beverly* we find the painter's mature style at its most serene and evocative. Moving from an earlier interest in dense woodland vistas filled with rocks, foliage, and running water, Kensett here employed his favored composition of a large rock mass to one side balanced by an almost empty expanse of water and sky on the other. A small figure at the left and a couple of distant sailboats at the horizon on the right suggest an expansive scale, enhanced by the warm clear light and sense of peaceful calm suffusing the whole. Another, nearly identical version of this exact view (but without the rowboat and figure) indicates that Kensett sought to capture the most subtle shifts and nuances of changing light and tide levels during the day as he moved from one canvas to the next. This is a pure luminist vision at its best—poetic, economical, contemplative, spacious. In such pictures the more we reflect on the immediate order of nature's surface, the more we are transported to an awareness of her timeless perfection.

c. 1850/60. Oil on canvas, 22 x 34 in. (55.8 x 86.4 cm.)
Gift of Frederick Sturges, Jr., 1978

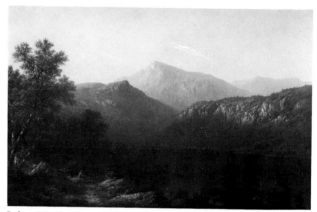

John W. Casilear, *View on Lake George*, 1857
Oil on canvas, 19⅞ x 30 in. (50.5 x 76.2 cm.)
Gift of Frederick Sturges, Jr., 1978

31 Martin Johnson Heade
Rio de Janeiro Bay

Heade was one of the foremost exponents of the luminist style, a mid-nineteenth-century mode of composing in broad open panoramas, usually with an emphasis on stillness and the stopped moment, and given above all to glowing effects of light and atmosphere. He had found a landscape subject peculiarly his own in the marshes of Newburyport, Massachusetts, which appealed for their gentle undulations, as did later the fields around Newport, Rhode Island, and the coastal wetlands of New Jersey and Florida. Heade traveled incessantly, and something of his unsettled nature must have felt at home in the always changing geography of the marshes, partly land and partly water depending on the tide. Across their meandering surfaces were dotted salt haystacks, spaced out on Heade's canvases with the measured cadences of musical notations.

Inspired to travel to South America in part by the example of his friend Frederic Edwin Church and in part by an ambition to record the Brazilian hummingbirds for a lithograph portfolio, Heade painted several landscapes in the Rio area. Some depict the dramas of a coming storm or a volcanic mountain, but *Rio de Janeiro Bay* surveys the great bay under hot sunlight, with the rhythmic wavecrests now replacing the rounded haystacks of his marsh scenes. The impulse to travel so far afield to such an exotic climate during the height of the American Civil War—we see this as well in other contemporaries like William Stanley Haseltine—seems as much a pursuit of a new frontier as a flight from turmoil at home.

1864. Oil on canvas, 17⅞ x 35⅞ in. (45.5 x 91.1 cm.)
Gift of the Avalon Foundation, 1965

32 Jasper F. Cropsey
The Spirit of War

Cropsey was one of Thomas Cole's ablest followers of the next generation, and this work shows the impact of Cole's powerful allegorical style. Comparison with the older master's *Voyage of Life* and *Crawford Notch* (Plates 28, 27) reveals Cropsey's adaptation of similar pink mountain cliffs, lush green foliage, blasted tree trunks, small figures on horseback, and fluid dabs of brushwork. In *The Spirit of War* Cropsey was inspired by the romantic poetry of Sir Walter Scott, in particular lines describing the pillaging of a medieval village. The burning fires in the distance, knights riding out to battle, a mother fallen on her child (in the left foreground), a ring of fire barely visible in the cave to the right, are all matched by the apocalyptic drama of a fiery evening sky. The romance of medieval chivalry captured the American imagination and its presence was felt pervasively at mid-century, whether one thinks of Mark Twain's novel *A Connecticut Yankee in King Arthur's Court*, or the Gothic and Romanesque styles springing up in architecture everywhere. Indeed, the Smithsonian castle was being constructed on the Washington Mall by James Renwick in the same year that Cropsey's painting was done. A companion work, *The Spirit of Peace* (Woodmere Art Gallery, Philadelphia), replaced the Gothic castle with a classical temple and an associated golden serenity. But within a decade Cropsey was to turn his attention fully to pure landscape, as evident in his huge canvas *Autumn—On the Hudson River*, in which literary allegory is totally subsumed into the panoramic drama of pristine nature.

1851. Oil on canvas, 43⅝ x 67⅝ in. (110.8 x 171.6 cm.)
Avalon Fund, 1978

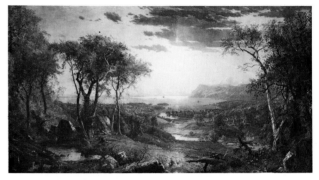

Jasper F. Cropsey, *Autumn—On the Hudson River,* 1860
Oil on canvas, 60 x 108 in. (152.5 x 274.3 cm.)
Gift of the Avalon Foundation, 1963

110

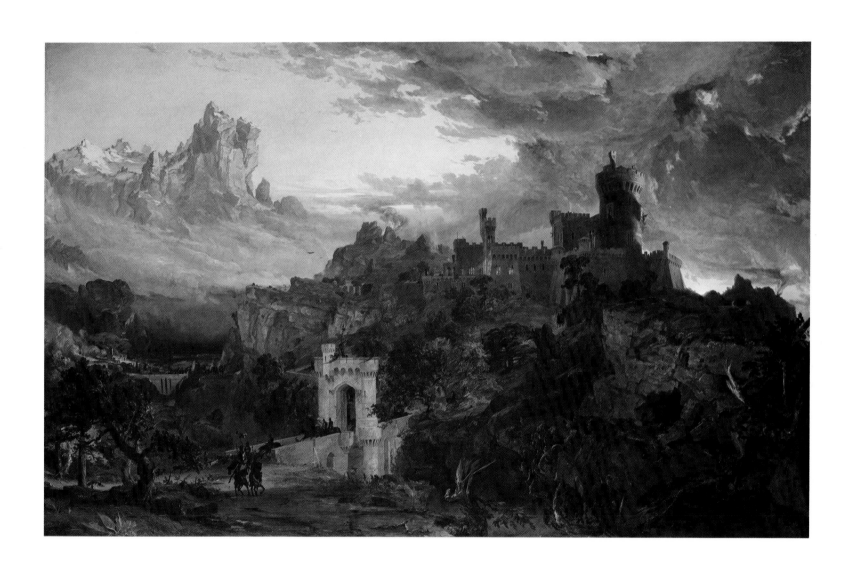

33 George Inness
The Lackawanna Valley

This painting originally bore the title of *The First Round-House of the D. L. & W. R.R. at Scranton* owing to its commission by the first president of the Delaware and Lackawanna Railroad Company. The ironic difficulties which attended Inness's work and the painting's subsequent history are scarcely evident in this harmonious, contemplative image. Inness had made his way to Scranton, Pennsylvania, by stage to begin his sketch, and while there had lost his belongings and had to ask his wife to send funds. The Company added to his frustration by declaring its dissatisfaction with his finished canvas, for it had requested that Inness prominently depict the line's four trains and roundhouse and paint on at least one engine the Company's initials. Although these gave the artist certain perspective problems, he managed to place most of the factual details in the background, reserving much of the vista for the gentle sweep of the pastoral landscape and the suffusing radiance of the golden atmosphere. Inness's artistic grounding in the compositions of Hudson River School painting and his recent exposure to Barbizon art in France partially explain his devices here of the large framing tree to the left and the clear zones of space from foreground to distance. This painting is one of the central images of the mid-nineteenth century's play of forces between the engines of industry and the Edenic purity of nature. Along with the viewing figure we look across a field of tree stumps to the advancing agents of civilization. Inness was paid only $75 for his efforts, and late in his life found the picture for sale in a Mexico City curiosity shop.

1855. Oil on canvas, 33⅞ x 50¼ in. (86 x 127.5 cm.)
Gift of Mrs. Huttleston Rogers, 1945

34 Frederic Edwin Church
Morning in the Tropics

Now recognized as America's greatest painter prior to Winslow Homer and Thomas Eakins, Church was the preeminent interpreter of American cultural aspirations in the middle years of the nineteenth century. As Thomas Cole's only pupil, for a couple of years in the mid-1840s, he inherited something of the older master's heroic, philosophic vision of landscape, but importantly turned it towards a nationalist character. He associated the great wilderness sites of the new world (Niagara Falls, the Natural Bridge, Mount Desert and Grand Manan islands) with an Edenic national identity full of promise and possibility. With his trips to South America beginning in the mid-fifties Church extended his vision to embrace both continents, and produced huge canvases equal to these expansive terrains. Alternatively they contrasted north and south, arctic ice and volcanic heat, light and dark, earth and sun, liquid and solid in a series of visual extravaganzas. These powerful images celebrated America's golden age of optimism and self-possessed sense of destiny, but with the explosions of the Civil War the fiery twilights and volcanoes also seemed to bear the resonances of a national apocalypse. This particular painting is a later recapitulation of earlier voyages into the South American wilderness, full of precise botanical detail worthy of Ruskin and a central suffusion of sunlight recalling Turner, though finally a hermetic journey as much into the jungle as into the imaginative self.

1877. Oil on canvas, 54⅜ x 84⅛ in. (138.1 x 213.7 cm.)
Gift of the Avalon Foundation, 1965

Frederic Edwin Church
Magdalena River, New Granada, Ecuador, 1853
Pencil touched with white, tan wash
on ivory wove paper
7½ x 10¹¹/₁₆ in. (17.9 x 27.2 cm.)
John Davis Hatch Collection

35 Ralph A. Blakelock
The Artist's Garden

A brooding, tormented individual, Blakelock brought to his art an air of melancholy contemplation. His mature style is known for its rough impastos and looming trees silhouetted against a glowing twilight or moonlight radiance. Usually these were interior visions cultivated by the imagination and colored by the poetry of meditation. Blakelock laboriously built up his pictures by layering his pigments on the canvas and allowing his dark blues, greens, and yellows to shimmer through to the surface, with often quite sensuous and abstract effects. In this relatively early work he seems to have caught more topographical details than usual, though we come to sense that his literal physical garden is but another location for inner reverie. The bright dabs of color acquire a vibrant pattern of their own, the buildings are swallowed within the rich foliage and dark shadows of surrounding trees, and the perspective lines of the garden appear to rush forcefully into the picture's center. These accentuations of reality curiously parallel the similar landscapes of Van Gogh's early painting years. Financial difficulties led to Blakelock's mental breakdown at the end of the century, and ironically while he was confined in a hospital his seemingly simple personal style encouraged widespread forgery of his work. But his finest pure images radiate with a jewel-like glow of color, rich traceries of brushwork, and the evocative aura of a true romantic.

c. 1880. Oil on canvas, 16 x 24 in. (40.7 x 61 cm.)
Gift of Chester Dale, 1954

36 Albert P. Ryder

Siegfried and the Rhine Maidens

Ryder is perhaps America's best known and most original visionary, parallel in his introspection, expressive brushwork and color, and near-abstract patterns to the mature Post-Impressionism of Gauguin and Van Gogh. The National Gallery has two Ryders in its collection: the first is an early pastoral landscape, *Mending the Harness* of about 1875. In contrast to that painting's paler golden tonalities, the richly painted *Siegfried and the Rhine Maidens* is characteristic of the darker greens and intense yellows of Ryder's later moonlight marines. It is a relatively small picture, intimate in scale and feeling, inviting the eye and mind of the viewer into its internal rhythms. Ryder loved mythology, classical literature and drama, epic poetry, and the great romantic operas. From these he drew his themes, not literal transcriptions of particular narratives or passages, but the evocations and resonances they inspired in his imagination. It was the magic and mystery in the stories of the Bible, the emotional response to a musical performance of Wagner, which deeply stirred him. Ryder often walked the streets of New York at night, and he several times crossed the Atlantic, to enjoy the experience of moonlight. This sense of recollection and meditation is apparent in his interpretation of Wagner's opera. Here the waving gestures of the maidens partake of the larger undulating patterns of the trees and clouds, all fused in the performance of a visual symphony.

Albert P. Ryder, *Mending the Harness*, c. 1875
Oil on canvas, 19 x 22½ in. (48.4 x 57.2 cm.)
Gift of Sam A. Lewisohn, 1951

1888/91. Oil on canvas, 19⅞ x 20½ in. (50.5 x 52 cm.)
Andrew W. Mellon Collection, 1946

37 Winslow Homer
Breezing Up (A Fair Wind)

Originally known as *A Fair Wind*, this is one of the most familiar and appealing images in the history of American art. Painted by one of our greatest artists, it culminates his early maturity, summarizing those themes so often favored both in Homer's own career and in the native tradition as well—the love of youth, sport and exercise, and the out-of-doors. The bright colors, vigorous brushwork, animated silhouettes of the figures, and strong diagonal forms all contribute to the lively sense of the subject. The open cockpit close to us invites our participation in the enjoyment of this exhilarating fair-weather moment, while the presence of another larger sailboat on a parallel course in the right background strengthens the visual feeling of motion. Homer is represented in the National Gallery at his best with this key work, along with three other oils, nearly two dozen fresh watercolors from all periods of his career, and several drawings of equal variety and interest. Among the latter, in the gift of John Davis Hatch, is the artist's pencil drawing of *Breezing Up*, done following the oil in preparation for its use as a magazine illustration. The painting maintains its special attraction, however, as an embodiment of American notions of promise and well-being, so prevalent in the genre tradition of mid-nineteenth-century painting. Yet there is an important underlying aspect of thoughtful seriousness here, too, seen in the faces which individually contemplate their separate portions of the horizon.

1876. Oil on canvas, 24⅛ x 38⅛ in. (61.5 x 97 cm.)
Gift of the W. L. and May T. Mellon Foundation, 1943

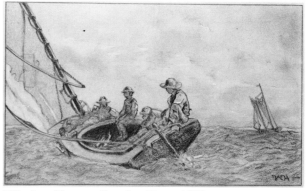

Winslow Homer, *Breezing Up,* c. 1879
Pencil highlighted with black crayon and white chalk on buff wove paper
9½ x 13³/₁₆ in. (24 x 33.5 cm.)
John Davis Hatch Collection

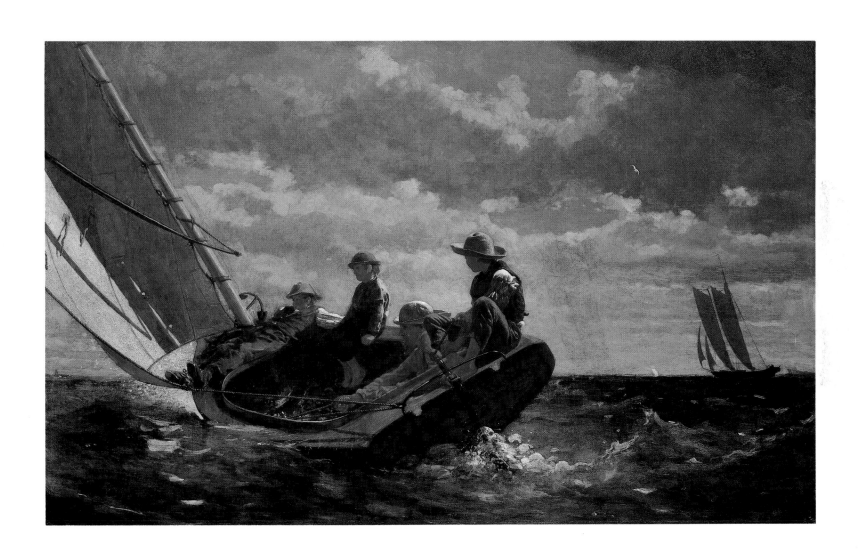

38 Winslow Homer
Autumn

The 1870s was an especially critical decade in Homer's work, for during those years he became a firmly established mature artist, leaving behind a profession as magazine engraving illustrator. He continued to draw as well as paint in oil with increasing facility and command, but in this period he also took up the challenging new medium of watercolor. Now in mid-career as well as mid-life, he began to move from subjects of youth, leisure, and games to those of older individuals in quieter moods and more contemplative poses. *Autumn* is from a sequence of pictures showing figures caught partway between the specificity of portraiture and the more generalized embodiment of feeling. Obviously a particular person posed for it in a richly detailed Victorian dress, yet by its title it also conveys the broader textures of a tone poem.

Unlike earlier paintings of autumn foliage by American landscape painters in the first half of the nineteenth century, for whom the brilliant turning leaves were signals of nature's force and the grandeur of the national wilderness, one feels here not a fiery celebration but rather a somber reserve and mood of pensive self-awareness. Not just the russet leaves and brown woodland path, but also the woman's dark dress and hat mark a turn in American art and architecture to earth colors and textures during the last quarter of the century, known as the Brown Decades. The woman pauses in her walk, gathering sprigs of foliage, her gaze fixed on us as if her train of thought had been interrupted, though the occasion remains private and impassive. What is relatively new for Homer is the attention both to the weighty physical world and to some inner psychological presence. The isolated figure stands still and statuesque, withdrawn in the closure of mind as much as of forest. One of the first to be so depicted in Homer's art, this woman as individual and as type anticipates the strong physical images to follow in his Cullercoats period and the grave human characters engaged in the great natural dramas of his later career.

Winslow Homer, *Mending the Nets*, 1882
Watercolor and gouache over graphite,
27⅜ x 19¼ in. (69.5 x 48.9 cm.)
Bequest of Julia B. Engel, 1984

1877. Oil on canvas, 38¼ x 24³⁄₁₆ in. (97.1 x 58.6 cm.)
Collection of Mr. and Mrs. Paul Mellon, 1985

39 Winslow Homer
Right and Left

The culminating achievement of Homer's career (the second to last work completed before his death a year later), this powerful and subtly disturbing painting is possibly the greatest American work in the National Gallery's collection. At first glance its quiet restrained coloring and its ordinary subject taken from nature suggest the unassuming world of the sportsman or naturalist. Yet further looking makes us realize this is both a landscape and a frozen still life, in which these humble creatures were stopped in time, at the instant a shotgun blast in the left distance was fired. Uncomfortably, we view the subject from the disquieting vantage point of the birds in the foreground, an unstable, turbulent area of water and air. The title is one given by a viewer at the painting's first showing and refers to shooting two birds successively with the separate barrels of the gun. In fact, we cannot tell which shot from the huntsman's gun has gone off and which, if either, of these ducks has been hit. Scholars have argued about whether one of the birds is responding to the shock of death. More provocatively, it would seem we are witnessing that intense moment *between* the blast and its strike, that is, the pivotal moment between life and death. The almost abstract patterns of the birds' sharp silhouettes against the flattened space suggest various precedents with which Homer might have been familiar: Muybridge's photography, Audubon's *Birds of America* series, Japanese prints. But he makes the vision original by carrying us from the momentary to the timeless, and by compelling us to ponder the very nature of mortality itself.

1909. Oil on canvas, 28¼ x 48⅜ in. (71.8 x 122.9 cm.)
Gift of the Avalon Foundation, 1951

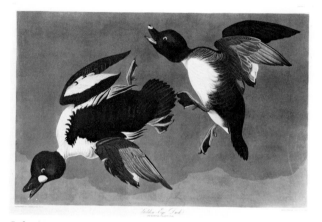

John James Audubon, *Golden-Eye Duck (Fuligula Clangula)*, 1836
Engraving, mezzotint, and hand coloring
21³/₁₆ x 30⅜ in. (53.8 x 77.2 cm.)
Gift of Mrs. Walter B. James, 1945

124

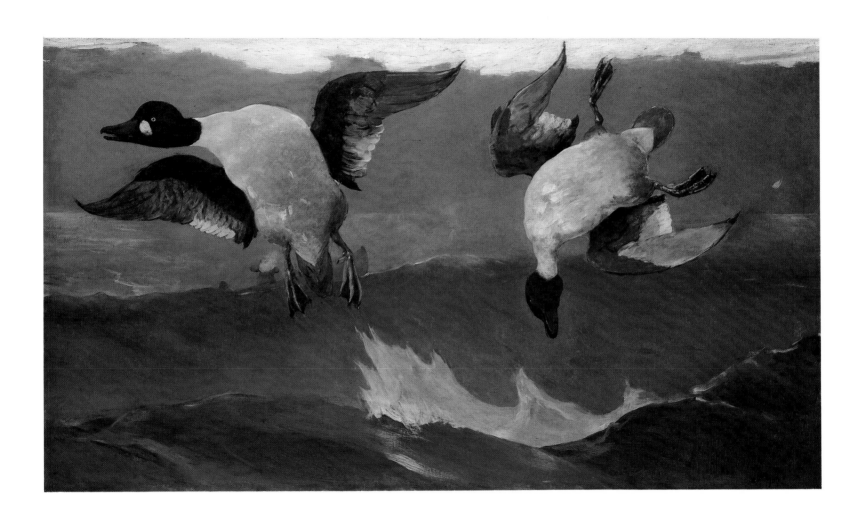

40 William Michael Harnett
My Gems

Harnett's world takes us into high Victorian America, the Brown Decades after the Civil War so named by Lewis Mumford for the dark, massive architecture, the somber tonalities of later nineteenth-century realist painting, and the often brooding mood of intellectual thought in that period. In this still life we are present in an environment of material possessions, the gathered acquisitions of the wealthy, the stuffs and textures of a comfortable man's library. A Philadelphian, Harnett received his early artistic training at the Pennsylvania Academy of the Fine Arts, and his first paintings of tabletop arrangements (usually pipes, mugs, and newspapers) owe a debt to the local still-life traditions set by the prolific Peale family. After establishing his technical abilities and a solid reputation at home, he left to work in Munich during the mid-1880s. Partly responding to the more polished and refined style of German painting, his work of this period and after becomes more jewel-like in its tightness of scale, meticulously finished surfaces, and air of precious artifice. This is one of several variants: a larger later composition completed after Harnett's return to New York is now in the collection of the White House, and substitutes a current copy of *The Cincinnati Inquirer* for the sheet of French music here. At his best Harnett is incomparable in his technical dexterity of intricately modulated brushwork and exquisite rendering of varied juxtaposed forms.

1888. Oil on wood, 18 x 14 in. (45.7 x 35.5 cm.)
Gift of the Avalon Foundation, 1957

William Michael Harnett, *A Sprig of Plums*, 1873
Pencil and charcoal, 13¼ x 9 in. (33.5 x 23 cm.)
Collection of Mr. and Mrs. Paul Mellon, 1985

41 John Frederick Peto
The Old Violin

Peto was a fellow student and early follower of his better known colleague in Philadelphia, William Michael Harnett. Both were at the Pennsylvania Academy of the Fine Arts in the 1870s, and doubtless were familiar with the still-life precedents of tabletop compositions by various members of the Peale family at the beginning of the nineteenth century. By mid-century painters like John F. Francis and Severin Roesen had come to prominence with luscious and effulgent arrangements of foods and flowers, symbols of nature's promise and by extension America's sense of its own self-fulfillment in these years. In contrast, Peto's generation was conscious of a more somber and introspective world coping with the aftermath of the Civil War's turmoil, the uneasy intrusions of technology, and the challenges of regionalism to the country's earlier beliefs in youthful union. Peto at first derived his formulas of pipes and mugs from Harnett's polished examples, but by the 1880s was moving towards a more personal style and subject matter of looser brushwork, rich colors, evocative lighting, and forms subject to deteriorations of aging. Like Harnett, he delighted in essaying illusionistic arrangements in shallow spaces, a popular tradition in American painting from the Peales onward. The violin was a favorite theme in Peto's later work: in the first place it possessed a purity of formal shaping which appealed to his love of abstract design, but equally it served for him as a metaphor of a sister art, another agent of creative power capable of artistic expression even as it is subject to the erosions of time's passage. Such a vision profoundly and eloquently speaks of the anxious, elegiac imagination in America facing the threshold of the twentieth century.

c. 1890. Oil on canvas, 30⅜ x 22⅞ in. (77.2 x 58.1 cm.)
Gift of the Avalon Foundation, 1974

42 Thomas Eakins
Baby at Play

Painted about the same time that Eakins was working on his most famous and monumental canvas, *The Gross Clinic*, this more intimate picture of his niece playing in the family backyard is a comparable essay in human concentration. Recent scholarship has even argued that the artist may have consciously intended the two paintings to be related. Like the great medical picture, this also focuses on a central single individual (here surrounded by toys rather than colleagues). Both forehead and hands stand out under strong illumination, stressing the formal and conceptual linking of brain and body in concert, of intelligence joined purposefully to physical action. But where the group portrait with Dr. Gross presents the culmination of life's wisdom and experience in a stance of self-confident authority, *Baby at Play* gives us the emergence of human consciousness and learning, the hesitant yet assured gestures of testing order and organization. Both the lettered and building blocks hint of the basic languages of words, mathematics, and architecture, a child's world of imagination full of promise and realization.

The dark enclosed planes of the bricked garden and the ground level vantage point suit well the private introspective stance of a young child preoccupied in the first stages of understanding the surrounding physical world. Her horizons of discovery are still nearby and literally at hand, although the sense of tension in the carefully balanced body, the force of gaze and care of hand in holding the block all testify to the potentials of human will and awareness. As with all Eakins's best work, we have the literal textures, colors, and surfaces of the present world meticulously recorded with his closest scrutiny, at the same time that he invests the seemingly simplest subjects with an almost psychological power and deep intensity of feeling. Tenderly and gently, Eakins portrays this small figure, no less than an adult, seeking to fix a place in her universe.

1876. Oil on canvas, 32¼ x 48⅜ in. (81.9 x 122.8 cm.)
John Hay Whitney Collection, 1982

Left:
Thomas Eakins, *Study for "Negro Boy Dancing": The Banjo Player*, c. 1878
Oil on canvas mounted on cardboard, 20 x 15¼ in. (50.8 x 38.7 cm.)
Collection of Mr. and Mrs. Paul Mellon, 1985

Right:
Thomas Eakins, *Study for "Negro Boy Dancing": The Boy*, c. 1878
Oil on canvas, 21 x 9⅛ in. (53.3 x 23.2 cm.)
Collection of Mr. and Mrs. Paul Mellon, 1985

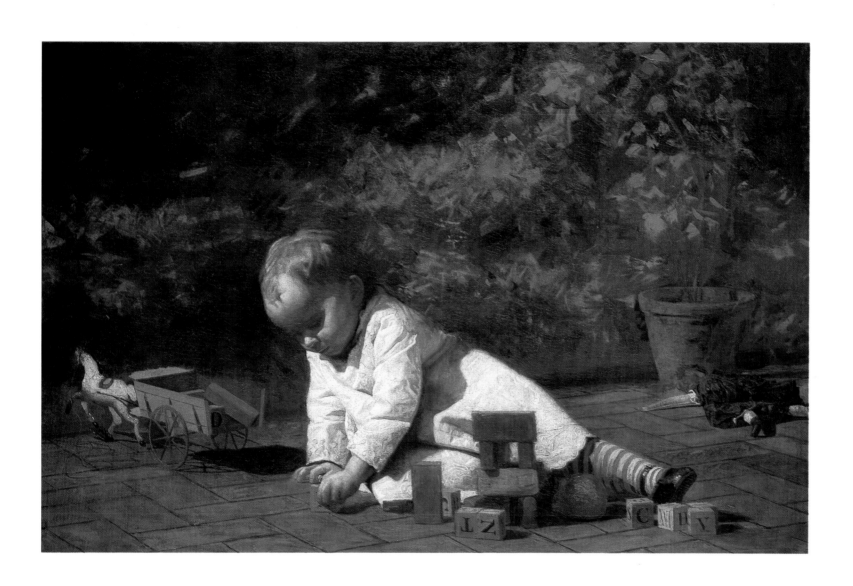

43 Thomas Eakins
The Biglin Brothers Racing

After returning from his academic training under Gérôme in Paris, and his study of the seventeenth-century Spanish and Dutch masters in Madrid, Eakins began his mature career in Philadelphia with two interrelated series of pictures. One was a group of interiors showing his sisters in darkened corners of rooms, often at the piano. Complementing these was a series of outdoor sculling pictures depicting many of his rowing companions, painted along the Schuylkill River in warm sunlight. The construction of these works was based on elaborate perspective drawings and careful anatomical scrutiny of the human figure. In them Eakins fused his deep interests in the various branches of the sciences, including mathematics, perspective, and medicine, with the practice of his art. The cropping of the sculls here at the canvas's lower edges and the sense of the men caught in a stopped-action moment of their stroke suggest a proto-photographic vision. And Eakins was indeed to make important use of the camera by the next decade, both for study purposes and for aesthetic images in their own right. Here the crafts of art and science join in examining a world of man and nature defined by order, harmony, and organic unity. Beyond the celebration of self-discipline, control, and glowing achievement, we also become aware of the poignance of things in passage—the golden light of the day and season, the river and the boats each gliding at their own pace, and the men caught at a vigorous moment in the human aging process.

1873. Oil on canvas, 24⅛ x 36⅛ in. (61.2 x 91.6 cm.)
Gift of Mr. and Mrs. Cornelius Vanderbilt Whitney, 1953

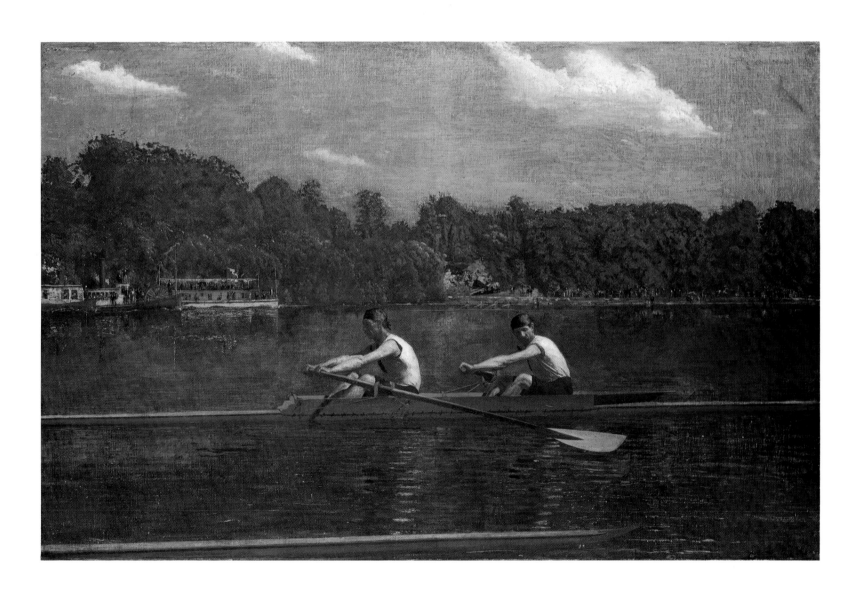

44 Thomas Eakins

Archbishop Diomede Falconio

As a consequence of a number of factors—among them the critical and public rejection of his most ambitious medical pictures, his forced resignation from an influential teaching position at the Pennsylvania Academy, and the sequential deaths of several close friends and family members—Eakins increasingly turned in his later years to portraiture of single figures in isolation. These brooding, incisive, and uncompromising images are perhaps the greatest and most compelling faces painted in the history of American art, the natural culmination of Eakins's own career, and worthy of the seventeenth-century masters Rembrandt and Velázquez, whom he so much admired. The National Gallery also owns a fine group of smaller bust-format portraits of the Husson family, but it is in the grand and haunting canvas of *Archbishop Diomede Falconio* that we see the essence of Eakins's strongest achievement.

Almost like an ancient Egyptian ruler or Greek philosopher, Falconio sits enthroned, as much an imposing physical presence as a timeless spiritual force. As Eakins turned increasingly inward, he sought to examine the nature of humanity, his own and others', to probe and weigh the balances of our possibilities along with our frailties, our promise and our failure, our self-possession and self-understanding. To this end he frequently turned after 1900 to portraying fellow creative spirits—other artists, musicians, scientists, and writers. Appropriately among the priests of the Catholic Overbrook Seminary in Philadelphia he found a group of individuals whose presence inspired him to reveal the most profound spiritual truths of our humanity.

1905. Oil on canvas, 72⅛ x 54¼ in. (183.2 x 137.7 cm.)
Gift of Stephen C. Clark, 1946

Thomas Eakins. All oil on canvas
Top: Louis Husson, 1899. 24 x 20 in. (61 x 50.9 cm.)
Gift of Katharine Husson Horstick, 1956
Center: Mrs. Louis Husson, c. 1905. 24 x 20 in. (61.1 x 50.9 cm.)
Gift of Katharine Husson Horstick, 1956
Bottom: Harriet Husson Carville, 1904. 20⅛ x 16 in. (51.2 x 40.5 cm.)
Gift of Elizabeth O. Carville, 1976

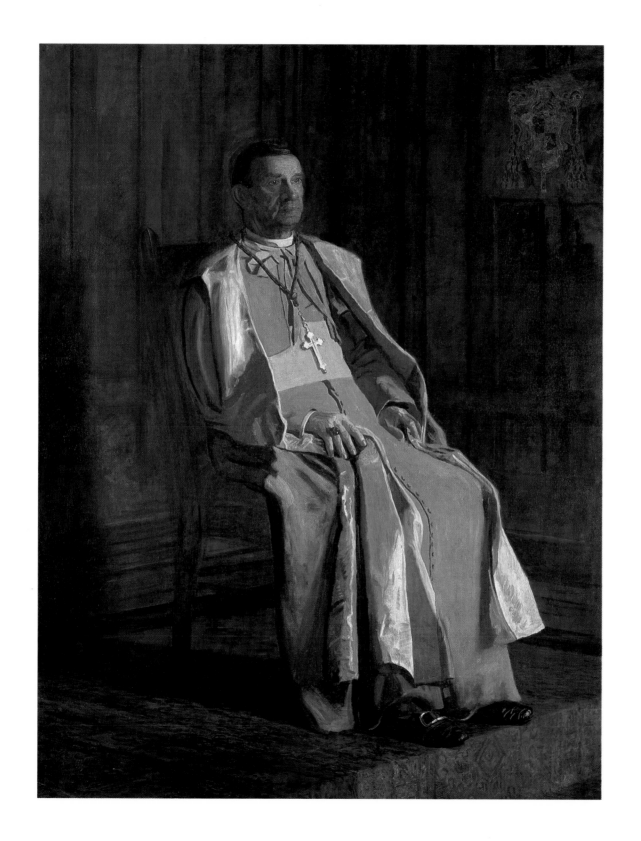

45 John Singer Sargent
Mrs. Adrian Iselin

The National Gallery's Sargent holdings include exemplary water-colors and drawings and eight oil paintings, among which are a half-dozen full-length portraits from various moments of his career. The earliest and strongest of these is the portrait of Mrs. Iselin, painted four years after the notorious image of *Madame X* (now in The Metropolitan Museum of Art) and bearing something of the same austerity of pose and composition. Although without the provocative décolletage and profile of Madame Gautreau, Mrs. Iselin similarly stands with her outstretched arm resting on a table, her other hand clutching a fan, and she poses in a black dress sharply silhouetted against a blank background. The artist's friend Henry James praised these earlier portraits of Sargent for their force and daring, but worried that the painter had nowhere to go to surpass himself, "that he perhaps does not fear energies quite enough." Indeed here we sense Sargent confronting the strong personal energy and character of Mrs. Iselin. His spare design, economic handling of detail, and utterly confident brushwork convey powerfully not only the selected physical details but also an intimation of psychological presence. Much of this evaporates later in Sargent's fashionable and flattering images of international aristocratic society, as he relied increasingly on his dashing technical bravura to capture the elegant textures of clothing, furniture, and a world of surfaces.

1888. Oil on canvas, 60½ x 36⅝ in. (153.7 x 93 cm.)
Gift of Ernest Iselin, 1964

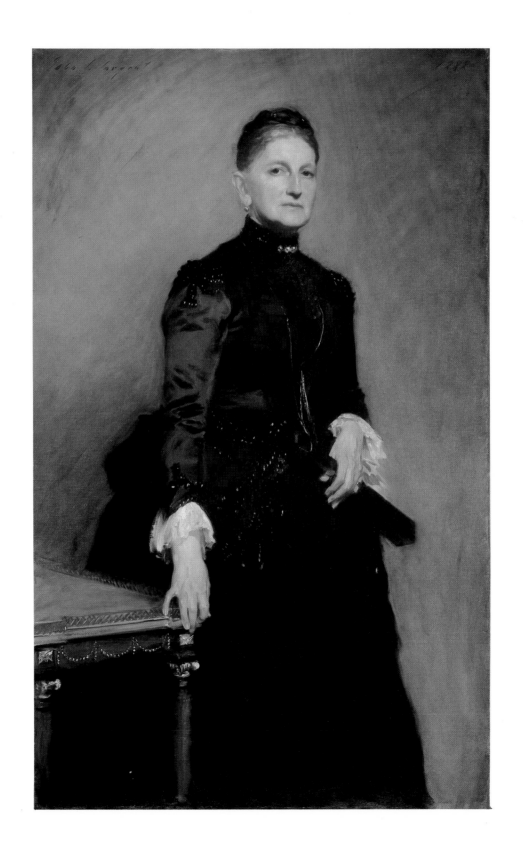

46 John Singer Sargent
Repose

Sargent's later portraits often appear to be dazzling and dexterous tours de force of paint handling, but shallow in intellectual content and significance. On a more intimate scale reserved for genre works, however, he was capable of fusing sensuous effects of brushwork with images of striking feeling. Sometimes in scenes of back streets, partially darkened corners of architecture, or quiet sections of rooms he could capture evocative effects of light and shadow-laden atmosphere, and figures caught up in inner reveries. *Repose* is just such an example that seems to embody a lingering fin-de-siècle mood of languor, elegant indulgence, and brooding calm. As in his best watercolors, Sargent handled pigment and stroke with unequalled dash, here creating a symphonic play of flowing brushwork and creamy yellow colors which acquire an almost abstract life of their own. We are witness to that late Victorian world of stuffs and textures, of fashionable possessions and comfortable surroundings, of material well-being and leisure. Sargent's style of broad brushstrokes and dramatic tonal contrasts is partially indebted to such Spanish seventeenth-century masters as Velázquez, whose style he studied in Paris under Carolus-Duran and then firsthand in 1879 on a visit to the Prado. This was in fact an international style adapted by many of Sargent's own American contemporaries, including realists like Thomas Eakins and Winslow Homer, but to different personal and aesthetic ends.

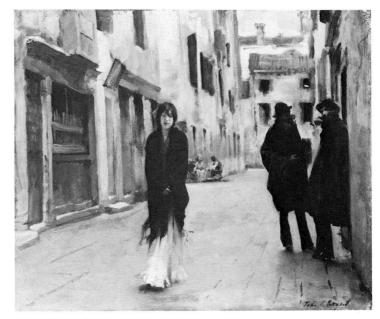

John Singer Sargent, *Street in Venice*, 1882
Oil on wood, 17¾ x 21¼ in. (45.1 x 53.9 cm.)
Gift of the Avalon Foundation, 1962

1911. Oil on canvas, 25⅛ x 30 in. (63.8 x 76.2 cm.)
Gift of Curt H. Reisinger, 1948

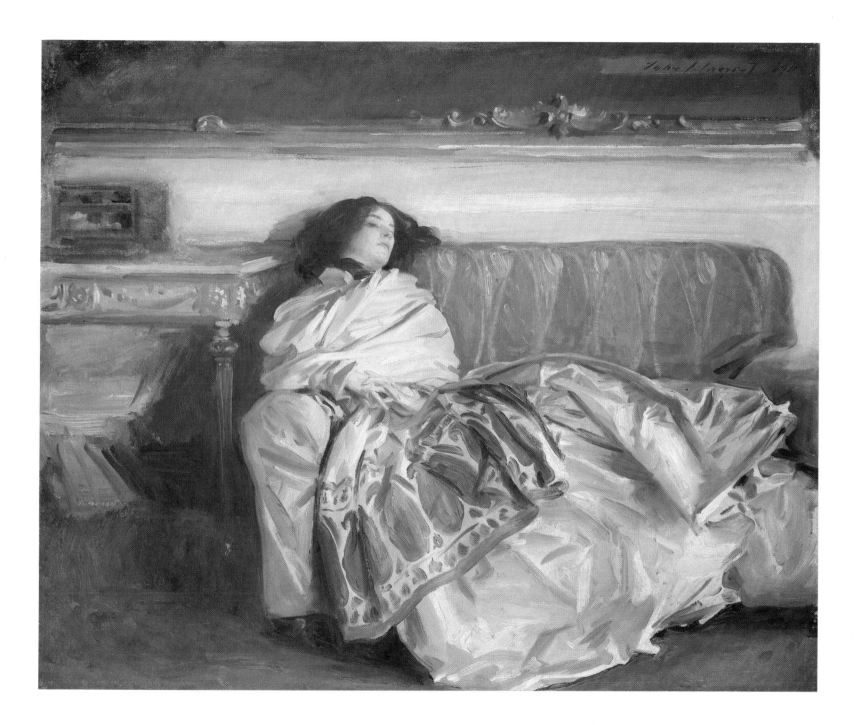

47 James McNeill Whistler
Wapping on Thames

Whistler's early training as an engraver and illustrator led him to master the essentials of drawing and of understanding forms in terms of light and dark. Those fundamentals are evident in his paintings as well, from the first major oils onward. An international artist for most of his life, Whistler left his native America in 1855 for Paris, where he came into critical contact with the new work of Courbet and Manet among others of the French avant-garde. After five years he settled in London, and this subject is one of his first major accomplishments there. The complexity of its myriad details, especially of overlapping lines and silhouettes, and the dense articulation of spatial recession—all handled with clarity and visual interest—testify to his strong graphic training. Indeed, at this same time he also undertook his first major group of etchings devoted to London river scenes, known as the Thames set. At the center of the composition is his red-headed mistress, Joanna Heffernan, who would also pose as his model for the notorious *White Girl*. Whistler's creamy brushwork and sense of spontaneous observation owe much to recent French art, and in particular, his orchestration of whites and blacks appears to recall a number of Courbet's landscapes, while the group of foreground figures vaguely parallels Manet's grouping of companions in the *Déjeuner sur l'herbe*. Whistler shared with many of his contemporaries the interest in recording the energies of current daily life, and in composing both foreground and distant forms cropped by the framing edges. Such devices created a feeling of immediacy as well as a dynamic picture design.

The Gallery has long been strong in its Whistler holdings, owning a number of important later portraits and a broad sampling of his best graphic work. But this picture added a significant new subject of his early maturity to the collections, when it came as a gift in 1982 from the late John Hay Whitney.

1860/64. Oil on canvas, 28½ x 40¼ in. (72.3 x 102.2 cm.)
John Hay Whitney Collection, 1982

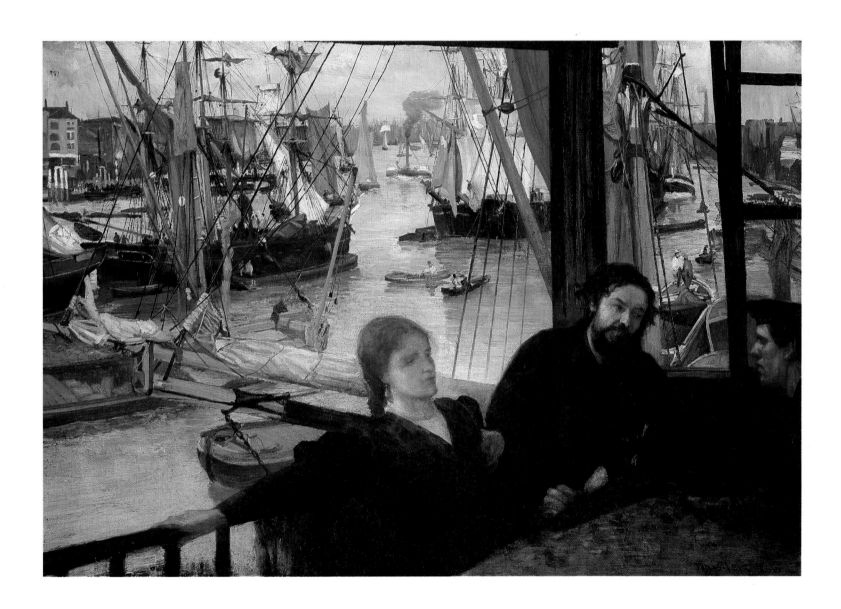

48 James McNeill Whistler
The White Girl: Symphony in White, No. 1

Certainly one of the most sensational paintings of its time, this work has remained a famous image in the history of both American and modern art. Whistler added the subtitle six years after finishing and exhibiting the canvas to draw attention to its independent and expressive aesthetic qualities analogous to the rhythms and harmonies of music. His mistress Joanna Heffernan was the model here as well as in many related paintings executed in this decade. Like his fellow expatriate John Singer Sargent, Whistler admired the precedents of Velázquez's bold full-length portraits and carefully designed interior arrangements. But Whistler's languid figure with her melancholy air and floral details is also close to the allegorical meditations of his English Pre-Raphaelite colleagues. Doubtless the lily in Jo's hand, the floral carpet, and bear rug underfoot, along with the predominant whites, carried allusions to sexuality and virginity. Such aspects of emotional content as well as the purely formal concerns with color and design for their own sake made the picture a cause célèbre from the beginning. Rejected first by the Royal Academy in 1862, and then by the Paris Salon the next year, it gained more notoriety than Manet's *Déjeuner sur l'herbe* in the 1863 Salon des Réfusés. Its striking modernism of near abstract color and subjective content, however, immediately found sympathetic praise from the French avant-garde, who recognized this as one of the first modern images making art its own subject.

1862. Oil on canvas, 84½ x 42½ in. (214.7 x 108 cm.)
Harris Whittemore Collection, 1943

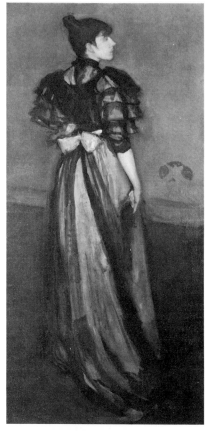

James McNeill Whistler, *L'Andalouse, Mother-of-Pearl and Silver*, c. 1894
Oil on canvas, 75⅜ x 35⅜ in.
(191.5 x 90 cm.)
Harris Whittemore Collection, 1943

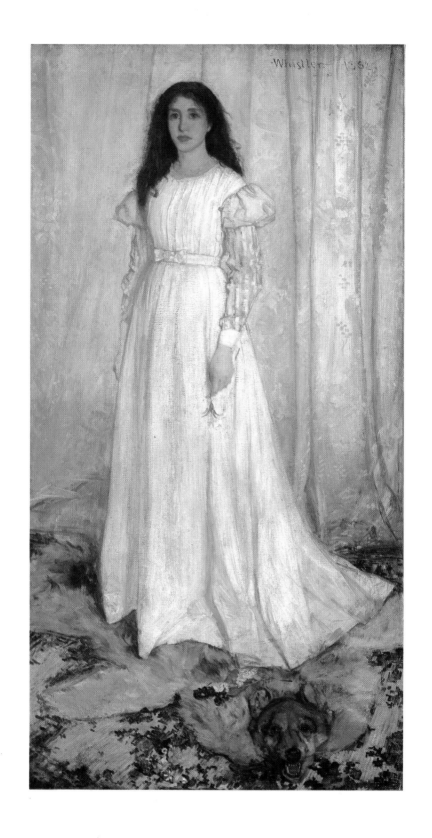

49 Thomas Wilmer Dewing
Lady with a Lute

This mysterious and suggestive painting is one of the first painted by Dewing on the theme of music, a theme he treated many times again in subsequent years. Conscious of Whistler's stark and controversial figure portraits in profile painted in 1872, and in turn indebted to the clear arrangements of figures in interiors by Vermeer, Dewing placed his woman in an abstracted space of textured shadows and pregnant silence. Like Whistler's harmonies, symphonies, and nocturnes, this too is a purely formal study of color, in the varied nuances of dark greens, and of shapes, notably the repeated bulging curves of bosom and lute. The result is a fusion of undercurrents: the physical sense of implicit sexuality and eroticism and an emotional sense of reverie and meditation. Parallel to the jewel-like still-life compositions being painted by William Harnett in the same years, this is an almost hermetic contemplation on the nature of objects, their sensuous surfaces, their formal properties of line and contour, and their inner life.

The fascination with musical instruments was especially strong for numerous American artists at the end of the nineteenth century, when music became a larger metaphor for art, and instruments could be seen as agents not just of a sister muse but of the entire creative impulse. Thomas Eakins often painted individuals playing the piano, violin, or cello; and John F. Peto's still life of *The Old Violin* (Plate 41) in the National Gallery's collection demonstrates a similar aesthetic and formal concern on his part.

1886. Oil on wood, 20 x 15 in. (50.8 x 38.1 cm.)
Gift of Dr. and Mrs. Walter Timme, 1978

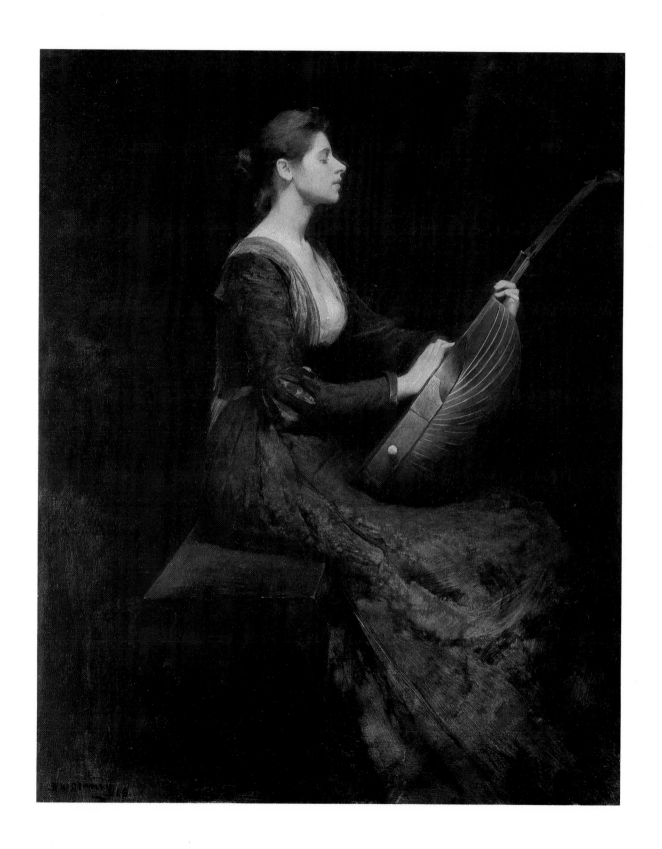

50 Mary Cassatt
Little Girl in a Blue Armchair

To an already strong and broad collection of works by Mary Cassatt, thanks to the generosity of Chester Dale and Ailsa Mellon Bruce, two more important oils were added by Mr. and Mrs. Paul Mellon. On the occasion of Mr. Mellon's retirement as Chairman of the Gallery's Board of Trustees in 1983, he announced this major gift which totaled nearly one hundred French, English, and American works, including another Cassatt, *Child in a Straw Hat*, c. 1886. Both are beguiling images of children and special for their immediate sense of character. Both exploit limited ranges of color—tans and grays in the later picture, blue-greens in this—as well as a clear silhouetting of the figure to bring out the idiosyncrasies of mood and personality. *Blue Armchair* was one of Cassatt's first truly original and memorable achievements, so striking that it was rejected for the Paris Exposition of 1878.

A relatively early work done in Paris after the artist had met Degas, this shows evidence of his influence, and even of his hand in the finishing of the background. French artists generally at the time, and Degas in particular, were responding to the strong design effects of Japanese prints, especially their compressed angles of vision, colorful patterning, and cropping of views. These devices are all put to expressive results here; for example, the low viewpoint, the cutting off of all the armchairs, and the play of active versus empty color areas. Most reminiscent of Degas in this composition is the tilted narrowing of space into the background, marked by the bright French windows, similar to his dance-floor paintings of this period. Close as it is to his work, however, its charm and wit are very much Cassatt's own manner, not as somber or serious, perhaps, as the psychological penetration often found in his portraits. These two Mellon Cassatts bring to the Gallery extremely unusual examples of her art, unlike any of the others in the collection.

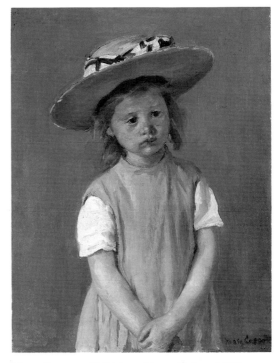

Mary Cassatt, *Child in a Straw Hat*, c. 1886
Oil on canvas, 25¾ x 19½ in. (65.3 x 49.5 cm.)
Collection of Mr. and Mrs. Paul Mellon, 1983

1878. Oil on canvas, 35¼ x 51⅛ in. (89.5 x 129.8 cm.)
Collection of Mr. and Mrs. Paul Mellon, 1983

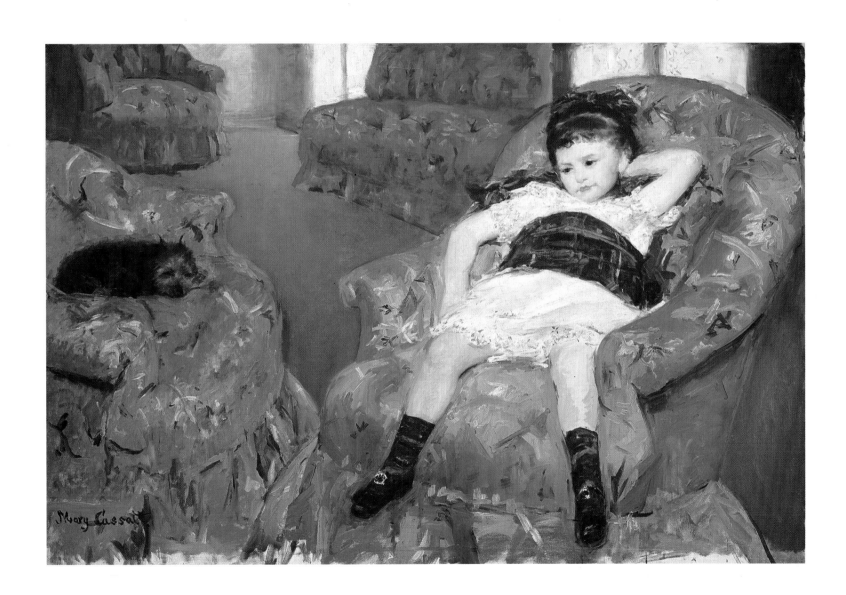

51 Mary Cassatt
Miss Mary Ellison

This relatively early work by Cassatt has something of the American penchant for palpable realism and solid modeling of volume. As a student she had attended the Pennsylvania Academy of the Fine Arts at the same time Thomas Eakins was enrolled there. Both went abroad contemporaneously, but thereafter pursued divergent careers. Soon falling under the influence of Degas and his French colleagues, Cassatt began to take on the lighter palette, fresher brushwork, and informal vision of the Impressionist mode.

Although Miss Ellison is carefully posed here in a thoughtful gaze, the sketchy treatment of details, the close-up viewpoint, the cropping of forms by the frame, and the play of a mirror image behind are all French in inspiration. The seated figure holding a fan or flower is a motif found in several variations in the Gallery's other works by Cassatt. For her the figure became more than a portrait, but a shape to be placed within a calculated design of rhythmically repeated colors and contours. The device of the mirror, so often employed in French art from Ingres to Picasso, was a favorite element in many of Degas's interiors. It at once defines a surface and makes it ambiguous, playing with the limits of a room and with the viewer's perceptions. Also close to Degas here is the intimation Cassatt gives us of a psychological presence, not a consistent concern with her, but in this image touching in its delicate revelation of feeling.

c. 1880. Oil on canvas, 33½ x 25¾ in. (85 x 65.3 cm.)
Chester Dale Collection, 1962

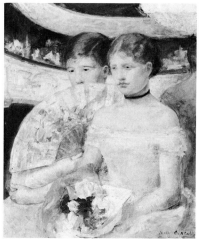

Mary Cassatt, *The Loge,* 1882
Oil on canvas, 31½ x 25⅛ in.
(79.9 x 63.9 cm.)
Chester Dale Collection, 1962

Mary Cassatt, *The Loge,* c. 1882
Pencil, 10⅛ x 8⅛ in.
(39.9 x 22.7 cm.)
Gift of Chester Dale, 1948

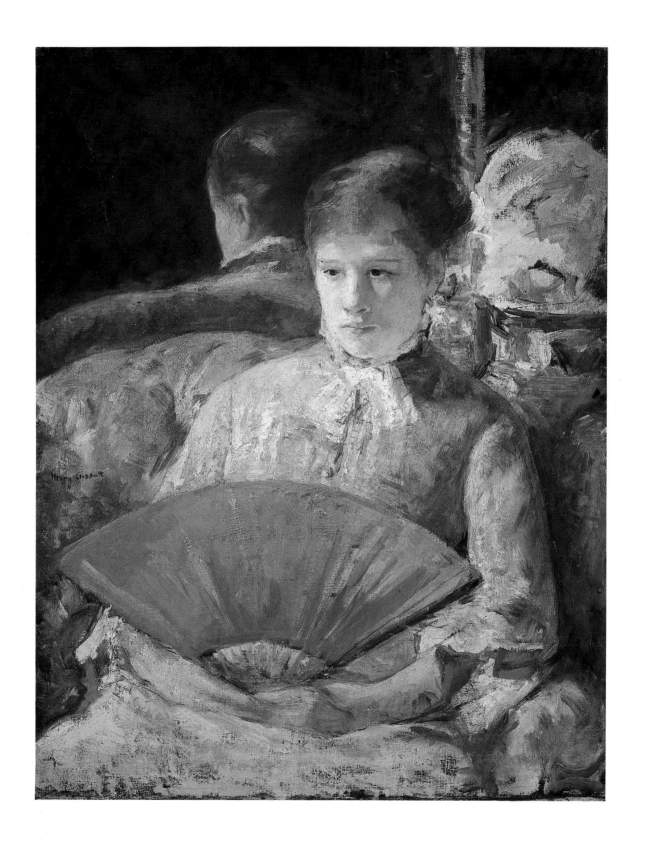

52 Mary Cassatt
The Boating Party

The National Gallery is fortunately strong in its collection of America's greatest woman artist. It holds more than a dozen of her oils dating from about 1880 to 1905, including portraits as well as genre compositions indoors and out. These are complemented by an important group of her graphic achievements: drawings for paintings and for prints, and proofs along with final impressions of her most important aquatints. One of her best known and most original works is this canvas, reminiscent of similar scenes by her French colleagues Manet and Monet. Along with Whistler and Sargent, Cassatt established herself in Paris as one of America's foremost expatriate painters, and gained unprecedented acceptance within the major circle of Impressionists. She exhibited with them at their Salon des Indépendants on several occasions, and was a close friend of Edgar Degas, whose idiosyncratic interest in the human figure (in contrast to the preference for landscape of the other Impressionists) carried over to her own work.

In this particular composition Cassatt achieved an especially bold framing of the figures by means of the high horizon, close-up vantage point, and strong simplified zones of color. Rather than the broken colors and quick strokes of classic Impressionism, she worked with solid patterns and broad complementaries of yellow and blue as well as white and black. She nonetheless created a sense both of intimacy in the compact domestic grouping and of immediacy in the cropped edges and foreshortened forms.

1893/94. Oil on canvas, 35½ x 46⅛ in. (90.2 x 117.1 cm.)
Chester Dale Collection, 1962

Mary Cassatt, *In the Omnibus
(The Tramway)*, c. 1891
Black crayon, 14⅜ x 10⅝ in.
(36.5 x 27 cm.)
Rosenwald Collection, 1948

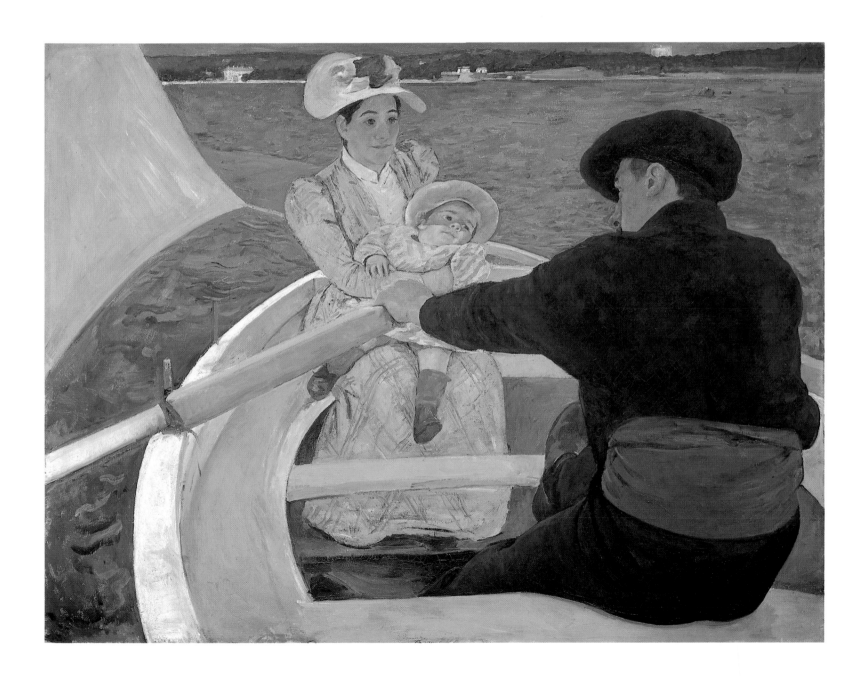

53　William Merritt Chase
A Friendly Call

One of Chase's finest performances and a summary work of American impressionism, this painting is an almost paradoxical fusion of delicate touch and strong design, of casual fashionableness and formal complexity, of ordinary genre and highly subtle aestheticism. It has supporting echoes in other contemporaneous works belonging to the National Gallery, for example, Frank W. Benson's *Portrait in White* and Edmund Tarbell's *Mother and Mary*. But Chase's canvas possesses a surpassing richness of effect. On one level it is a composition of engaging formal ingenuity: the whole is a sequence of repeated rectangles, most notable in the frames and hangings behind the figures, but these become enriched by our awareness of three-dimensional space, described by the floor of the room. Further spatial recession is allowed by the mirror, giving us a glimpse of the room behind us, and in turn by the windows and door we see indirectly, which open to other spaces yet beyond. Of course, on another level this is an affectionate rendering of fin-de-siècle social discourse and fashion, of casual conversation among friends in the rooms of the artist's New York studio. It may be distantly indebted to Velázquez's *Las Meninas*, which Chase and many of his contemporaries admired, and more immediately to his friend Sargent's *Daughters of Edward Darley Boit* (Museum of Fine Arts, Boston). Both were inventively constructed spatial interiors. But Chase's picture, in its studio setting, in its emphasis on works of art all about, and in its playing with our perceptions, ultimately addresses the life of the painter and the life of his art.

1895. Oil on canvas, 30⅛ x 48¼ in. (76.5 x 122.5 cm.)
Gift of Chester Dale, 1943

Frank W. Benson
Portrait in White, 1889
Oil on canvas, 48⅛ x 38¼ in.
(122.2 x 97 cm.)
Gift of Sylvia Benson Lawson, 1977

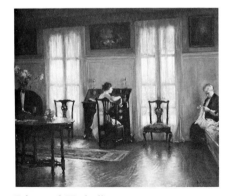

Edmund Tarbell
Mother and Mary, 1922
Oil on canvas, 44⅛ x 50¼ in.
(112.1 x 127.5 cm.)
Gift of the Belcher Collection,
Stoughton, Mass., 1967

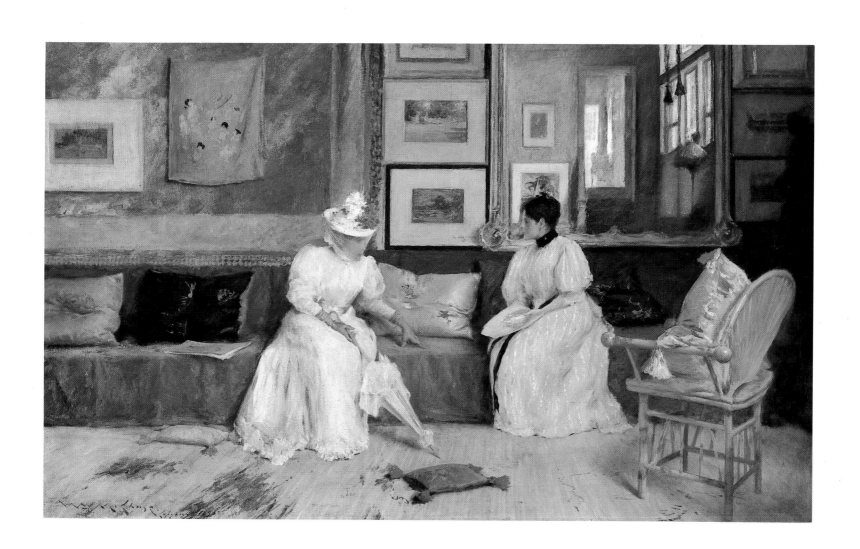

54 Robert Henri
Young Woman in White

One of the special concentrations in the National Gallery is in the works of the Ashcan school at the beginning of the twentieth century, and especially the paintings of the group's leader Robert Henri. Besides this imposing full-length portrait, there are two other portraits and a street scene, *Snow in New York*. Henri was not only one of the foremost practitioners of the new realist style and the natural leader among his colleagues, but he was also one of the ablest and most influential teachers in the history of American art. His style of direct observation and recording derives from the traditions of the Pennsylvania Academy, where he had studied in the 1880s under Eakins's successor Thomas Anshutz. In the Eakins manner Henri also admiringly studied the Baroque precedents of Rembrandt and Hals, as is evident in this starkly illuminated figure against a rich black background. As such, this portrait forms a useful transitional link between the Gallery's portrait group by Whistler and Sargent in an earlier generation and the figural works painted by Henri's associates and younger followers, such as George Luks and George Bellows. As a teacher and writer Henri was less interested than his friends in addressing social or political causes with his art, as this sympathetic yet straightforward portrait suggests. He was not interested so much in advancing or exposing any class of society as he was in investigating such artistic concerns as tonal contrasts and vigorous handling of paint for expressive effect.

1904. Oil on canvas, 78¼ x 38⅛ in. (198.8 x 96.8 cm.)
Gift of Violet Organ, 1949

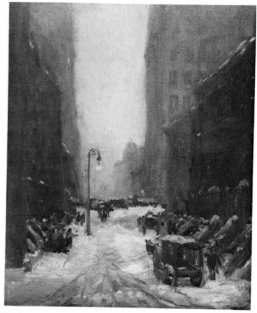

Robert Henri, *Snow in New York*, 1902
Oil on canvas, 32 x 25¾ in.
(81.3 x 65.5 cm.)
Gift of Chester Dale, 1954

55 Henry O. Tanner
The Seine

One of America's most accomplished black artists, and the first to be elected to the National Academy of Design (in 1909), Tanner began his artistic education under Thomas Eakins at the Pennsylvania Academy of the Fine Arts. From his teacher Tanner learned how to look at nature with a fresh objective eye, to sketch directly in paint, and to exploit contrasts in tonality for expressive effects. During the 1890s he went to Paris, spending time as well as working in Brittany. Though he is better known for his later religious works, his realistic portraits and plein-air landscapes are less contrived and sentimental. At some point, it is clear, he came to appreciate the works of Whistler, for his own portrait of his mother in 1897 employed a similar format of the figure seated in profile against a plain background. This small canvas, *The Seine*, likewise makes an appropriate comparison to Whistler's nocturnes painted on the Thames and the Venice lagoon. The soft colors and gauzy silhouettes, the open expanse of water and sky, and the high horizon serving to flatten out the spatial recession are all Whistlerian in character. The abstracted design and poetic mood make this work surprisingly modern in feeling for Tanner. Within the National Gallery's collection of later nineteenth-century scenes by American artists, this takes its stylistic place comfortably between a realist shoreline painting called *The Much Resounding Sea*, by Thomas Moran, and Whistler's purer color study of *Chelsea Wharf: Grey and Silver*.

1902. Oil on canvas, 9 x 13 in. (23 x 32.9 cm.)
Gift of the Avalon Foundation, 1971

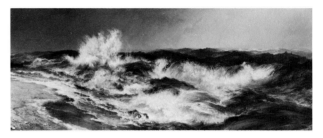

Thomas Moran, *The Much Resounding Sea,* 1884
Oil on canvas, 25 x 62 in. (63.6 x 157.6 cm.)
Gift of the Avalon Foundation, 1967 181

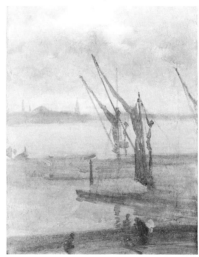

James McNeill Whistler, *Chelsea Wharf: Grey and Silver,* c. 1875
Oil on canvas, 24¼ x 18⅛ in. (61.5 x 46 cm.)
Widener Collection, 1942

56 John Henry Twachtman
Winter Harmony

The group of American impressionist paintings in the National Gallery is small but choice, highlighted by important examples by Chase, Hassam, and Cassatt. One of the most characteristic works of the movement by a central figure is this winter landscape by Twachtman. A student at the Munich academy along with Chase and Duveneck, Twachtman shifted his style in the 1880s from a dark palette of strong contrasts and heavy brushwork towards the softer touch and paler tonalities of Impressionism. Whistler's muted harmonies also had an impact on his later work, as this restrained and poetic picture suggests. Even though this scene appears to dissolve in a gauzy light, it retains an inherent sense of pattern which probably derives from Twachtman's familiarity, respectively, with Japanese prints, the tonal structure of the Munich style, and Whistlerian decorative designs. Yet Twachtman never pushed to extremes of aestheticism or abstraction, preferring to examine nature in its changing phases (winter was a favorite theme) and to contemplate its romantic charms. The whole surface of his canvas is a field of muted colors and sensuous textures which appeal equally for visual, emotional, and tactile reasons. In fact, the subjective quality of Twachtman's painting carries his mature work beyond the surface objectivity and retinal records of pure Impressionism to a more personal and hermetic world.

c. 1900. Oil on canvas, 25¾ x 32 in. (65.3 x 81.2 cm.)
Gift of the Avalon Foundation, 1964.

57 Childe Hassam
Allies Day, May 1917

Hassam matured into one of America's foremost impressionists. He spent a number of years studying and working in France, and familiarized himself fully with the work of his European contemporaries. He adapted many of their techniques successfully to his own subjects: the quick brushwork and broken colors, the sunlit vistas and floral themes, the cropped viewpoints and odd angles of vision suggesting the casual moment. Yet ultimately Hassam retained an underlying American sensibility in his reliance on solidly defined forms and a palette of tonal contrasts that included the dark hues of the color scale.

Hassam's patriotic spirit culminated in a series of canvases actually begun in 1910, when he was inspired by a Bastille Day parade in Paris. After the United States joined European allies in World War I, Hassam turned to the brilliant patterns of the various national flags for his composition in this and some two dozen related paintings. The United States had entered the war in May, and New York's Fifth Avenue was shown decorated with the banners of its allies. The subject had been treated on different occasions by artists as diverse as Monet, Van Gogh, and Dufy. Hassam drew on the successive concerns of French art from the optics of color in late Impressionism to the passion of personal feeling in Post-Impressionism and Fauvism. Joined by a gentle impressionist landscape also in the National Gallery, *Midsummer Twilight* by Willard Metcalf, Hassam's bright image celebrates finally a last moment of optimism even as the twentieth century's first great upheavals were underway.

Willard Metcalf, *Midsummer Twilight*, c. 1885/87
Oil on canvas, 32¼ x 35⅝ in. (81.8 x 90.4 cm.)
Gift of Admiral Neill Phillips in memory of
Grace Hendricks Phillips, 1976

1917. Oil on canvas, 36¾ x 30¼ in. (93.5 x 77 cm.)
Gift of Ethelyn McKinney in memory of her brother Glenn Ford
McKinney, 1943

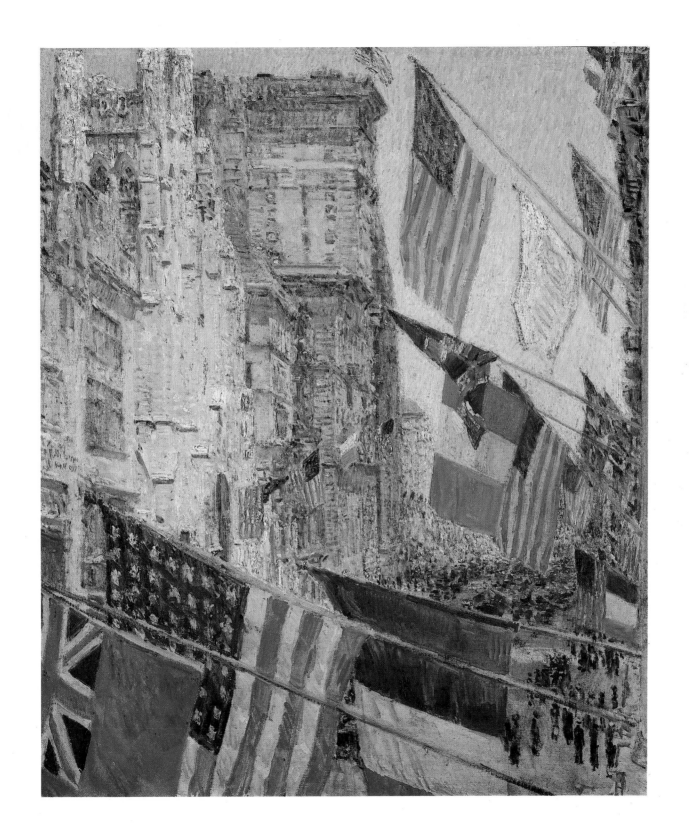

58 George Luks
The Bersaglieri

Although contemporary in date, theme, and handling with Childe Hassam's *Allies Day* (Plate 57), this painting belongs to the spirit of a younger generation. Instead of being grounded in the nostalgic optimism and pastoral tradition of Hassam's impressionist mode, Luks aggressively championed the social causes and urban vision of the Ashcan school. Like another major work by Luks in the Gallery, *The Miner* of 1925, this is large in scale and ambition. With strong colors and thick, broad brushwork it seeks to capture the dynamic forces of industrial civilization in the early twentieth century. The specific scene represented here was a parade of Italian sharpshooters sent to the United States to encourage interest in the Liberty Loan campaign. President Woodrow Wilson led the parade down to Washington Square in New York on October 12, and the following day the *Times* recounted the Italians coming by "at a 'turkey trot', and as it was Italy Day at the Altar of Liberty as well as the anniversary of the discovery of America by Christopher Columbus, the veterans got a double-sized tribute. They were still 'turkey trotting' when they disappeared down the avenue." The company had originated in Sardinia in the middle of the nineteenth century, and some twelve regiments were part of Italy's regular army when she entered World War I in 1915. In this densely packed composition of strong contrasts and powerful rhythms one senses the excitement of a martial spirit and the rush of contemporary events.

1918. Oil on canvas, 40⅛ x 59⅝ in. (101.9 x 151.5 cm.)
Gift of the Avalon Foundation, 1950

59 Maurice Prendergast
Salem Cove

While the National Gallery had long been strong in its American holdings of colonial and late nineteenth-century portraits and of work by the Ashcan school, one period in which it was relatively thin was that of early American modernism from the first half of the twentieth century. That underrepresentation changed significantly with a number of major gifts in the 1980s: a Hopper bequeathed by John Hay Whitney, a dozen key paintings from the estate of Georgia O'Keeffe, the John Marin archives presented by the artist's son, and this Prendergast oil, accompanied at the same time by one of his finest Venetian watercolors. These examples greatly enhance our understanding of the complicated relationships in early modern art between America and Europe. Prendergast's oil is also representative of the artist at his best, in its orchestrated color harmonies, densely worked pigments, and animated surface design.

Although much of his work is associated with Boston, Prendergast did visit Europe in the 1890s, and in France responded warmly to the latest currents of Impressionism and Post-Impressionism. The bright designs and pointillist touch of the Nabis especially stimulated his own variations of similar subjects, and his intimate depictions of young women and children at leisure or play in parks clearly recalled the examples of Bonnard and Vuillard. But Prendergast also traveled to Italy in 1898, and there delighted in the ancient and medieval mosaics he saw in Padua and Florence. As a city, Venice itself was a colorful work of art to him, with its shimmering architecture and carnival stage-set atmosphere. These various recollections fused in his own style adapted to New England's parks and playgrounds on his return. Like many artists of this period, Prendergast experimented in the tensions between representing and abstracting nature. Here, for example, his colors both depict forms and independently express a holiday mood of gaiety, a spirit about to change with the First World War's transformation of the twentieth century.

1916. Oil on canvas, 24⅛ x 30⅛ in. (61.3 x 76.5 cm.)
Collection of Mr. and Mrs. Paul Mellon, 1985

Maurice Prendergast, *Saint Mark's, Venice*, 1898
Watercolor over graphite, 14⅛ x 19⁷⁄₁₆ in.
(35.7 x 49.3 cm.)
Gift of Eugenie Prendergast, 1984

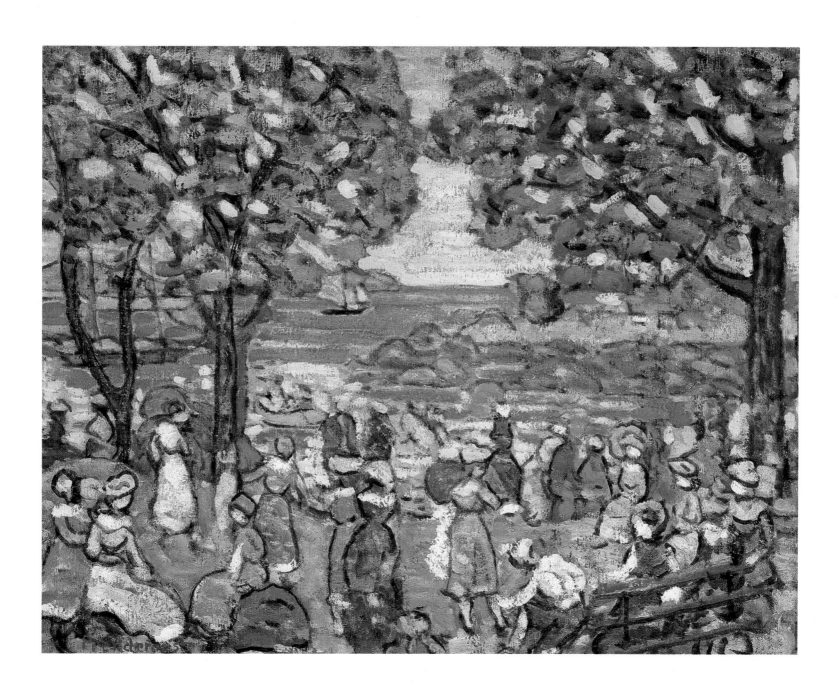

60 George Bellows
Both Members of This Club

Though not a formal member of The Eight—that gathering of friends in the opening decade of the twentieth century devoted to the causes of modernism—Bellows knew and associated with these colleagues. Some members were derided as the Ashcan school for their low-life subject matter and intentionally rough manner of vigorous brushwork and lighting, and they counted Bellows among them. Within the National Gallery's strong group of Ashcan paintings are included seven canvases by Bellows, some among the best work he ever did. Among the four portraits two are of Chester and Maud Dale, he being one of the Gallery's most generous and influential early donors and presidents.

Bellows equally loved to paint the figure in action, as he does here in a work that was part of a series devoted to boxing. At that time boxing was not yet a recognized sport, and so fights were conducted in private clubs. Bellows conveys the excitement and energy of this action by his conscious choice of a close-in view, bold juxtaposition of light and dark forms, and heavy, turbulent brushwork. Unlike the similar boxing scenes painted a generation earlier by Thomas Eakins, which were generally meditative and poised, Bellows's concentrate on moments of maximum tension and vigor in the combat. Bellows himself had been a professional baseball player as a youth in Ohio before deciding on coming to New York and on a career in art. Hence, the passion in this painting is not least that of deep personal exhilaration.

1909. Oil on canvas, 45¼ x 63⅛ in. (115 x 160.5 cm.)
Gift of Chester Dale, 1944

George Bellows, *Chester Dale*, 1922
Oil on canvas, 44¾ x 34¾ in.
(113.7 x 88.3 cm.)
Gift of Chester Dale, 1945

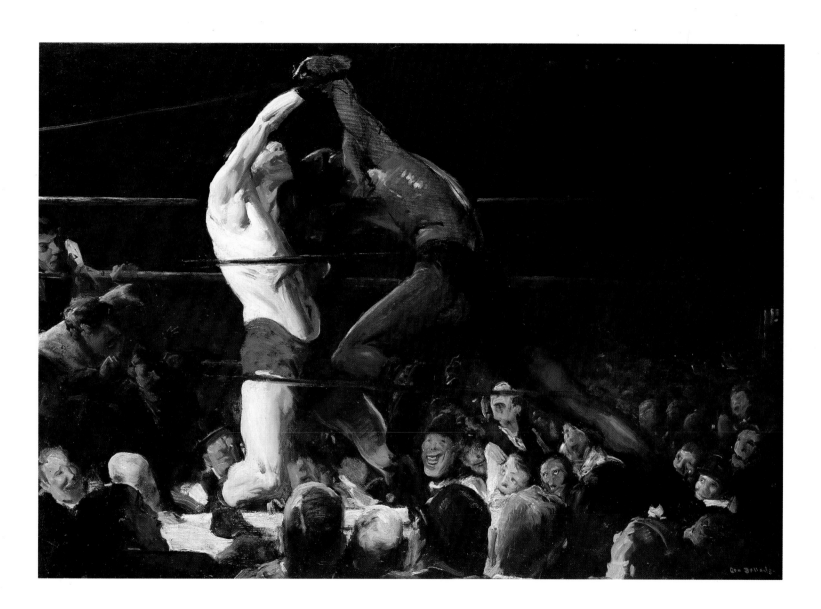

61 George Bellows
Blue Morning

Along with another large view of New York, *The Lone Tenement*, this work is a hymn to the rising urban landscape and new industrial energies of the twentieth century. While its bright colors and broadly defined forms may distantly echo the pastoral world of the American impressionists or the tonal harmonies of Whistler's visions at the end of the nineteenth century, it presents a boldness of approach and a celebration of forces that belonged to the modern world. Just as Bellows was observing the structures of the present and future come to dominate the past, as the Fifty-ninth Street Bridge does in *The Lone Tenement,* in *Blue Morning* he recorded the churning excavations for the old Pennsylvania Railroad Station in mid-Manhattan. Like the contemporary photographs of Alfred Stieglitz these at once document and praise the vivid presence of the steam engine, skyscraper, and electric lights making their marks on the new cityscape. While the composition at first appears to have a solid balance and stability, with the working figures and looming building behind holding the center of the design, we sense a dynamism present in the oppositions of light and dark areas, the quick strokes of Bellows's brush, and heavy masses of paint. Similarly, the fence, iron structure, and derrick both frame the scene and introduce lively visual tensions. Bellows's subject in the largest sense was the building of a new age.

1909. Oil on canvas, 31⅝ x 43⅜ in. (80.3 x 112 cm.)
Gift of Chester Dale, 1962

George Bellows, *The Lone Tenement*, 1909
Oil on canvas, 36⅛ x 48⅛ in. (91.8 x 122.3 cm.)
Gift of Chester Dale, 1962

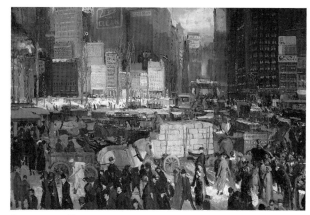

George Bellows, *New York*, 1911
Oil on canvas, 42 x 60 in. (106.7 x 152.4 cm.)
Collection of Mr. and Mrs. Paul Mellon, 1986

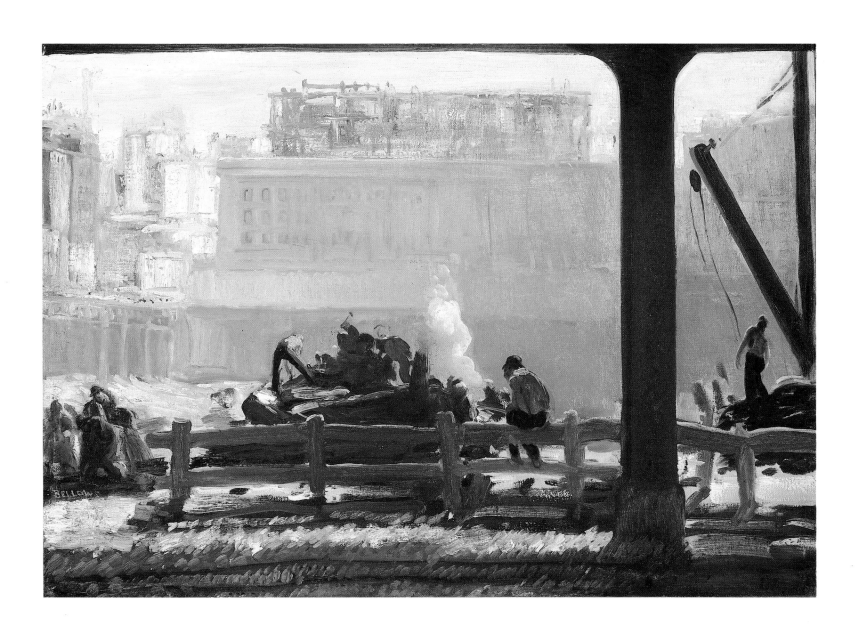

62 John Sloan
The City from Greenwich Village

Most of the members of The Eight are well represented in the National Gallery's collections. William Glackens and John Sloan are present only with single examples, in the former's case the large and imposing artist's *Family Group*, and for Sloan this striking night view of New York City. These works have come to the Gallery through the generosity, respectively, of Glackens's son and Sloan's widow.

Sloan here has chosen one of the favorite subjects of the Ashcan style: the excitement of the new century's urban scene, marked particularly by the drama of rising buildings, elevated railways, and artificial illumination. Like many of his colleagues, he had begun his artistic career in Philadelphia as a newspaper journalist before following Robert Henri to work in New York. As a consequence, Sloan was typical in bringing to his pictures a reporter's eye, that instinct for the quick, exciting impression and the summary, telling detail. In this work he invokes a strong visual dynamism by the bold railway track arrowing into the center of the composition. The elevated vantage point allows the capturing of both lively details and a sparkling panorama. The rhythms of dark colors punctuated by the patterns of light in turn reinforce our experience of a city and a time full of vitality. We must assume that the one legible sign in the painting—"Moonshine" on the building in the left foreground—was for Sloan an intentional and appropriate artistic pun.

1922. Oil on canvas, 26 x 33¾ in. (66 x 85.7 cm.)
Gift of Helen Farr Sloan, 1970

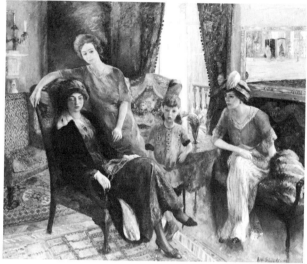

William Glackens, *Family Group*, 1910–11
Oil on canvas, 72 x 84 in. (182.8 x 213.3 cm.)
Gift of Mr. and Mrs. Ira Glackens, 1971

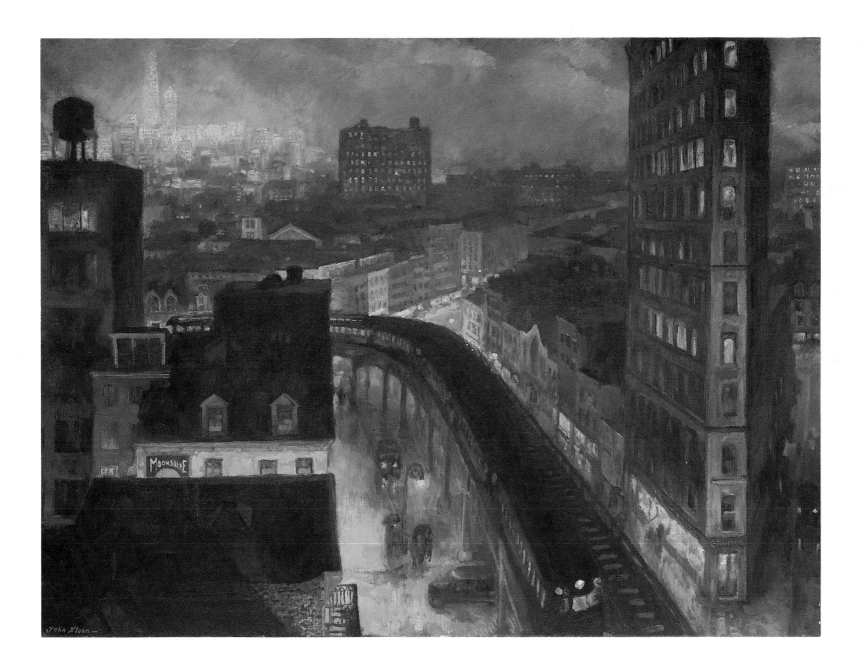

63 Max Weber
Rush Hour, New York

This painting is one of a small but representative group in the National Gallery of modernist works by the circle around Alfred Stieglitz. Complementing it are three canvases by Marsden Hartley and one by Arthur G. Dove, *Moth Dance*. Dove, Hartley, and Weber, along with John Marin, were among the first Americans to experiment with issues of abstraction in the first decades of the twentieth century. Their experiments, in part resulting from visits during these years to Europe, both parallel and reflect avant-garde developments then underway by painters in France, Germany, and Russia. Gathering in New York around that pioneer champion of modernism, Alfred Stieglitz, they wrestled with both realist and abstracted forms for representing their experience of a contemporary culture and environment.

Weber's most original work in response to the developments of Cubism and Futurism in France tended to be his earlier paintings done in the years around World War I. (Later it appeared he fell back on the conservative security of solid figure painting.) Like his colleagues in the Ashcan school who were recording their impressions of the New York cityscape in a new century, Weber equally sought to convey the rush, intensity, and compression of activity in this urban scene. But as this image demonstrates, he chose not the bold realism and aggressive brushwork of Ashcan painting, but rather the fragmented forms and repeated patterns derived from Cubism to suggest the pace and motion of this world.

1915. Oil on canvas, 36¼ x 30¼ in. (92 x 76.9 cm.)
Gift of the Avalon Foundation, 1970

Arthur G. Dove, *Moth Dance*, 1929
Oil on canvas, 20 x 26⅛ in. (50.8 x 66.4 cm.)
Alfred Stieglitz Collection, 1949

64 Marsden Hartley
The Aero

The Gallery has three typical Hartleys from different moments in his career: this early abstraction from his German series of 1914, a New Mexico view *Landscape No. 5* from around 1922–23, and a large canvas in the *Mount Katahdin* series dated 1942. Hartley's early landscapes developed out of the tradition of William Merritt Chase's plein-air naturalism on the one hand and Albert P. Ryder's more mystical simplifications of nature's forms on the other. But the first real transformation of his style into an original vision of his own came with Hartley's trips to Europe in 1912–14. First in Paris, he became aware of the powerfully structured late still-life compositions of Cézanne and the new Cubist experiments of Picasso; at the same time he responded to the bright decorative designs of Matisse. Later in Berlin, Hartley was further stimulated by the parallel investigations of abstraction and expressionism by Wassily Kandinsky and Franz Marc. These various elements may be seen fused in Hartley's own paintings on themes of German militarism done at this time. Eschewing the intellectual rarification of Picasso's Cubism, Hartley maintained its sense of construction and fragmentation, yet favoring even more the emotional force of color he saw in Matisse and Kandinsky. Above all, these were personal, romantic visions responding to the colorful costumes and parades of soldiers, the aggressively masculine atmosphere of Berlin and the German military state in those years. In particular, Hartley was enamored of a young German soldier who was killed in uniform. Through his art consequently burst an expression at once heroic, tragic, and poetic.

c. 1914. Oil on canvas, 42 x 34½ in. (106.7 x 87.7 cm.), including painted frame
Andrew W. Mellon Fund, 1970

Marsden Hartley, *Mount Katahdin, Maine,* 1942
Oil on Masonite, 30 x 40⅛ in. (76 x 101.9 cm.)
Gift of Mrs. Mellon Byers, 1970

65 Georgia O'Keeffe
Jack-in-the-Pulpit No. V

When O'Keeffe died in 1986 at the age of ninety-nine, she left behind a prodigious body of work from the early years of the century on, a good deal of it kept back in her own possession and thus not well known. Her reputation was confirmed as one of America's greatest women artists and one of the central artistic figures of the twentieth century. In the settling of her estate, eight of her most important paintings were allocated to the National Gallery, including five works considered a signature series of her career, the *Jack-in-the-Pulpit* suite. The first paintings by her to be owned by the Gallery, these constituted in one gesture a dramatic addition to the modern American collections. Besides this group of flower compositions, the Gallery also received a more geometric abstraction, *Line and Curve*, one of the snail shell studies, and a fine example from her late sky and clouds series. Together with works on paper given or purchased, these afford an overview of the high moments in O'Keeffe's style and subject matter.

Of all the themes associated with her life's accomplishment, perhaps none is more fundamental in her art than her sustained attention to flowers as pure forms. Over more than five decades her art wove a path between nature and abstraction. By exploiting a process of simplification and magnification O'Keeffe created a personal imagery which hovered between recognizable shapes and independent geometric harmonies. The dislocation of an enlarged scale and close-up view gave her pictures a particular mystery and drama that forced the viewer to see them as both distilled personal experience and imaginative invention. Pursuing the floral form in serial images allowed O'Keeffe to explore simultaneously the evocation of natural growth and change as well as the different expressive harmonies of sequential color combinations and rhythmic picture shapes.

1930. Oil on canvas, 48 x 30 in. (121.9 x 76.2 cm.)
Alfred Stieglitz Collection, Bequest of Georgia O'Keeffe, 1987

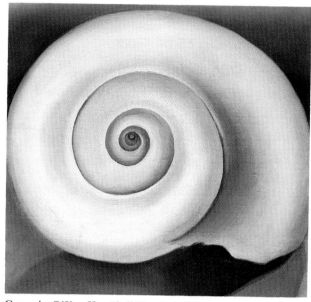

Georgia O'Keeffe, *Shell No. 1*, 1928
Oil on canvas, 7 x 7 in. (17.8 x 17.8 cm.)
Alfred Stieglitz Collection, Bequest of
Georgia O'Keeffe, 1987

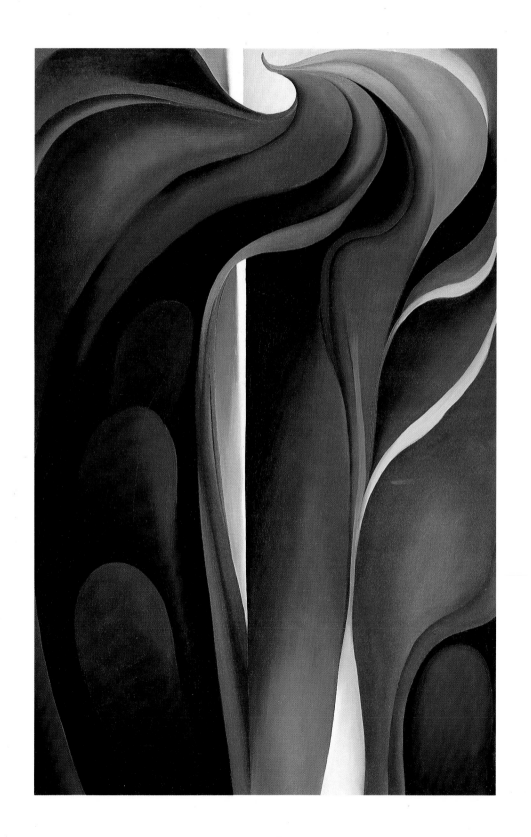

66 John Marin
Grey Sea

This moody late work by Marin was the highlight of a major donation to the National Gallery in 1987 by the artist's son and daughter-in-law, Mr. and Mrs. John Marin, Jr. Included in the gift were an important early watercolor of the Woolworth Building and a large group of sketchbooks of the artist from all periods of his career. This material establishes a broad Marin archive full of indispensable materials for future research, as well as dozens of fascinating working sketches, finished academic studies, and fresh watercolors. Throughout Marin's style there is an ever-evolving play between representation and abstraction, which culminates in the vigorous work of his later career, as exemplified in *Grey Sea*.

Marin was ambidextrous, giving rise to the interesting idea that this may have contributed to his particular abilities to balance opposites; for example, his confident handling of the liquid spontaneity and freshness of watercolor and the equally controlled build-up of rich solid pigments in oil paintings. The Maine coastal landscape perfectly suited his fascination with the constant juxtaposition of fluid and solid, of water and rock, of transparent light and rugged mass. His art itself belonged to the first stages of modernism in American art unfolding in the opening decades of the twentieth century. Through various stages and changing subjects his style followed a course simultaneously addressing in differing combinations concerns for observation and pure energy of form. *Grey Sea* in a chronological context is also in a transitional position between the bold, solid realism of Winslow Homer's late Maine seascapes from the turn of the century and the abstracted early landscapes of Adolph Gottlieb and Mark Rothko at mid-century. This painting's expressive power lies both in its evocation of the raw American wilderness and in its rich physical surface of churning brushstrokes and thick paint layers.

1938. Oil on canvas, 22 x 28 in. (55.9 x 71.1 cm.)
Gift of Mr. and Mrs. John Marin, Jr., 1987

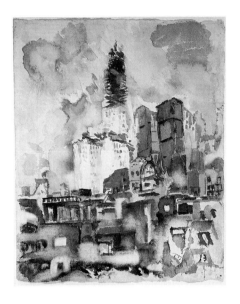

John Marin, *Woolworth Building under Construction*, c. 1913
Watercolor on wove paper, 19½ x 15⁷⁄₁₆ in. (49.6 x 39.2 cm.)
Gift of Mr. and Mrs. John Marin, Jr., 1987

John Marin, *Study for Seaside Grouping*, 1893
Pen and ink, 14¼ x 19½ in. (36.2 x 49.5 cm.)
Gift of John Marin, Jr., 1986

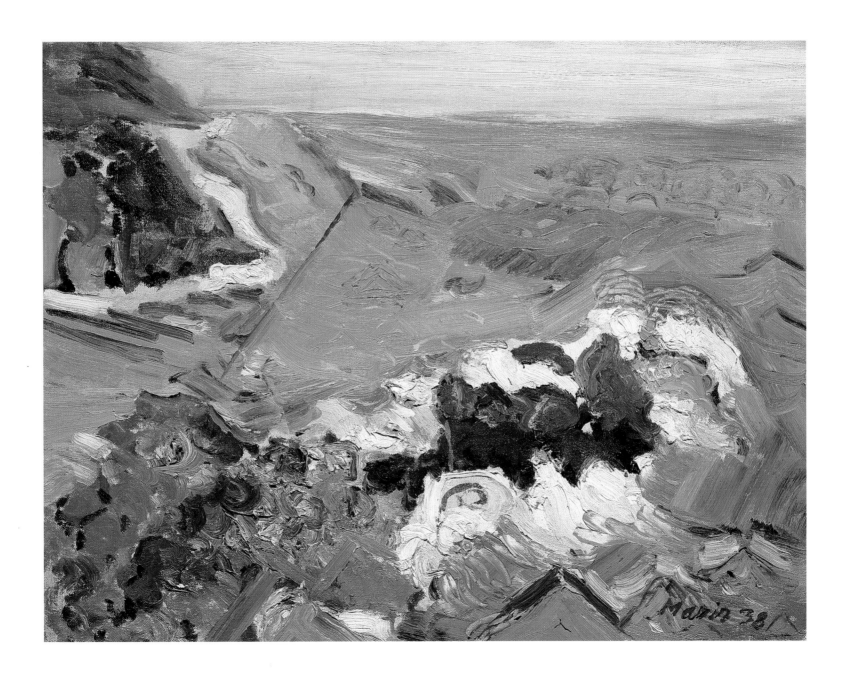

67 Edward Hopper
Cape Cod Evening

Known as much for his often stark cityscapes as for his coastal land-scapes, Hopper almost always made an architectural facade or structure an important part of his compositions. Growing up near New York, working early in his career in Paris, he retained a sense of the city as perhaps a quintessential environment of the twentieth century. Not least it set off individuals in their own isolation, and Hopper frequently focused his pictures around contrasts of the animate and inanimate, the curves of human forms and movements placed near the angular geometries of walls, roadways, rooflines, windows, or doors. Outside of his New York subjects he found extensive material for his art in three specially favored regions: Gloucester, Massachusetts, the southern Maine coast around Portland, and the eastern end of Cape Cod. Hopper and his wife, Jo, visited the latter area in the early 1930s, and decided to build a house in South Truro, where he painted on and off over the next two decades.

Many of Hopper's Cape Cod subjects have a particular air of detachment and stillness, and the nearby farmhouses he painted seem notably isolated by empty spaces. Although the house in *Cape Cod Evening* stands next to evergreen woods, the couple and dog are framed apart and separate in a mood of introspection bordering on melancholy. Always a master of powerful design, Hopper here uses the broad planes of his composition to emphasize human aloneness. First, there are the three large zones of green trees, tan grass, and white facade, which in turn reinforce the three living figures marked by comparable colors. They are additionally echoed by the three major architectural elements of the housefront: the woman standing by the bay window, the man seated in the doorframe, with the smaller single window matching the dog silhouetted apart in front. The cool evening light and sensed lack of connection among these figures emphasize their loneliness.

1939. Oil on canvas, 30¼ x 40¼ in. (76.8 x 102.2 cm.)
John Hay Whitney Collection, 1982

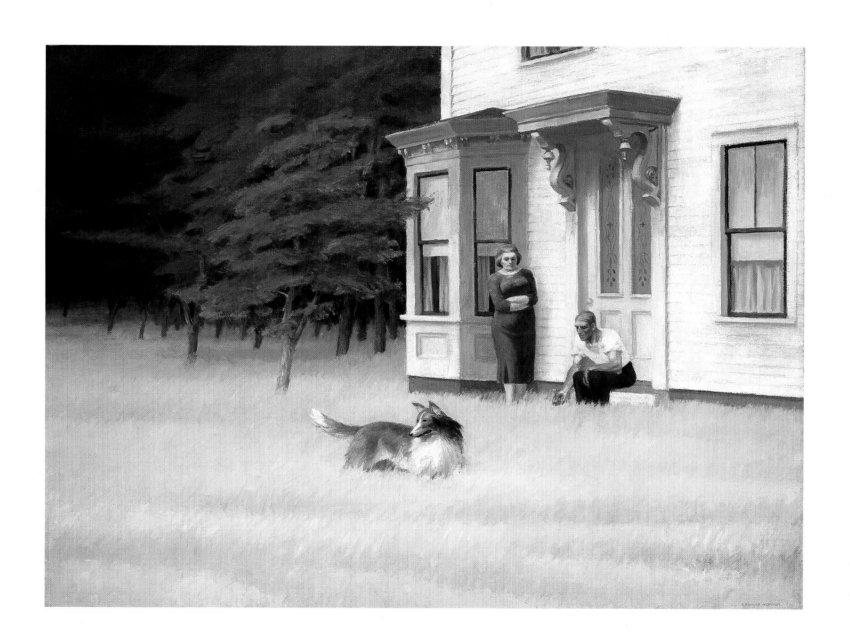

68 Thomas Hart Benton
Trail Riders

A summary work of the artist's later years, this is also one of his largest canvases, embodying the sweep of the American western landscape that Benton so much admired and valued. Its ambitious scale, strong coloring, and powerful forms suit well his celebration of the nation's expansive geography and its indigenous culture. Painted in the style that remained largely consistent with Benton throughout most of his mature career, it displays the bold undulating patterns of strong flat color and simplified shapes that show his familiarity with modernist developments in early twentieth-century art. After World War I, however, Benton turned away from his exposure to the work of Cézanne and Matisse in France in 1908–11 and experiments with abstraction, to promulgate an American subject matter and style of realism. His canvases became hymns of praise to the nation's past as he devoted series of works to its history and arts, especially in the regions of the Midwest, South, and Far West which were as yet, he felt, undamaged by the sophisticated intellectualism of European avant-garde culture. The grand and glowing vista seen here, with its pioneer horsemen small but at home in this invigorating environment, continued the grandiloquent ninteenth-century romantic tradition of landscape painting by Thomas Moran and Albert Bierstadt. Its size, implicit optimism and self-confidence recapitulate virtues depicted a century earlier, as evidenced elsewhere in the National Gallery's American collection, for example, Frederic Edwin Church's *Morning in the Tropics* (Plate 34) and Jasper F. Cropsey's *Autumn—On the Hudson River* (page 110).

1964–65. Oil on canvas, 56⅛ x 74 in. (142.6 x 188 cm.)
Gift of the artist, 1975

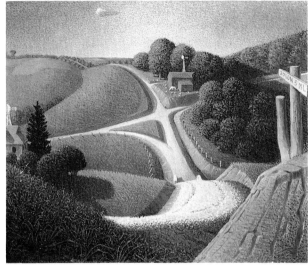

Grant Wood, *New Road*, 1939
Oil on canvas mounted on hardboard, 13 x 14⅞ in.
(33 x 37.9 cm.)
Gift of Mr. and Mrs. Irwin Strasburger, 1982

69 Andrew Wyeth
Snow Flurries

Enormously admired for his unsurpassed technical skills as a drafts-man and his mastery of the American realist tradition in the twentieth century, Wyeth is equally prolific working in pencil, watercolor, and tempera. One of his most abstract and haunting works in the last medium is this winter study of the landscape around the Kuerner farm in Brandywine, Pennsylvania. It is a rolling countryside re-dolent with the history of the Revolutionary War. Gentle and rugged at the same time, it often seems starkest and most interesting in character during the winter and early spring seasons, when there are few distractions of lush growth or color. Rather the eye becomes sharpened to the crisp air edging the silhouetted contours of the fields and to the subtle nuances of tone and texture within the seemingly monochromatic environment. By choosing an elevated vantage point and by raising the horizon line, Wyeth enhanced the sense of cold isolation and raw beauty of the place. He exploited the painstaking technique of working with his egg tempera to achieve the jewel-like effects of grassy details. Across much of the ground he has scratched through the brown pigment with the butt end of his brush to allow flecks of the underground to show through, which convincingly read as cold patches of snow or frost. The lack of overt anecdotal detail or narrative figuration is relatively unusual for Wyeth. As a result we are especially drawn here to the more abstract and subjective elements of his painting, aspects which link Wyeth to the larger currents of modern art.

1953. Tempera on panel, 37¼ x 48 in. (94.5 x 122 cm.)
Gift of Dr. Margaret I. Handy, 1977

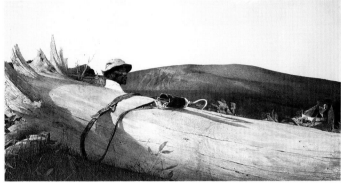

Andrew Wyeth, *Field Hand*, 1985
Dry brush watercolor on wove paper, 21¾ x 39⅝ in.
(55.3 x 100.7 cm.)
Gift of Leonard E. B. Andrews, 1986

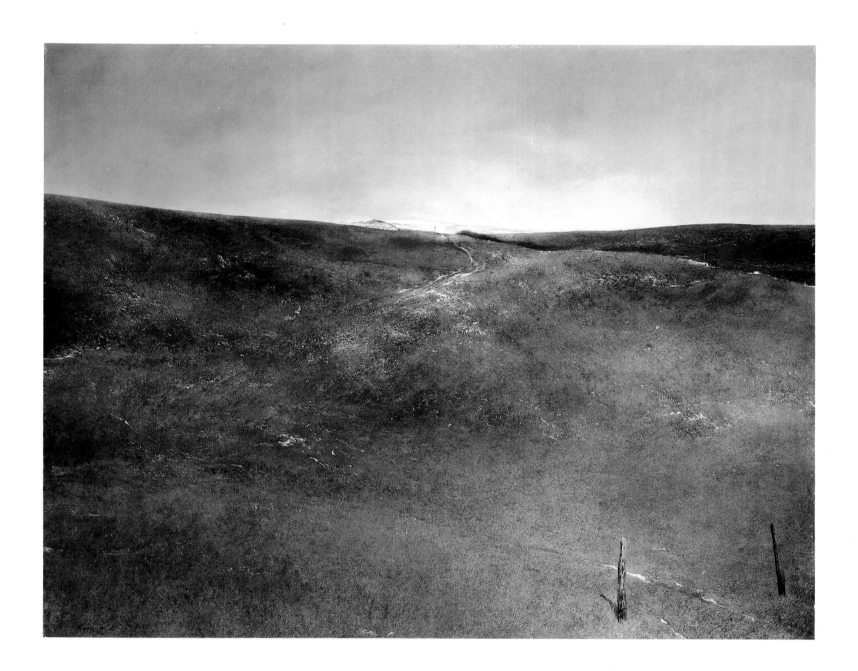

70 Jacob Lawrence
Daybreak—A Time to Rest

One of America's foremost black artists of the twentieth century, Lawrence has through much of his career pursued a style fusing realism with abstract decorative design. His art has primarily addressed an imagery depicting the life and history of blacks, from their African heritage through the continuing struggles with slavery to the experience of the urban ghetto in the twentieth century. To this end Lawrence undertook a number of series devoted to various black heroes, such as the Haitian liberationist Toussaint L'Ouverture and in America Frederick Douglass and Harriet Tubman. While these possess an underlying narrative content, Lawrence has fused his figures and story-telling elements with simplifications of form and distortions of color to convey expressive feelings beyond mere illustration.

Daybreak—A Time to Rest is related to the sequence of gouaches Lawrence completed in 1967 to illustrate a children's book on the life of Harriet Tubman, entitled *Harriet and the Promised Land*. Other images in the series show figures set against a similarly bright ground and dark sky above. Here Lawrence takes us into a dream world of sleep in the fields with its strange dislocations in scale. The resting figures and enlarged insects are juxtaposed with the huge feet at the center, behind which in possibly a foreshortened relationship are a head and a hand holding a gun. Preferring the unmodeled primaries red, yellow, and blue, Lawrence achieves a balance between recognizable imagery and abstraction which continues the pioneering modernism of Marsden Hartley, Arthur G. Dove, and Georgia O'Keeffe.

1967. Tempera on Masonite, 30 x 24 in. (76.2 x 61 cm.)
Gift of an anonymous donor, 1973

71 Arshile Gorky
The Artist and His Mother

This is the second version of this composition: the better-known image, in the Whitney Museum, is sharper in its outlines and stronger in its flat areas of bright color. By contrast, the loose brushiness of execution, the more unfinished contours of form, and above all, the soft delicate colors in this work create a special quality of mystery and poignance which hauntingly anticipate Gorky's great final period of abstracted landscapes. In seeking to build up its collection of twentieth-century American art, especially post-World War II modernism, the National Gallery has sought to acquire groups of key works by major masters, rather than attempt initially for a representative survey of the modern field. Thus, along with this painting came two other exemplary works by Gorky from other phases of his career—*Organization*, 1933–36, and *One Year the Milkweed*, 1944—to join a large preparatory drawing for *The Plough and the Song* of 1946. Together, these works document the development of a central figure in the evolution of the Abstract Expressionist movement from its roots in surrealist figure painting and Cubism to the internalized images and purely formal power at its apogee of achievement. Here Gorky's structured design recalls his indebtedness to Cézanne, the masklike faces of Picasso's proto-cubist figures, and the evocative floating colors of Miró's surrealist visions. But it was Gorky's great triumph to emerge from this artistic apprenticeship with works of art in his later career which were more than images of self: they were fully about the creative act and art as an autobiographical process.

c. 1926–36. Oil on canvas, 60 x 50 in. (152.3 x 127 cm.)
Ailsa Mellon Bruce Fund, 1979

Arshile Gorky, *Organization,* 1933–36
Oil on canvas, 50¼ x 60 in. (126.4 x 152.4 cm.)
Ailsa Mellon Bruce Fund, 1979

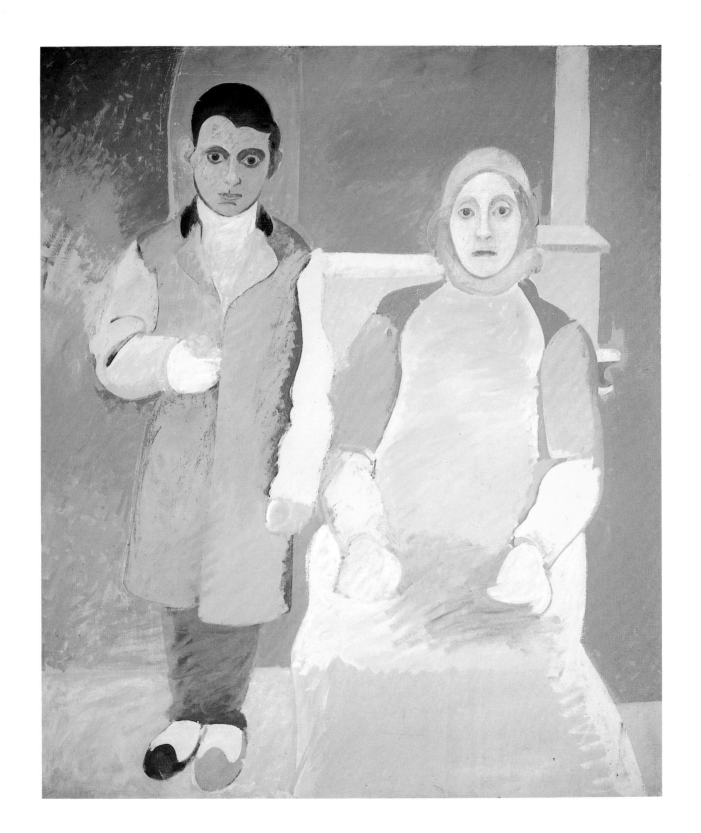

72　Mark Rothko

Orange and Tan

Abstract Expressionism as a movement had generally two major types of painting, an active linear gesturalism associated most perhaps with Jackson Pollock, Franz Kline, and Willem de Kooning, and canvases of broad color fields, seen foremost in Clyfford Still, Barnett Newman, and Mark Rothko. Both modes ultimately derive from the precedents of earlier twentieth-century art in Europe, notably the hermetic experiments of Cubism which questioned the nature of three-dimensional forms on flat surfaces. Expressionism in France and Germany contributed a liberated sense of color and feeling separate from the description of form or carrying of narrative content. In turn, Surrealism stimulated an awareness of the unconscious, techniques of automatism, and the magic imagery of mythology. With World War II many prominent European painters came to New York, and the currents of these modern movements confronted the new scale and energy of America.

Rothko's painting emerged from this context, as he developed from a style of biomorphic figures and automatic calligraphy into ever larger shapes of floating rectangles on huge canvases. The brushwork of his presence is evident across the surface of this later work, yet he created a picture space no longer an extension of the outer world but one in which figure and ground float in ambivalent tension with each other, suggesting both immediate flatness and infinite space. With their close juxtapositions of colors, they allude to vast environments inviting contemplation and immersion in a transcendent world of the spirit.

1954. Oil on canvas, 81¼ x 63¼ in. (206.4 x 160.6 cm.)
Gift of Enid A. Haupt, 1977

Franz Kline, *Four Square,* 1956
Oil on canvas, 78⅜ x 50¾ in. (199 x 128.9 cm.)
Gift of Mr. and Mrs. Burton Tremaine, 1971

73 Jackson Pollock
No. 1, 1950 (Lavender Mist)

The centerpiece of the National Gallery's modern collection is this work from the culminating period of America's greatest artist of the twentieth century. Pollock is perhaps the best known and most controversial painter working within the area of Abstract Expressionism that stressed the artist's subjective gestures. In the background of Pollock's mature work was his youthful consciousness of the American West and Southwest. He knew something of America's vast and powerful geography, and as a beginning painter gained stimulation variously from Albert P. Ryder's mystical visions, the totemic images of Indian sand painting, and the mural scale of his teacher Thomas Hart Benton's work. Once in New York in mid-career, Pollock was exposed to the mythological subjects of Picasso and the subjective forms of the Surrealists. From these he steadily moved away from their overt symbolism, while retaining the expressiveness of the painter's creative energies. In a decisive move he began to place his canvases on the floor, walking on and around them as he splattered and dripped the paint before him. The resulting image is an almost unlimited field of carefully balanced colors and a density of work which creates a space that is simultaneously opaque and expansive. Importantly, color and line no longer belong to forms and figures but exist as independent energies, embodiments of the painter's physical act, so that this art is truly about itself. Certainly not illustrations, such paintings may be allied with comparable developments of our time like the X ray, theories of relativity, and nuclear energy.

1950. Oil, enamel, and aluminum on canvas, 87 x 118 in. (221 x 299.7 cm.)
Ailsa Mellon Bruce Fund, 1976

Jackson Pollock,
Untitled, c. 1950
Blue ink, 20½ x 7 in.
(52 x 17.7 cm.)
Ailsa Mellon Bruce
Fund, 1985

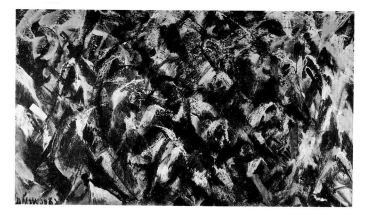

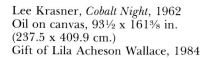

Lee Krasner, *Cobalt Night*, 1962
Oil on canvas, 93½ x 161⅜ in.
(237.5 x 409.9 cm.)
Gift of Lila Acheson Wallace, 1984

74 Robert Motherwell

Reconciliation Elegy

Besides major works of the Abstract Expressionist movement by Jackson Pollock and Mark Rothko, the National Gallery also holds examples by Franz Kline from the first generation of the school, and by Jules Olitski, Kenneth Noland, Howard Mehring, Morris Louis, and Frank Stella, who have been among those more recently pursuing the formal implications of the movement's original innovations. One of the founding figures of Abstract Expressionism, Robert Motherwell, painted this enormous canvas as a commission at the time the Gallery opened its new East Building in 1978. His own personal style had long been rooted in the rich decorative collages of Cubism and the color patterns of Matisse's paintings. During the Spanish civil war Motherwell undertook a series of Elegies whose large organic forms and dark colors suggest a landscape of oppositions, or, as he himself once said, "the contrast between life and death, and their interrelation." Working on thematic variations of the subject over recent decades, Motherwell has given the subject an ever larger and more profound grandeur, allowing it to suggest the tragic tenor of modern humanity. In using the term "reconciliation," Motherwell said he had in mind the new sense of humanism in contemporary Spain, but was also thinking of his own accommodation with older age and personal consciousness of mortality. It was the largest painting the artist had yet executed, appropriate to the spaciousness and elegance of its architectural setting, yet carrying the personal power of art as a heroic vision.

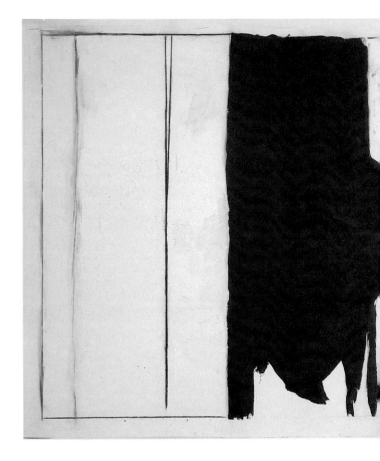

1978. Acrylic on canvas, 120 x 364 in. (304.8 x 924.2 cm.)
Gift of the Collectors Committee, 1978

Biographical Notes

George Bellows 1882–1925
Born in Columbus, Ohio, Bellows attended Ohio State University, where he worked as an artist on the school paper. He studied at the New York School of Art with Robert Henri (1904–06) and later taught at the Art Students League (1910–11) and the School of the Art Institute of Chicago (1919). Bellows's early paintings were landscapes and prizefight scenes such as *Both Members of This Club* (1909). In 1916, he began working in lithography.

Bellows did not study abroad. Working primarily in New York, he summered in Maine, California, New Mexico, and Rhode Island, painting portraits and figure compositions of his family and friends. A leader in early twentieth-century art and a member of the Ashcan school, George Bellows helped to organize the 1913 Armory Show and was a founding director of the Society of Independent Artists. He died of appendicitis in New York in 1925.

Thomas Hart Benton 1889–1975
Son of a U. S. congressman, Benton was born in Missouri. He studied at the Art Institute of Chicago (1906–07) and at the Académie Julian in Paris (1908–11). In Europe, he came under the influence of Cubism and Synchromism and studied paintings of the Italian Renaissance and El Greco.

Back in the United States, Benton worked on and off in New York between 1913 and 1935. He was a draftsman at the naval base in Norfolk, Virginia (1918), and in 1919 he began his American Historical Epic series. For ten years, he worked on this group of subjects taken from U.S. history and folklore. Other artists (Grant Wood and John Steuart Curry) worked in this genre, but Benton was the most popular of the Regionalist painters.

Thomas Hart Benton served as director of the Paintings Department at the Art Institute of Kansas City, Missouri (1935–41). In the later years of his life, he concentrated on themes from the West, such as *Trail Riders* (1964–65).

Ralph A. Blakelock 1847–1919
Beginning his artistic career as a landscape painter in the Hudson River style, Blakelock became one of the most poetic and visionary artists in America. He was born in New York, where he studied at the Cooper Union after leaving college. Following three years in the West (1869–72) painting topographical scenes, he returned to New York and painted the haunting moonlit imaginary scenes for which he became known. Unfavorable critical response and ongoing financial problems in the 1880s and 1890s led to a mental breakdown (1899), and Blakelock was hospitalized for the remainder of his life. Ironically, his paintings became popular at the beginning of the twentieth century and set auction sales records for works by a living American artist.

Mary Cassatt 1844–1926
Born to a wealthy family near Pittsburgh, Cassatt spent much of her childhood traveling around Europe. Her family moved (1858) to Philadelphia and she was a student at the Pennsylvania Academy of the Fine Arts (1861–65). In 1866, Cassatt went to Paris where she remained for most of her life. Mary Cassatt studied the paintings of Correggio, Velázquez, Rubens, and Hals, and in 1872 she began to exhibit her paintings at the Paris Salon. Edgar Degas introduced her to the French Impressionists, and it is with that group she most often exhibited her works during 1879–86. Her paintings of women at the opera, at their toilette, or with their children were among the earliest impressionist works exhibited in the U.S.

Cassatt's early works were impressionist in technique, characterized by high-keyed color applied in small strokes, but in the 1880s, her style—under the influence of Degas, Manet, and Japanese prints—evolved to emphasize large, solid, outlined forms, strong patterning, and brilliant color. *The Boating Party* of 1893 is typical of this new style. By 1914 she was forced by failing eyesight to abandon painting.

George Catlin 1796–1872
Born in Wilkes-Barre, Pennsylvania, and trained as a lawyer, Catlin taught himself to paint portraits and miniatures. He worked in Philadelphia (1820–25) and Washington, D.C. (1825–29), and in 1832 he began a six-year journey to paint the American Indian. The result was nearly five hundred paintings of forty-eight different tribes, which showed portraits of specific Indian men and women, and also recorded Indian culture and scenes from everyday life.

Catlin exhibited his Indian Gallery both in this country and abroad (1837–51), and in 1841 he published his *Illustrations of the Manners, Customs and Condition of the North American Indians*. He also painted the Indians of South America (1852–57) and went to Europe for twelve years before returning to the U.S. in 1870.

Thomas Chambers 1815–after 1866
A native of England, Chambers came to the United States in 1832. He worked in New York City, Albany, and Boston, painting landscapes, portraits, and seascapes in a naive style. Chambers's romantic paintings—often based on prints—feature large, boldly outlined shapes, brilliant color, and an almost enamel-like finish. They are simplified, sometimes almost to the point of abstraction.

Winthrop Chandler 1747–1790
Chandler was a folk artist from Woodstock, Connecticut, who may have been trained as a house and sign painter in Boston. He was not an itinerant artist, like many "limners" during the eighteenth century, but worked mainly in Woodstock and in Worcester, Massachusetts, where he lived for several years. Most of his paintings, which are distinguished by monumental figures and dramatic color, are portraits of his family and friends from those two New England towns.

William Merritt Chase 1849–1916
A painter of portraits, landscapes, and still lifes in a variety of styles, Chase was also one of the most influential teachers in America at the turn of the century. Born in Williamsburgh, Indiana, Chase grew up in Indianapolis and studied art there. After further study at the National Academy of Design in New York and a year in St. Louis painting still lifes, Chase went to Munich in 1872 to study at the Royal Academy and shared a studio with Frank Duveneck. Chase's paintings of this time are in the dark Munich style, influenced by Hals and Van Dyck. However, a nine-month stay in Venice with Duveneck and John Twachtman in 1877 brought a lighter tone to Chase's work.

Returning to the United States in 1878, Chase began his teaching career. American artists such as Hartley, Hopper, Demuth, O'Keeffe, Sheeler, and Maurer were among his students at the Art Students League (1878–94), Brooklyn Art School (1890–95), Shinnecock Art School (1892–1902), Chase School (1896–1908), and Pennsylvania Academy of the Fine Arts (1898–1911).

Frederic Edwin Church 1826–1900
Church was born in Hartford, Connecticut, son of a successful insurance adjustor, who financed two years of study for Church with Thomas Cole. In 1846 Church opened a studio in New York and ex-

hibited landscapes at the National Academy of Design and the American Art-Union.

Church began to travel in search of subject matter for his paintings, visiting the Upper Mississippi (1851), Mount Desert Island and the Katahdin region in Maine (1850, 1851, 1852), and Grand Manan Island in Canada (1852). In 1853, inspired by writings of German naturalist Alexander von Humboldt, he made the first of two trips to South America. His tropical landscapes along with his major U.S. landscapes, such as the 1857 *Niagara*, caused a sensation.

During the late 1850s and the 1860s, Church continued to visit exotic locales. His output slackened in the eighties and nineties, however, and his paintings came to be looked upon as overly exaggerated and theatrical by both art critics and the public. During those years, he concentrated most of his attention on his Moorish villa, "Olana," above the Hudson River across from Catskill, and when he died there in 1900, he was virtually forgotten as a painter.

Thomas Cole 1801–1848
One of the founders of the Hudson River School, Cole emigrated to Ohio from England with his family at the age of nineteen and was first trained as a wood engraver. With the encouragement of an itinerant painter named Stein, he decided around 1820 to become a painter. He was first an itinerant portraitist in Ohio, but in 1823 he moved to Philadelphia. By 1825, settled in New York, Cole began to paint landscapes and gained the attention of such leading artists as Asher B. Durand and John Trumbull. In 1826 he was one of the founding members of the National Academy of Design, and his reputation lasted until his early death in 1848. Cole traveled to Europe for three years beginning in 1829, and again in 1841–42.

In 1834 Cole began a series of five allegorical paintings for his patron Luman Reed called *The Course of Empire.* The great success of this series encouraged Cole to undertake other series such as *The Voyage of Life,* which was reproduced in engravings and established his popularity throughout the country. Cole came to view these allegorical paintings as his most serious and important works, although up to his death in 1848 at Catskill, New York, he accepted commissions for landscapes depicting actual locations in Italy and America.

John Singleton Copley 1738–1815
America's leading colonial artist, Copley was born in Boston, Massachusetts, in 1738. He studied painting and engraving with his stepfather, artist Peter Pelham, and by age nineteen was a well-established painter of portraits and miniatures. In 1766 Copley sent his *Boy with a Squirrel* to London, where it received a great deal of favorable notice. Benjamin West, who had already settled in England, urged Copley to move to London, but Copley preferred his secure and prestigious position in Boston to a more uncertain future abroad.

In 1774, however, the events preceding the American Revolution led Copley to travel abroad, and he was to spend the rest of his life in England. Before settling in London, he spent a year studying the old masters, first in Paris and then in Rome. In London, Copley began to produce historical and religious paintings as well as portraits. He achieved a measure of success in England and became a member of the Royal Academy in 1776, but in his last years, Copley's patronage declined markedly. He died in London in 1815 amid strife, rebuffs, and constant financial worries.

Jasper F. Cropsey 1823–1900
Son of a Dutch immigrant, Cropsey was born on Staten Island in 1823. He was apprenticed to an architect and took watercolor lessons and experimented in oil painting in his free time. In 1843, after moving to New York City to continue his architectural practice, he exhibited several landscapes at the American Art-Union and the National Academy of Design, and was elected an Associate of the Academy. In 1847 Cropsey traveled through England and Scotland and then to Rome. Back in the U.S. in late 1849, he devoted almost all his time to painting, although he continued to accept architectural commissions.

In 1856 Cropsey again traveled to England, returning to New York in 1863. He exhibited his paintings both in the U.S. and in England and painted a variety of subjects including allegories, nature studies, and book illustrations, but he achieved most of his popularity with his landscapes. By the 1880s Cropsey's popularity, reflected by the prices of his paintings, began to decline, although he continued to exhibit landscapes, especially ones depicting autumnal scenery, until his death in 1900 at his home in Hastings-on-Hudson.

Thomas Wilmer Dewing 1851–1938
A native of Boston, Dewing started his artistic career by working briefly for a lithographer and by drawing chalk portraits. From 1876 to 1879 he studied at the Académie Julian in Paris under Gustave Boulanger and Jules Lefebvre and in Munich with Frank Duveneck. Upon his return from Europe, Dewing settled permanently in New York City, where he taught at the Art Students League (1881–88). He was elected an Associate of the National Academy of Design (1887) and an Academician (1888), but seems to have exhibited his work principally with the Society of American Artists. In 1898 Dewing resigned from the Society to align himself with a group of Boston and New York artists who exhibited as the "Ten American Painters." Other members of The Ten included John Twachtman, Julian Alden Weir, Childe Hassam, and Edmund Tarbell.

Dewing was very much an aesthete in both his personal life and his work. After 1920 he painted little, and he died in New York at age eighty-seven.

Thomas Doughty 1793–1856
Born in Philadelphia, Doughty was apprenticed to a leather merchant, but around 1820 he turned to painting and soon became a successful artist. Doughty worked in Boston and Philadelphia until 1837, when he left for two years in England. His paintings of the English countryside are more idealized than the scenes from the Hudson River valley for which he became known. Upon his return to the U.S., Doughty settled in New York for most of the rest of his life.

Doughty was a pioneer. He was one of the first American painters to choose landscape exclusively for subject matter, and his lyrical, pastoral paintings of America's wilderness were very popular and were exhibited both here and abroad. He was also in the forefront of artists to use the medium of lithography.

Thomas Eakins 1844–1916
Eakins was a painter, sculptor, photographer, and teacher. Born in Philadelphia, he studied drawing at the Pennsylvania Academy of the Fine Arts and attended anatomy classes at Jefferson Medical College. From 1866 until 1869 he was in Paris at the École des Beaux-Arts, with trips to Italy, Germany, and Spain to study the art of those countries. Back in Philadelphia, he continued his anatomical studies at Jefferson Medical College (1873–74) and began to teach at the Pennsylvania Academy in 1876. His insistence on using a nude male model in coed classes led to his resignation as director of the Academy in 1886. Many of his students then formed the Art Students League of Philadelphia, where Eakins taught without pay for the next seven years. In 1880, he began experiments with photography to study action for his paintings, and in the 1880s and early 1890s he was also producing sculpture.

Eakins was always a realist, and his boating scenes on the rivers around Philadelphia (1870s) and his later psychological portraits of family and friends are some of the finest artistic images ever created in this country.

Ralph Earl 1751–1801
Born in Worcester County, Massachusetts, Earl was probably apprenticed to a house and sign painter. However, by 1745 he had established himself as a portrait painter in New Haven, Connecticut. His four drawings of the battles of Lexington and Concord (1775), engraved by his friend Amos Doolittle, brought him fame, but in 1778, due to his Tory leanings, he fled to England. There he studied with Benjamin West and painted portraits for about seven years.

Back in the U.S. in 1785, Earl was an itinerant portrait and landscape painter in Vermont, Connecticut, Massachusetts, and New York. Many of his works, such as *Daniel Boardman* (1789), combine landscape with a portrait. Earl's native talent and the polish he learned under West made him one of the best American portrait painters of his time.

Francis William Edmonds 1806–1863
Born in Hudson, New York, Edmonds became a banker in New York City. He was interested in painting, though, and he took classes at the National Academy of Design, first exhibiting there under the pseudonym E. F. Williams. In 1840, he traveled to Europe to study the old masters, and it is evident from such works as *The Bashful Cousin* that he was greatly influenced by Dutch artists.

Although Edmonds painted portraits, landscapes, and literary subjects, he came to specialize in nationalistic and often humorous genre scenes. Edmonds finally retired from banking in 1855, and he continued to paint and exhibit his work until 1859.

Jacob Eichholtz 1776–1842
Born in Lancaster, Pennsylvania, and trained as a sign painter and coppersmith, Eichholtz began to paint small profile portraits as early as 1806. It is said that he received some artistic advice from Gilbert Stuart and Thomas Sully, but Eichholtz was largely self-taught. He produced a few landscapes and genre scenes, but he specialized in strong, brightly colored, linear portraits of people living in the Philadelphia–Baltimore area.

Arshile Gorky 1904–1948
Born Vosdanig Manoog Adoian in an Armenian village, Gorky and his family fled when the Turks invaded. They lived as refugees for several years, and Gorky's mother died of starvation in 1919. The following year Gorky came to the United States, was reunited with his father in Providence, Rhode Island, and began studies at the Rhode Island School of Design. In New York in 1925, he was affiliated with Grand Central Art School until 1931, teaching and studying the works of the Impressionists, Cézanne, and the Cubists.

While working for the WPA (1936–38) Gorky painted the recently rediscovered abstract mural at the Newark, New Jersey, airport. Gorky was by this time associated with the Surrealists, with whom he exhibited in 1942. Seeing art as a language, Gorky invented "ideograms," images taken from nature and the subconscious. Gorky's art is considered to have laid the groundwork for Abstract Expressionism in America. The artist committed suicide in 1948.

Chester Harding 1792–1866
Although born in Conway, New Hampshire, Harding grew up in poverty in New York. In 1917 he worked for a time as a house and sign painter in Pittsburgh, learning portrait painting from an itinerant artist. He then joined his brother, a cabinetmaker and portraitist in Paris, Kentucky. Around 1820, Harding studied briefly at the Pennsylvania Academy of the Fine Arts, then returned to Kentucky and worked as an itinerant there and in Ohio and Missouri, painting figures such as the legendary Daniel Boone. Encouraged by his success, Harding moved to Boston and received many more commissions.

Harding was in London from 1823 to 1826 and, influenced by Sir Thomas Lawrence, he established himself as a portrait painter. He returned to Boston and finally settled in Springfield, Massachusetts. He painted more than one thousand portraits, and he was so successful that the phenomenon was called "Harding fever."

William Michael Harnett 1849–1892
Acknowledged today as one of the greatest of the late nineteenth-century American still-life painters, Harnett was born in County Cork, Ireland, but came to Philadelphia with his family in 1849. He began his career as a silver engraver. From 1867 he attended evening classes at the Pennsylvania Academy of the Fine Arts, and after moving to New York in 1869, attended night classes at the Cooper Union and the National Academy of Design, where he exhibited his first painting in 1875. In 1876, having decided to become a painter of still lifes, Harnett returned to Philadelphia, resumed his studies at the Pennsylvania Academy, and exhibited his paintings at Academy exhibitions. He traveled to Europe in 1880. In London and Frankfurt Harnett studied the still-life paintings of seventeenth-century Dutch masters, then proceeded to Munich for four years where he achieved considerable popular success. A version of his *After the Hunt* was accepted by the Paris Salon of 1885 and subsequently influenced late nineteenth-century American still-life painting after being shown in the United States.

In 1886 Harnett returned to New York. The paintings of his last six years include many tabletop still lifes, like *My Gems* (1888), in which objects of different form and texture are set against a paneled wall. Although Harnett achieved a significant reputation as an artist and had little difficulty selling his paintings, many critics considered his work overly imitative and lacking in creativity. He died in New York City in 1892.

Marsden Hartley 1877–1943
Hartley was born in Lewiston, Maine, and showed an early talent for drawing. He studied at the Cleveland School of Art (1898), and in New York at the Chase School (1899) and the National Academy of Design (1900). He came to the attention of Alfred Stieglitz who gave Hartley a show at his "291" gallery in 1909 and who, along with Arthur B. Davies, helped send Hartley to Europe in 1912. In France, Hartley experimented with Cubism and Fauvism; in Germany (1913–15) he came under the influence of Kandinsky and Franz Marc, exhibited with the Blaue Reiter group, and produced a group of colorful paintings based on German military emblems. When he returned to America, however, he abandoned the mysticism and emotionalism apparent in the European works and settled down to a more straightforward abstraction.

Another trip to Europe in 1921 lasted ten years. This was followed by Hartley's famous Dogtown series, with its heavily outlined forms and somber coloration, produced in 1931 in Gloucester, Massachusetts. Beginning in the 1830s, Hartley returned to Maine each year to paint its seascapes and mountain scenes. He died in Ellsworth, Maine, in 1943.

Childe Hassam 1859–1935
Born in Dorchester, Massachusetts, son of an old New England family, Hassam left high school to work in Boston and trained there as a wood engraver. He first was employed by Little, Brown & Company and then worked as an illustrator (1880s and 1890s) for *Scribner's* and *Harper's*. After studying at the Boston Art Club and the Lowell Institute and with artist Ignatz Gaugengigl, Hassam set up his own studio.

Hassam went to Europe in 1883 and again in 1886, when he enrolled at the Académie Julian in Paris for three years. There he came into contact with the Impressionists, and his paintings became brighter in color with looser brushwork.

Hassam, with J. A. Weir and John Twachtman, founded the American impressionist group called The Ten. Although Hassam used impressionist techniques to create his paintings of New England landscapes and New York City street scenes, his works are decidedly American in that they never lost definition of form. In 1915, Hassam became interested in etching, and in 1917–18 did a series of lithographs of street scenes and harbor views similar to Whistler's.

Martin Johnson Heade 1819–1904
Heade was born in Lumberville, Pennsylvania. He received his early artistic training from Edward Hicks and Hicks's younger cousin, Thomas Hicks, and then traveled to Europe (probably in the early 1840s), spending two years in Rome. Upon his return to the U.S., Heade established a studio in New York City, but traveled almost constantly; by 1860, he had lived in eight different cities and had journeyed widely in America and Europe. In the late 1850s, Heade began to paint landscapes of shore scenes and salt marshes around the Narragansett Bay region of Rhode Island, where he spent the summer. He painted the salt marsh, his favorite subject, throughout his later career; over one hundred of these paintings survive to this day.

In 1863, Heade made the first of three trips to South America, perhaps inspired by the South American paintings of his friend Frederic Church, and began to paint forest and flower still-life scenes based on these trips. In the 1870s, Heade combined hummingbirds and orchids in his paintings, creating sensual and exotic images which came to take precedence over his landscapes in the later stages of his career. Heade was not particularly well known as a painter, but he continued painting up to his death in 1904 in St. Augustine, Florida, and was one of the few painters of his generation who was equally adept in painting both landscapes and still lifes.

Robert Henri 1865–1929

Influential teacher and painter of realistic portraits and figure studies, Robert Henri was born Robert Henry Cozad in Cincinnati in 1865. After living in Nebraska, Colorado, and New Jersey, Henri studied at the Pennsylvania Academy of the Fine Arts with Thomas Anshutz and Thomas Hovenden (1886–88). Then he went to Paris to study at the Académie Julian and École des Beaux-Arts. In 1891 Henri returned to Philadelphia, where he met fellow artists John Sloan, George Luks, William Glackens, and Everett Shinn, later all members of The Eight. During another stay in Europe (1895–1900), Henri abandoned the impressionist style he had used since his first trip there and began to paint in a darker style more akin to Hals and Manet.

Back in the U.S., Henri continued his distinguished teaching career in New York: at the New York School of Art (1902–12), at the Henri School (established 1909), at the Ferrer Center School (1911–18), and at the Art Students League (1915–18). A leading painter among the urban realists of the early twentieth century and a spokesman for many younger artists, Henri helped organize the exhibition of The Eight (1908) and the Exhibition of Independent Artists (1910).

Edward Hicks 1780–1849

America's best-known nineteenth-century folk artist, Hicks was born in Bucks County, Pennsylvania. Apprenticed to a carriage maker, he repaired carriages and painted coaches, signs, chairs, firebacks, and other objects. Hicks was an active Quaker preacher and painted religious subjects as well. His most famous was *The Peaceable Kingdom,* of which he made over one hundred versions. Hicks's paintings illustrate his strong sense of color and design. He died in 1849, and it is said that about three to four thousand people attended his funeral.

Winslow Homer 1836–1910

Homer began his artistic career in 1854 by drawing music-sheet illustrations for Bufford's lithography firm in his native Boston. Resolving to "never again [work] for wages," he made wood engravings as a free-lance artist, submitting his illustrations to *Ballou's* and *Harper's* magazines. In 1859 Homer moved to New York, and he continued to produce illustrations for *Harper's.* He also began to paint in oil and submitted his Civil War subjects to the National Academy in 1863 and 1864, when he was elected an Academician. In 1866 he visited Paris. In 1873 Homer began to paint in watercolor—a medium he used extensively for the rest of his career. That year he spent his first summer painting in Gloucester, Massachusetts, and the next year went to the Adirondacks. Both areas, representing the dual themes of the sea and the woods, were to figure significantly in his later work.

In 1881 Homer spent a year and a half in the coastal town of Tynemouth, England. There, working principally in watercolor, he chronicled the daily life of Tynemouth's residents and their constant battle with the sea. In 1882 he settled in Prout's Neck, Maine, where he was to live, except for occasional excursions, for the rest of his life. Along with his oils and watercolors of the Maine coast, Homer painted Adirondack subjects and scenes set in the Bahamas and Florida where he spent several winters during 1884-1904. He continued to exhibit his work at the National Academy of Design and by the mid-1880s had achieved a reputation as a major artist—one that endures to the present day. He died in Prout's Neck in 1910.

Edward Hopper 1882–1967

Born in Nyack, New York, Hopper received his first art training in New York City under Robert Henri. As a leader of the Ashcan school and proponent of the modern urban scene, Henri passed on both principles of direct realistic painting and attention to the contemporary look and life of the city. In 1906 Hopper went to Paris, painting urban views there, and returned again at the end of the decade. Although he was able to sell a painting at the Armory Show in 1913, he had little further professional success for the next ten years, and turned as a result to a highly successful output of etchings in this period. During the 1930s he undertook his extensive series of paintings around Gloucester, on eastern Cape Cod, and along the southern Maine coast. Like his continuing city views of lower Manhattan, these views showed a simplicity of form and mass, a powerful sense of natural and architectural structure, and the defining force of strong lighting. An often lonely individual himself, Hopper conveyed both the feeling and actuality of emptiness and isolation in many of his mature works. In the 1940s and fifties he visited the southwest and Mexico, painting bold landscapes in the sharp western light and broad defining masses. He still remained an observer of ordinary people preoccupied with their daily lives in the modern city, usually positioning them alone or separated from one another, framed (and metaphorically confined) by the architecture of their environment. His later work tended to be brighter in color but more drained of warmth and intimacy. A successful watercolorist as well for much of his career, Hopper undertook a large group in this medium on his later trips to the southwest. Honors and retrospectives came to him from the 1930s on. Living as frugal a life as his images were spare, Hopper died in his Washington Square, New York, studio where he had worked for over fifty years.

George Inness 1825–1894

Though born in Newburgh, New York, Inness was raised in Newark, New Jersey, where he first studied art with Jesse Barker, an itinerant artist. He was apprenticed to a New York engraving firm for two years, and then studied art with Regis Francois Gignoux, a French landscape painter with a New York studio. By 1850 Inness had developed a modest reputation as an artist, and Ogden Haggerty, a patron, provided funds which enabled him to study in Europe. He sailed to Italy for about fifteen months, returning to New York in 1852. He made a second trip, to Paris, at the end of 1853.

Inness stood somewhat apart from his contemporaries as a landscape painter, and even in the late 1840s many reviewers criticized his disinclination to base his paintings upon a literal interpretation of nature. He was an admirer of the Barbizon School, and Rousseau, Daubigny, and Corot were among his favorite painters.

In 1860 Inness left New York for Medfield, Massachusetts, and around 1863 settled near Perth Amboy, New Jersey. His reputation by this time was well established, but financial success did not come until the mid-1870s, when Inness took as his agent Thomas B. Clarke. From 1870 to 1874 Inness traveled to Paris and Rome, and in 1878 moved to Montclair, New Jersey, for the rest of his life. By the 1880s, Inness's art was at the forefront of prevailing taste, and his reputation continued up to his death on a trip to Europe in 1894.

Eastman Johnson 1824–1906

One of the best-known American figure painters of his generation, Johnson was born in Lovell, Maine, and first showed artistic talent drawing crayon portraits of his family and friends. After a brief apprenticeship at Bufford's lithographic shop in Boston, Johnson worked as a portraitist in 1842 in Augusta, Maine, again using crayon and charcoal, and continued his career in Washington, D.C. (1845–46) and Boston (1846–49). In 1849 he went to Düsseldorf, where he shared a studio with Emanuel Leutze, then to The Hague; in 1855 he went to Paris, where he studied briefly with Thomas Couture, and back to Washington.

In 1856 and again in 1857, Johnson visited his sister in Superior, Wisconsin; he became fascinated with the Chippewa Indians in 1857 and lived for several months in one of their camps, painting Indian portraits. In 1858 he moved to New York, his base for the rest of his career, and where he died in 1906.

During the Civil War, Johnson spent time with the Union troops, painting anecdotal scenes of soldiers' camps and the home front. He also painted rural scenes of farmers at work and at leisure in New England. In the 1870s he increasingly painted interior and garden scenes of women and children, set in Nantucket, where Johnson spent much of the year. After 1880 he turned to portraiture almost exclusively. He painted many of the great public figures of his time and could charge up to $10,000 for a portrait.

Joshua Johnson active 1796–1824

Thought to be the earliest professional black artist in America, Baltimore painter Joshua Johnson may

have been a slave who purchased his freedom with his paintings. Little is known about Johnson's background, although it is suspected that he received some artistic instruction from Charles Peale Polk, Charles Willson Peale's nephew. Most of Johnson's paintings are charming and decorative portraits of Baltimore's leading families.

John F. Kensett 1816–1872
Born in Cheshire, Connecticut, Kensett began his artistic career as an engraver of business items and banknotes. Resolving to become an artist, Kensett traveled to Europe: in 1840 to Paris where he alternated between landscape painting and engraving to support himself; in 1843 to London; and in 1845 to Rome.

Returning to New York City in late 1847, Kensett exhibited at the National Academy of Design and quickly established his reputation as one of America's leading landscape painters. His output following his return from Europe was consistent in both style and subject matter, treating familiar outdoor scenes (particularly the coast around Newport, Rhode Island) in a quiet manner, which contrasted with the dramatic landscapes of Bierstadt and Church. Kensett traveled West in 1870 with fellow artists Worthington Whittredge and Sanford Gifford and made several painting tours of Europe, but most of his paintings were of the mountains and coastal regions of New York and New England.

Fitz Hugh Lane 1804–1865
Born in Gloucester, Massachusetts, Lane began his artistic career as an apprentice at Pendleton's lithography shop in Boston. At Pendleton, Lane made small sketches of the harbor and environs of Boston which were incorporated into sheet-music covers. About 1835, he formed a lithographic firm with J.W.A. Scott, a marine painter, and published coastal scenes, moving up and down the New England coast for his subjects. In the early 1840s Lane also painted in oil, influenced in part by the work of the marine painter Robert Salmon.

In 1849, his lithography firm dissolved, Lane devoted full attention to marine painting. He returned to Gloucester and also made annual visits to the Maine coast until 1855, although he painted Maine scenes up to his death in Gloucester in 1865. Lane's trips to Maine had a pervasive effect on his later work; his fascination with the light of dawn and dusk, for instance, stemmed from these visits.

Jacob Lawrence b. 1917
Born in Atlantic City, New Jersey, Lawrence spent his first years in Easton, Pennsylvania, where his father was a coal miner. In 1920, he and his mother moved to Harlem. Lawrence studied with black artist Charles Alston (1932–39) and was employed by the WPA (1934–38). He also won a scholarship to the American Artists School (1937–39) and was given his first one-man show in New York in 1941.

His colorful, stylized tempera paintings, often accompanied by written explanations, deal with the lives of black people. His first series, based on the life of Toussaint L'Ouverture (the black slave who founded Haiti), was created in 1936. Other series based on Negro history included *The Migration of the Negro* (1940–41), *Life in Harlem* (1943), a series on abolitionist John Brown (1946), and *Sanitarium* (1950). In the 1950s and 1960s, Lawrence focused on the Civil Rights movement. In 1964 Lawrence went to Nigeria which served as inspiration for his later works.

George Luks 1866–1933
Luks was born in Williamsport, Pennsylvania, to parents who were amateur artists. In 1883, he and his brother moved to Philadelphia and performed there in vaudeville. He studied at the Pennsylvania Academy of the Fine Arts (1884) and, beginning in 1885, continued his studies in Düsseldorf, Paris, and London. When he returned to the U.S., he worked as an artist-reporter for the Philadelphia *Press* and became friends with other newspaper artists who would eventually form The Eight. Luks went to Cuba in 1895 as a war correspondent for the Philadelphia *Evening Bulletin* and in 1896 moved to New York where he became a cartoonist for the *New York World*. It was about this time that William Glackens encouraged Luks to try painting. Luks's realistic works from the early years focused on themes from the urban ghetto. After 1915 he concentrated on rural subject matter and in the 1920s he painted a group of powerful character studies of Pennsylvania coal miners.

John Marin 1870–1953
Born in Rutherford, New Jersey, Marin had begun drawing before he was twenty, and during the 1890s he worked for several architects in nearby Union Hill. At the end of the decade he turned his attention to becoming a serious artist, and went to study first at the Pennsylvania Academy of the Fine Arts and then at the Art Students League in New York. He went to Europe in 1905 for five years, and there became familiar with the currents of Post-Impressionism. Although introduced into the circle of Alfred Stieglitz in 1909, Marin was slow to embrace the more radical interests of modernism. While abroad, he also devoted himself actively to making etchings, and thereafter would develop with parallel strengths as both a graphic artist and painter. Around 1912 his style began to take on a new abstraction in line as well as color, largely in response to the new works of Cubism and Orphism shown by Stieglitz and dramatized by the Armory Show in New York in 1913. The following year Marin made his first of many trips to Maine, and in the twenties he also made return visits to New Mexico to paint. His love of landscape, and its rendering alternatively in oil and watercolor, was partially indebted to the precedents of Winslow Homer, though Marin's fusing of the realist tradition

with abstract fragmentation and energy expressed a clearly modernist impulse. During the 1930s he painted more extensively in oil, developing surfaces of dense layers and patterns of paint which anticipate something of the freedom and purity of Abstract Expressionism. During his later career he returned regularly to his house and studio on the rural Maine coast. He remained busy and productive until his death at Cape Split in 1953.

Robert Motherwell b. 1915
One of the leaders of the Abstract Expressionist movement, Motherwell was born in Aberdeen, Washington, and grew up on the West Coast. He studied at the Otis Art Institute in Los Angeles (1926), the California School of Fine Arts in San Francisco (1932), and graduated from Stanford University in 1937. He traveled to Europe (1935 and 1938–40) and did graduate work in philosophy (Harvard, 1937–38) and art history (Columbia, 1940–41). Columbia professor Meyer Schapiro introduced him to such European artists as Duchamp, Ernst, Mondrian, and Matta, and he also met de Kooning, Rothko, Newman, Baziotes, Gottlieb, and Hofmann. With the latter group he helped run the art school Subjects of the Artist. He has also taught at Black Mountain College in North Carolina (1945, 1951), at Hunter College in New York (1951–58), and at Harvard and Yale.

Motherwell's most famous abstract series, on which he has worked for over twenty years, is the *Elegy for the Spanish Republic*. Another series, *Je t'aime*, was produced in the mid-1950s and his *Open* series came in the 1960s. Since that time he has concentrated on creating huge abstract collages.

Georgia O'Keeffe 1887–1986
Born in Sun Prairie, Wisconsin, O'Keeffe first studied art in Chicago at the Art Institute, and between 1910 and 1912 successively enrolled at the Art Students League in New York, the University of Virginia, and Teachers College at Columbia University. Soon after, she went south and undertook her first abstract watercolors and charcoal drawings. She sent a group of the latter to a colleague in New York who in turn showed them to Alfred Stieglitz, contrary to the artist's wishes. Seeing them prompted the art dealer and photographer to make the famous exclamation, "Finally a woman on paper!" From this initial turbulent exchange emerged a personal and professional association that led to their marriage in 1924 and lasted until Stieglitz's death in 1946. Thereafter she exhibited regularly at his 291 Gallery, greatly expanding her style and subject matter during the late 1920s. She painted alternatively in realist and abstracted modes, and took up both landscape and cityscape views, as well as magnified renderings of shells, flowers, and bones. She made her first extensive visit to the southwest in 1929, and returned again to New Mexico in 1934 for a summer at Ghost Ranch near Abiquiu. The following year she bought a house

there and came back to paint each summer until the late 1940s when she moved there permanently. These same years also saw her first major retrospectives organized by the Art Institute and then the Museum of Modern Art. A good deal of European and other foreign travel followed in the 1950s and sixties, while other important exhibitions and honors confirmed her place as one of America's greatest artists of the twentieth century. In her later years she undertook large-scale mural paintings of clouds, inspired by her air travel across the continent. She died at home just short of her one-hundredth birthday.

Linton Park 1826–1906

The youngest of nine children of a Scotch-Irish family in western Pennsylvania, Park learned to be a furniture maker and coach and sign painter in his father's shop. During the Civil War, he was stationed in Washington and was assigned to the burial corps and guard duty at the White House. After the war, Park traveled and then returned to his hometown of Marion, Pennsylvania. There he was a painter of wagons and signs, a logger, and an inventor. Among his inventions was a venetian blind which won a prize at the Centennial Exposition of 1876.

Park's earliest known paintings are dated in the 1870s. His genre scenes of farm and logging operations document life in nineteenth-century rural Pennsylvania.

Charles Willson Peale 1741–1827

Peale was born in Queen Anne County, Maryland, and grew up in Annapolis where he was apprenticed to a saddler. He then worked in Maryland as a silversmith, upholsterer, harness-maker, and sign painter. In Philadelphia he received instruction in portrait painting from John Hesselius, in Boston he saw the works of colonial artists John Smibert and John Singleton Copley, and in London he was able to study under Benjamin West for more than a year.

Returning to Annapolis in 1769, Peale set up a successful portrait practice; George Washington numbered among his sitters. He settled in Philadelphia in 1776, but soon left to serve in the Revolutionary War as militia captain. Following the war, Peale added a gallery to his Philadelphia house and there exhibited his portraits of war heroes. He established the Pennsylvania Academy of the Fine Arts in 1805. But it was to his natural history museum, "a world in miniature," that Peale was to devote his time and energies from 1786 until the end of his life. Over 100,000 objects were on view there: birds, animals, fossils, minerals, and even a mastodon that Peale had helped to excavate. Several of Peale's seventeen children—many of whom he named after artists such as Rubens, Raphaelle, Rembrandt, and Titian—also became famous artists.

Rembrandt Peale 1778–1860

Rembrandt was the seventh child (and third surviving) of Charles Willson Peale, born at the height of the American Revolution, while his father was actually serving and painting with Washington's troops. As a child he became familiar with the artist's tools and prints collected by his father; he was inspired early to become a painter himself after the example of numerous other painting members of the family. An undated self-portrait is one of his first attempts at professional results in these youthful years. Additional stimulus for the young artist obviously also came from the presence of Robert Edge Pine's work in Philadelphia as well as Gilbert Stuart's arrival there in the mid-1790s. Rembrandt's first major achievements date from this period, including portraits of Washington and Jefferson and the famous portrait of his brother, *Rubens Peale with a Geranium*. At the same time he also became involved in his father's museum work and in his excavations of the mastodon bones in upstate New York. In 1802 he went to London with his family to promote an exhibition of one skeleton set and to pursue his art through increasing familiarity with the English tradition. Two years later he was back in the United States, but returned to Paris in 1808, again coming home a couple of years later. During the 1820s he took up ambitious history paintings and his formal new "Standard Likeness of Washington," which would be the basis for dozens of copies in succeeding years. He carried on into later life the museum activities of his father and brothers, promoting art and aspiring to create an elevated national artistic expression. Other trips to Europe followed, as did painting excursions to Niagara Falls and elsewhere. In the 1830s he published his *Graphics*, an art education manual, popular for many years thereafter, and in the 1850s his autobiographical *Reminiscences*. His later art tended toward repetitiveness and stiffness, as his long life concluded in an age of dramatically shifting tastes and concerns. Writing and lecturing almost up to the end, Rembrandt Peale died at home in Philadelphia in 1860.

John Frederick Peto 1854–1907

Born in Philadelphia, Peto studied at the Pennsylvania Academy of the Fine Arts. At first greatly influenced by fellow student William Michael Harnett, Peto began in the late 1870s to paint still lifes of books, pipes, mugs, and newspapers. In fact, many Peto paintings today still carry the forged signature of the better-known Harnett. Peto's rack pictures and other works did not bring him success, however, and he supplemented his income by playing cornet at camp meetings in Island Heights, New Jersey. Growing more and more reclusive, Peto in 1889 moved to Island Heights for good. There he continued to paint dark, melancholy, trompe-l'oeil still lifes composed of often worn-out objects from everyday life.

Jackson Pollock 1912–1956

Born Paul Jackson Pollock in Cody, Wyoming, the artist grew up in Arizona and California. He studied at the Art Students League under Thomas Hart Benton (1926–33) and painted in Benton's anecdotal, regional style. He went on several cross-country sketching trips in the 1930s and occasionally worked for the WPA between 1935 and 1942. At this time he became interested in the work of Mexican muralists Orozco and Siqueiros, as well as Picasso and the Surrealists, and met Robert Motherwell and other Abstract Expressionists. Pollock was supported by Peggy Guggenheim in 1943–47. He began to experiment with pouring and dripping paint on canvas, putting his whole body into the act of painting. In 1945 he moved to The Springs, Long Island, and continued to paint abstract images. Larger drip paintings were painted in 1948–50. For a brief period (1950–52), he abandoned abstraction and returned to a more representational and figural style. In 1953 he began a new type of drip painting, with patterns of overlapping and intertwining lines, which he worked on until his death in 1956.

Maurice Prendergast 1859–1924

Though born in St. John's, Newfoundland, Prendergast grew up in Boston, where he showed an early interest in watercolor sketching. His first training came with trips to Europe in the 1880s and nineties. He took formal training in Paris and began actively painting on working excursions outdoors. His style of bright colors, tight brushstrokes, and animated surface designs reflected the influence of key post-impressionist developments in Paris at the close of the century, especially the work of the Nabis, the symbolists, and the neo-impressionists. Bonnard's intimate compositions, abstracted formats, and colorful patterns in particular served as inspiration for Prendergast as he also took up subjects of women and children at leisure or play in the parks. When he returned to Boston in 1895 Prendergast began to collaborate with his brother Charles, now active as a frame designer and producer. Often the latter's elegant gold-leaf designs and floral decorations perfectly embellished Maurice's lively oils and watercolors. The painter returned to Europe in 1898 for another two years, this time spending time in Venice painting delicate but strongly composed watercolors inspired as much by Renaissance mosaics as by the fantastic carnival atmosphere of the watery city itself. After the turn of the century, Prendergast rapidly gained a solid reputation and recognition in museum awards and exhibitions. He was asked to join with other painters in New York the group known as The Eight, devoted in part to painting the modern city scene and to championing modern directions in art. Prendergast continued to travel abroad until World War I. His sense of pure design and color intensified with the Armory Show and a continuing attention to modern French styles; his feeling of happy celebration and nostalgia seemed to survive detached from the shocks and crises of the new century. His outlook and stylistic convictions remained steady until his death in 1924.

John Quidor 1801–1881
Born in Tappan, New York, Quidor moved to New York City where he was apprenticed to artist John Wesley Jarvis, probably between 1814 and 1822. Although he is listed as a portrait painter in New York directories, no portraits are known to exist. He earned a living painting signs, banners, and ornamentations for New York fire companies. Between 1837 and 1850 he worked on a series of seven large biblical paintings—since lost—that he hoped would be received like those done by Benjamin West. From 1851 to 1868, however, he concentrated on romantic and humorous genre scenes illustrating stories from writers such as Washington Irving and James Fenimore Cooper.

After a series of misfortunes, Quidor went to live with his daughter in New Jersey and painted nothing for the last ten years of his life.

Mark Rothko 1903–1970
Rothko was born in Dvinsk, Russia, in 1903, but moved with his family to Portland, Oregon, in 1913. He attended Yale (1921–23) and in 1925 moved to New York where he studied with Max Weber at the Art Students League. In 1935 Rothko joined with Adolph Gottlieb in organizing other painters who advocated an expressionist style into a loose group sometimes called The Ten. By 1938 he had begun to leave realism behind for a biomorphic style, being very much influenced by Surrealism at this time. In 1948 he helped to found an art school called Subjects of the Artist, which lasted until 1949, and his style moved increasingly toward abstraction. By 1950 he had come to the format for which he is known: contemplative paintings of two or three rectangles floating in an ambiguous space on the canvas.

Rothko taught at the Center Academy in Brooklyn until 1952, at the California School of Fine Arts in San Francisco in the summers of 1947 and 1949, and at Brooklyn College from 1951 to 1954.

Albert P. Ryder 1847–1917
Born in New Bedford, Massachusetts, Ryder received little education due to impaired eyesight. But he began painting landscapes near his home and around 1867 moved to New York where he attended classes at the National Academy of Design. Although he made many trips to Europe in his lifetime (1877, 1882, 1887, 1896), they were more for travel than for the study of European art.

Ryder's early works, such as *Mending the Harness* (c. 1875), are small naturalistic landscapes depicting rural life. In the 1880s, he took his themes from literature (the Bible, Shakespeare, Chaucer, Poe, Byron) and from Wagnerian operas (*Siegfried and the Rhine Maidens,* 1888/91), and his style became much more personal and visionary. However, Ryder is perhaps best known for his simplified moonlit seascapes built up of many thick layers of paint and glazes. Because the reclusive artist worked on each painting for an extended period of time, he produced fewer than 200 pictures in his lifetime.

John Singer Sargent 1856–1925
Sargent was born in Florence, where his expatriate American parents spent part of each year. Raised in a very cultured environment, Sargent received professional artistic training as a boy in Rome as early as 1868 and was enrolled in the Academia delle Belle Arte in Florence in 1870. In 1874, after his family moved to Paris, Sargent studied with the French portrait painter Carolus-Duran. He began to exhibit his paintings at the Paris Salon, and he made trips to Spain (1879), to Holland (1880), and to Venice (1880 and 1882). In 1885 Sargent transferred his studio to London, and in 1887 traveled to Boston. His second visit to the U.S. in 1890 brought him forty portrait commissions, and in the 1890s Sargent enjoyed tremendous success as a painter of portraits.

In 1909 Sargent gave up his work in portraiture and devoted his full attention to landscapes and genre scenes, frequently painted in watercolor—a medium he had used from time to time and developed fully in his later career. He divided the last ten years of his life between Boston and London and died in 1925 in London.

John Sloan 1871–1951
Born in Lock Haven, Pennsylvania, and raised in Philadelphia, Sloan studied at the Pennsylvania Academy of the Fine Arts with Thomas Anshutz (1892–94). He also worked as a commercial artist and an artist-reporter for the Philadelphia *Inquirer* (1892) and *Press* (1895–1903). In the 1890s he became acquainted with other artist-reporters, including Glackens, Luks, and Henri, later all members of The Eight. Sloan's first urban scenes, influenced by Henri, appeared in 1897. In 1904 he moved to New York and began a series of etchings depicting realistic scenes of city life.

The most political member of The Eight, Sloan joined the Socialist party in 1909 and thereafter contributed drawings to its magazines. He continued to paint, and his subject matter included landscapes and interiors as well as street scenes (*The City from Greenwich Village,* 1922). From 1929 to 1939, he concentrated on painting series of nude figures. Sloan was also an influential teacher at the Art Students League, and in 1939 he published *Gist of Art,* a summary of his thoughts.

Gilbert Stuart 1755–1828
Born near Newport, Rhode Island, Stuart was a pupil of Scottish painter Cosmo Alexander, with whom he went to Edinburgh in 1772. Alexander's sudden death forced Stuart to return to Newport, where he painted colonial portraits until 1775, the year he went to London. Stuart worked in Benjamin West's studio (1777–82), helping with history paintings and portraits. He opened his own studio in 1782 and was an immediate success due to the popularity of *The Skater.* He soon became one of the leading portraitists in London, but debts forced him from London—to Dublin (1787–92) and then to New York

(1792–94). He finally settled in Boston in 1805.

Stuart produced elegant, painterly portraits of the leading men and women of the Federal era, but he is best known for his likenesses of George Washington. He is also remembered as a teacher, to artists such as Mather Brown, John Trumbull, and Samuel F. B. Morse.

Thomas Sully 1783–1872
Born at Horncastle, England, Sully moved to Charleston, South Carolina, with his parents in 1792. His first instruction in painting came from miniature painters: schoolmate Charles Fraser, brother Lawrence, and brother-in-law Jean Belzons. From 1801 until 1807, when he settled in Philadelphia, Sully traveled widely in the United States. He began to paint oil portraits and received criticism from some of the nation's leading artists, notably John Trumbull and Gilbert Stuart. In 1809 several Philadelphia patrons sent Sully to England for further study. After a year in London studying with Sir Thomas Lawrence, he returned to Philadelphia.

Following Charles Willson Peale's death in 1827, Sully's position as Philadelphia's leading portrait painter was unquestioned. In 1838 he again visited England and painted a portrait of Queen Victoria. He was active at the Pennsylvania Academy, having become an Academician in 1812, but declined to become president. Throughout his career Sully traveled frequently to other cities to paint portraits, and maintained close ties with friends in Charleston.

Sully methodically recorded his paintings in a register, and his output numbered over twenty-six hundred paintings. In addition to portraits, he painted historical compositions, landscapes, so-called "fancy pictures," and copies after old masters. He died in Philadelphia in his ninetieth year.

Henry O. Tanner 1859–1937
Tanner was born in Pittsburgh, son of a bishop. The family moved to Philadelphia in 1866, where he studied at the Pennsylvania Academy of the Fine Arts under Thomas Eakins (1880–82). Tanner moved to Atlanta in 1888 where he opened a photography studio and taught at Clark University. In 1891, thanks to several patrons, he studied in Paris under Jean-Paul Laurens and Benjamin Constant and exhibited at the Salon; Paris became his home for the rest of his life. Tanner turned from landscapes and genre scenes to religious subject matter and in the late 1890s traveled to the Holy Land and later to Egypt and Morocco. Biblical subjects and landscapes became the focus of his paintings after 1900.

John Henry Twachtman 1853–1902
A founding member of the American impressionist group known as The Ten, Twachtman was born in Cincinnati in 1853, and began his artistic career painting decorations on window shades. After studying at the Ohio Mechanics Institute and at the Cincinnati School of Design under Frank Duveneck, Twachtman accompanied Duveneck to Europe in

1875. He continued studies at the Royal Academy in Munich and painted in the dark tonality of that school. He went to Venice with Duveneck and William Merritt Chase in 1877 and in 1878 returned to the United States.

Twachtman went back to Europe in 1880: he taught at Duveneck's school in Florence, accompanied J. A. Weir and J. F. Weir to Holland (1881), and went to Paris (1883). There he studied at the Académie Julian with Jules Lefebvre and Louis Boulanger and came under the influence of the French Impressionists and of Whistler. Back in the U.S. in 1885, Twachtman met American impressionists Childe Hassam and Theodore Robinson, and by the 1890s he was painting light, atmospheric canvases in the impressionist mode. Many of Twachtman's later works, such as *Winter Harmony* (c. 1890–1900), were painted on his farm in Greenwich, Connecticut, to which he moved in 1889.

Max Weber 1881–1961
Born in Bialystok, Russia, son of a tailor, Weber came to Brooklyn in 1891 and subsequently studied (1898–1900) at the Pratt Institute with Arthur Wesley Dow. He taught in Virginia (1901–03) and in Minnesota (1903–05). From 1905 to 1908, he studied in Paris and met artists such as Braque, Picasso, Matisse, and Henri Rousseau; he also exhibited with the Independents. Back in New York, Weber began to experiment with a number of the artistic styles (Fauvist, Cubist, Futurist, primitive) he had seen in Europe. He created some of the first American abstract sculptures, and he published *Essays on Art*, a major statement of modernism.

Around 1919, Weber turned away from abstraction and painted monumental nude figures. Then followed scenes of Jewish life and still lifes, nudes, and landscapes. In the 1930s his art depicted workers and refugees, and Weber became national chairman of the American Artists Congress. In the 1940s he painted colorful, distorted images in a personal, expressionistic style.

Benjamin West 1738–1820
The first American artist to be internationally famous was Benjamin West, who began his career as a primitive painter in Pennsylvania. William Williams, who was in Philadelphia in the 1840s, probably taught West to paint at an early age. At age fifteen, West obtained his first portrait commission. After working as a portrait and sign painter in Philadelphia, West in 1760 went to Rome for three years. He then settled in London and painted well-received biblical and classical scenes. His *Death of General Wolfe* (1770) gained him attention in London, and in 1772 he was appointed Historical Painter to the King. In 1792 he was elected President of the Royal Academy, a position he held until his death. Almost every American artist who went to London studied with West, among them C. W. Peale, Stuart, Morse, Allston, Trumbull, Copley, and Sully. West's paintings were mostly historical scenes, first in the grand neo-classical style and later moving to a more romantic one.

At his death in London, he was accorded the honor of burial in St. Paul's Cathedral.

James NcNeill Whistler 1834–1903
Born in Lowell, Massachusetts, Whistler lived in Russia (1843–49) while his father worked there. He attended West Point for awhile and worked as an illustrator, surveyor, and cartographer. In 1855, he sailed to Europe, never to return. He went first to Paris, where he studied under the academician Charles-Gabriel Gleyre and became acquainted with Courbet, Degas, Manet, and Fantin-Latour. In 1859, he settled in London. Whistler's delicate *White Girl: Symphony in White No. 1* startled the public at the 1863 Salon des Refusés as did his 1874 one-man show filled with paintings entitled "nocturnes," "symphonies," and "arrangements." In 1878, criticism from John Ruskin led to a lawsuit which Whistler won, but the costs of the suit bankrupted him.

Whistler was also a successful etcher, producing over five hundred landscapes, figures, and portraits. After the 1880s, he increasingly used etching, lithography, pastel, and watercolor for his works.

Andrew Wyeth b. 1917
Andrew Wyeth is primarily a self-taught artist, although he did study with his father, illustrator N. C. Wyeth, at home in Chadds Ford, Pennsylvania. His first one-man show was in New York when he was nineteen years old (1937), and his bright painterly Maine watercolors sold out within a day. Soon thereafter his style changed to a more subdued, linear, and precise style. Always realistic, his tempera paintings and watercolors have concentrated on the scenery and people of Chadds Ford and Cushing, Maine, where he spends each summer. Poetic landscapes and penetrating portraits of family and friends have made Wyeth the most popular artist in America. In 1976, the Metropolitan Museum of Art held a one-man show of his work.

Bibliography

General

Allyn, Nancy E. *The Index of American Design.* (Exhibition catalogue, National Gallery of Art) Washington, D.C., 1984.

American Light: The Luminist Movement, 1850–1875, Paintings, Drawings, Photographs. (Exhibition catalogue, National Gallery of Art) Washington, D.C., 1980.

Auping, Michael, et al. *Abstract Expressionism: The Critical Developments.* New York, 1987.

Baigell, Matthew. *Dictionary of American Art.* New York, 1979.

————. *A Concise History of American Painting and Sculpture.* New York, 1984.

Black, Mary. *American Naive Paintings from the National Gallery of Art.* (Exhibition catalogue, International Exhibitions Foundation) Washington, D.C., 1985.

Boyle, Richard J. *American Impressionism.* Greenwich, Conn., 1974.

The Britannica Encyclopedia of American Art. Chicago, 1974.

Brown, Milton W., et al. *American Art: Painting, Sculpture, Architecture, Decorative Arts, Photography.* Rev. ed., New York, 1979.

Carmean, E. A., Jr., et al. *American Art at Mid-Century: The Subjects of the Artist.* (Exhibition catalogue, National Gallery of Art) Washington, D.C., 1978.

Chotner, Deborah. *American Naive Watercolors and Drawings.* (Exhibition catalogue, National Gallery of Art) Washington, D.C., 1985.

Corn, Wanda M. *The Color of Mood: American Tonalism, 1880–1910.* (Exhibition catalogue, Fine Arts Museums of San Francisco) San Francisco, Calif., 1972.

Craven, Wayne. *Sculpture in America.* New York, 1968.

————. *Colonial American Portraiture.* Cambridge, England, 1986.

Doty, Robert, ed. *Photography in America.* New York, 1974.

Finch, Christopher. *American Watercolors.* New York, 1986.

Fine, Ruth E. *Gemini G.E.L.: Art and Collaboration.* (Exhibition catalogue, National Gallery of Art) Washington, D.C., 1984.

Flexner, James Thomas. *The Face of Liberty: Founders of the United States.* (Exhibition catalogue, Amon Carter Museum) Fort Worth, Tex., 1975.

Hills, Patricia. *The Painters' America: Rural and Urban Life, 1810–1910.* (Exhibition catalogue, Whitney Museum of American Art) New York, 1974.

————. *Turn-of-the-Century America.* (Exhibition catalogue, Whitney Museum of American Art) New York, 1977.

Hornung Clarence P. *Treasury of American Design.* 2 vols. New York, 1976.

Howat, John K. *The Hudson River and Its Painters.* New York, 1972.

————, et al. *American Paradise: The World of the Hudson River School.* New York, 1987.

Hunter, Sam, ed. *American Renaissance: Painting and Sculpture Since 1940.* (Exhibition catalogue, Museum of Art, Fort Lauderdale) Fort Lauderdale, Fla., 1986.

————, and John M. Jacobus. *American Art and Architecture of the 20th Century.* New York, 1975.

Lipman, Jean, and Tom Armstrong, eds. *American Folk Painters of Three Centuries.* (Exhibition catalogue, Whitney Museum of American Art) New York, 1980.

19th Century America, Paintings and Sculpture. (Exhibition catalogue, Metropolitan Museum of Art) New York, 1970.

100 American Drawings: Loan Exhibition from the Collection of John Davis Hatch. (Exhibition catalogue, National Gallery of Ireland) Dublin, 1976.

Rose, Barbara. *American Painting Since 1900: A Critical History.* 1967; 2nd ed., New York, 1974.

Saunders, Richard H., and Ellen G. Miles. *American Colonial Portraits: 1700–1776.* (Exhibition catalogue, National Portrait Gallery) Washington, D.C., 1987.

Stebbins, Theodore E., Jr. *American Master Drawings and Watercolors: A History of Works on Paper from Colonial Times to the Present.* New York, 1976.

Strickler, Susan E., ed. *American Traditions in Watercolor: The Worcester Art Museum Collection.* New York, 1987.

200 Years of American Sculpture. (Exhibition catalogue, Whitney Museum of American Art) New York, 1976.

Wilmerding, John. *American Art.* London and New York, 1976.

————, ed. *The Genius of American Painting.* London and New York, 1973.

Young, Mahonri Sharp. *The Realist Revolt in American Painting: The Eight.* New York, 1973.

Zellman, Michael David, et al. *300 Years of American Art.* 2 vols. Secaucus, N.J., 1987.

Artists

George Bellows

Carmean, E. A., et al. *Bellows: The Boxing Pictures.* (Exhibition catalogue, National Gallery of Art) Washington, D.C., 1982.

Morgan, Charles H. *George Bellows, Painter of America.* New York, 1965.

Young, Mahonri Sharp. *The Paintings of George Bellows.* New York, 1973.

Thomas Hart Benton

Baigell, Matthew. *Thomas Hart Benton.* New York, 1974.

Burroughs, Polly. *Thomas Hart Benton: A Portrait.* New York, 1981.

Ralph A. Blakelock

Geske, Norman A. *Ralph Albert Blakelock, 1847–1919.* (Exhibition catalogue, Nebraska Art Association) Lincoln, Nebr., 1974.

Mary Cassatt

Breeskin, Adelyn D. *Mary Cassatt: A Catalogue Raisonné of the Oils, Pastels, Water-Colors and Drawings.* Washington, D.C., 1970.

Matthews, Nancy Mowll. *Mary Cassatt*. New York, 1987.

———, ed. *Cassatt and Her Circle: Selected Letters*. New York, 1984.

George Catlin

Truettner, William H. *The Natural Man Observed: A Study of Catlin's Indian Gallery*. Washington, D.C., 1979.

William Merritt Chase

Atkinson, D. Scott, and Nicolai Cikovsky, Jr. *William Merritt Chase: Summers at Shinnecock*. (Exhibition catalogue, National Gallery of Art) Washington, D.C., 1987.

Pisano, Ronald G. *William Merritt Chase*. New York, 1979.

———. *William Merritt Chase, 1849–1916: A Leading Spirit in American Art*. Seattle, 1983.

Frederic Edwin Church

Huntington, David. *The Landscapes of Frederic Edwin Church: Vision of an American Era*. New York, 1966.

Kelly, Franklin, and Gerald L. Carr. *The Early Landscapes of Frederic Edwin Church, 1845–1854*. Fort Worth, Tex., 1987.

Thomas Cole

Noble, Louis Legrand. *The Life and Works of Thomas Cole*. 1853; reprint, Cambridge, Mass., 1964.

Merritt, Howard S. *Thomas Cole*. (Exhibition catalogue, Memorial Art Gallery of the University of Rochester) Rochester, N.Y., 1969.

John Singleton Copley

Prown, Jules D. *John Singleton Copley*. 2 vols. Cambridge, Mass., 1966.

Jasper F. Cropsey

Talbot, William S. *Jasper F. Cropsey, 1823–1900*. (Exhibition catalogue, National Collection of Fine Arts) Washington, D.C., 1970.

Thomas Doughty

Goodyear, Frank H., Jr. *Thomas Doughty, 1793–1856, An American Pioneer in Landscape Painting*. (Exhibition catalogue, Pennsylvania Academy of the Fine Arts) Philadelphia, 1973.

Thomas Eakins

Goodrich, Lloyd. *Thomas Eakins*. (Exhibition catalogue, Whitney Museum of American Art) New York, 1970.

———. *Thomas Eakins*. 2 vols. Cambridge, Mass., 1982.

Hendricks, Gordon. *The Life and Work of Thomas Eakins*. New York, 1972.

Johns, Elizabeth. *Thomas Eakins: The Heroism of Modern Life*. Princeton, 1983.

Schendler, Sylvan. *Eakins*. Boston, 1967.

Ralph Earl

Goodrich, Laurence B. *Ralph Earl, Recorder for an Era*. Albany, N.Y., 1967.

Jacob Eichholtz

Beal, Rebecca J. *Jacob Eichholtz, 1776–1842, Portrait Painter of Pennsylvania*. Philadelphia, 1969.

Arshile Gorky

Schwabacher, Ethel K., *Arshile Gorky*. New York, 1957.

Chester Harding

White, Margaret E., ed. *A Sketch of Chester Harding, Artist, Drawn by His Own Hand*. Boston, 1929.

William Michael Harnett

Frankenstein, Alfred. *After the Hunt, William Harnett and Other American Still Life Painters, 1870–1900*. Rev. ed., Berkeley and Los Angeles, 1969.

Marsden Hartley

Haskell, Barbara. *Marsden Hartley*. (Exhibition catalogue, Whitney Museum of American Art) New York, 1980.

Childe Hassam

Adams, Adeline. *Childe Hassam*. New York, 1938.

Hoopes, Donelson F. *Childe Hassam*. New York, 1979.

Martin Johnson Heade

Stebbins, Theodore E., Jr. *The Life and Works of Martin Johnson Heade*. New Haven, Conn., and London, 1975.

Robert Henri

Homer, William I. *Robert Henri and His Circle*. Ithaca, N.Y., and London, 1969.

Edward Hicks

Ford, Alice. *Edward Hicks, Painter of the Peaceable Kingdom*. 1952; reprint, Millwood, N.Y., 1973.

———. *Edward Hicks: His Life and Art*. New York, 1985.

Mather, Eleanore Price. *Edward Hicks: A Peaceable Kingdom*. Princeton, 1973.

Winslow Homer

Cooper, Helen A. *The Watercolors of Winslow Homer*. New Haven, 1986.

Goodrich, Lloyd. *Winslow Homer*. New York, 1944.

Hendricks, Gordon. *The Life and Work of Winslow Homer*. New York, 1979.

Wilmerding, John. *Winslow Homer*. New York, 1972.

Edward Hopper

Goodrich, Lloyd. *Edward Hopper*. New York, 1978.

Hobbs, Robert. *Edward Hopper*. New York, 1987.

Levin, Gail. *Edward Hopper: The Art and the Artist*. New York, 1980.

George Inness

Cikovsky, Nicolai, Jr. *George Inness*. New York, 1971.

———, and Michael Quick. *George Inness*. (Exhibition catalogue, Los Angeles County Museum of Art) Los Angeles, 1985.

Ireland, LeRoy. *The Work of George Inness, An Illustrated Catalogue Raisonné*. Austin, Tex., and London, 1965.

Eastman Johnson

Baur, John I. H. *Eastman Johnson, 1824–1906, An American Genre Painter*. (Exhibition catalogue, Brooklyn Museum) 1940; reprint, New York, 1969.

Hills, Patricia. *Eastman Johnson*. (Exhibition catalogue, Whitney Museum of American Art) New York, 1972.

Joshua Johnson

Pleasants, Jacob Hall. *Joshua Johnston, The First American Negro Portrait Painter*. Baltimore, 1942.

Weekley, Carolyn J., et al. *Joshua Johnson: Freeman and Early American Portrait Painter*. (Exhibition catalogue, Abby Aldrich Rockefeller Folk Art Center, Colonial Williamsburg) Williamsburg, Va., 1987.

John F. Kensett

Driscoll, John Paul, and John K. Howat. *John Frederick Kensett: An American Master*. New York, 1985.

Howat, John K. *John Frederick Kensett, 1816–1872*. (Exhibition catalogue, American Federation of Arts) New York, 1968.

Fitz Hugh Lane

Wilmerding, John. *Fitz Hugh Lane*. New York, 1971.

———, et al. *Paintings by Fitz Hugh Lane*. (Exhibition catalogue, National Gallery of Art) Washington, D.C., 1988.

Jacob Lawrence

Brown, Milton W. *Jacob Lawrence*. (Exhibition catalogue, Whitney Museum of American Art) New York, 1974.

Wheat, Ellen Harkins. *Jacob Lawrence, American Painter*. (Exhibition catalogue, Seattle Art Museum) Seattle, 1986.

George Luks

George Luks 1866–1933. (Exhibition catalogue, Munson-Williams-Proctor Institute) Utica, N.Y., 1973.

John Marin

Reich, Sheldon. *John Marin, A Stylistic Analysis and Catalogue Raisonné*. Tucson, 1970.

Robert Motherwell
Arnason, H. Harvard. *Robert Motherwell*. New York, 1976.
Carmean, E. A., Jr., et al. *Robert Motherwell, Reconciliation Elegy*. New York, 1980.

Georgia O'Keeffe
Cowart, Jack, et al. *Georgia O'Keeffe: Art and Letters*. Boston, 1987.
Goodrich, Lloyd, and Doris Bry. *Georgia O'Keeffe*. (Exhibition catalogue, Whitney Museum of American Art) New York, 1970.
Lisle, Laurie. *Portrait of an Artist: A Biography of Georgia O'Keeffe*. New York, 1980.

Charles Willson Peale
Richardson, Edgar P., et al. *Charles Willson Peale and His World*. New York, 1982.
Sellers, Charles Coleman. *Charles Willson Peale*. Rev. ed., New York, 1969.
――――. *Mr. Peale's Museum: Charles Willson Peale and the First Popular Museum of Natural Science and Art*. New York, 1980.

Rembrandt Peale
Hevner, Carol Eaton, and Lillian B. Miller. *Rembrandt Peale, 1778–1860: A Life in the Arts*. (Exhibition catalogue, Historical Society of Pennsylvania) Philadelphia, 1985.

John Frederick Peto
Frankenstein, Alfred. *John Frederick Peto*. (Exhibition catalogue, Smith College Museum of Art) Northampton, Mass., 1950.
Wilmerding, John. *Important Information Inside: The Art of John F. Peto and the Idea of Still-Life Painting in Nineteenth-Century America*. New York, 1983.

Jackson Pollock
O'Connor, Francis V., and Eugene V. Thaw. *Jackson Pollock: A Catalogue Raisonné of Paintings, Drawings, and Other Works*. 4 vols. New Haven, Conn., 1978.
Solomon, Deborah. *Jackson Pollock: A Biography*. New York, 1987.

Maurice Prendergast
Langdale, Cecily. *Monotypes by Maurice Prendergast in the Terra Museum of American Art*. Chicago, 1984.
Rhys, Hedley Howell. *Maurice Prendergast, 1879–1924*. Cambridge, Mass., 1960.

John Quidor
Baur, John I. H. *John Quidor*. (Exhibition catalogue, Whitney Museum of American Art) New York, 1965.
Sokol, David. *John Quidor, Painter of American Legend*. (Exhibition catalogue, Wichita Art Museum) Wichita, Kans., 1973.

Mark Rothko
Ashton, Dore. *About Rothko*. New York, 1983.
Clearwater, Bonnie. *Mark Rothko: Works on Paper*. (Exhibition catalogue, American Federation of Arts) New York, 1984.
Waldman, Diane. *Mark Rothko, 1903–1970: A Retrospective*. (Exhibition catalogue, Solomon R. Guggenheim Museum) New York, 1978.

Albert P. Ryder
Goodrich, Lloyd. *Albert P. Ryder*. New York, 1959.

John Singer Sargent
Hills, Patricia, et al. *John Singer Sargent*. (Exhibition catalogue, Whitney Museum of American Art) New York, 1986.
Lomax, James, and Ormond, Richard. *John Singer Sargent and the Edwardian Age*. (Exhibition catalogue, Leeds Art Galleries) Leeds, England, 1979.
Ormond, Richard. *John Singer Sargent*. New York, 1970.
Ratcliff, Carter. *John Singer Sargent*. New York, 1982.

John Sloan
Scott, David. *John Sloan*. New York, 1975.

Gilbert Stuart
McLanathan, Richard. *Gilbert Stuart*. New York, 1986.
Park, Lawrence. *Gilbert Stuart: An Illustrated Descriptive List of His Works*. 4 vols. New York, 1926.
Richardson, Edgar P. *Gilbert Stuart, Portraitist of the Young Republic, 1755–1828*. (Exhibition catalogue, National Gallery of Art) Washington, D.C., 1967.

Thomas Sully
Fabian, Monroe H. *Mr. Sully, Portrait Painter: The Works of Thomas Sully (1783–1872)*. (Exhibition catalogue, National Portrait Gallery) Washington, D.C., 1983.
Fielding, Mantle. *The Life and Works of Thomas Sully*. Philadelphia, 1921.

Henry O. Tanner
Matthews, Marcia M. *Henry O. Tanner, American Artist*. Chicago, 1969.

John Henry Twachtman
Boyle, Richard J. *John Twachtman*. New York, 1979.

Max Weber
Werner, Alfred. *Max Weber*. New York, 1975.

Benjamin West
Abrams, Ann Uhry. *The Valiant Hero: Benjamin West and Grand-Style History Painting*. Washington, D.C., 1985.
Alberts, Robert C. *Benjamin West: A Biography*. Boston, 1978.
Evans, Dorinda. *Benjamin West and His American Students*. (Exhibition catalogue, National Portrait Gallery) Washington, D.C., 1980.
Evans, Grose. *Benjamin West and the Taste of His Times*. Carbondale, Ill., 1959.
Kraemer, Ruth S. *Drawings by Benjamin West and His Son Raphael Lamar West*. (Exhibition catalogue, The Pierpont Morgan Library) New York, 1975.
von Erfa, Helmut, and Allen Staley. *The Paintings of Benjamin West*. New Haven, 1986.

James McNeill Whistler
Curry, David Park. *James McNeill Whistler at the Freer Gallery of Art*. (Exhibition catalogue, Freer Gallery of Art) Washington, D.C., 1984.
Fine, Ruth E. *Drawing Near: Whistler Etchings from the Zelman Collection*. (Exhibition catalogue, Los Angeles County Museum of Art) Los Angeles, 1984.
Taylor, Hilary, *James McNeill Whistler*. London, 1978.
Walker, John. *James McNeill Whistler*. New York, 1987.
Young, Andrew McLaren. *James McNeill Whistler*. (Exhibition catalogue, Arts Council of Great Britain) London, 1960.
――――, et al. *The Paintings of James McNeill Whistler*. 2 vols. New Haven, 1980.

Andrew Wyeth
Corn, Wanda M., et al. *The Art of Andrew Wyeth*. (Exhibition catalogue, Fine Arts Museums of San Francisco) San Francisco, Calif., 1973.
Wilmerding, John. *Andrew Wyeth: The Helga Pictures*. New York, 1987.

Index